Sean Scully: Twenty Years, 1976 – 1995 is organized by the High Museum of Art, Atlanta, Georgia, and is generously sponsored by the Members Guild on the occasion of its 30th Anniversary.

SEAN SCULLY

Sean Scully in his London studio, November 1994. Photo by Catherine Lee

SEAN SCULLY
TWENTY YEARS, 1976–1995

NED RIFKIN

with contributions by

Victoria Combalia
Lynne Cooke
Armin Zweite

FOR JOEL,
IN GRATITUDE FOR YOUR
EFFORTS IN SUPPORT OF
THIS SPECIAL PROJECT,

Ned

THAMES AND HUDSON

HIGH MUSEUM OF ART

This catalog is dedicated to the perpetuation
of the spirit—and to the memory of the lifetime
—of Isadora Jo Rifkin (1951–1991). N R

Sean Scully: Twenty Years, 1976–1995 was prepared on the
occasion of the exhibition of the same title, organized by the
High Museum of Art, Atlanta, Georgia.

Designed and produced by Thames and Hudson and
copublished with the High Museum of Art.

First published in hardcover in the United States of America
in 1995 by Thames and Hudson Inc., 500 Fifth Avenue,
New York, New York 10110

Library of Congress Catalog Card Number 94-61651
ISBN 0-500-09249-4

Printed and bound in Singapore

EXHIBITION DATES

14 June–10 September 1995
Hirshhorn Museum and Sculpture Garden,
Smithsonian Institution, Washington, D.C.

10 October 1995–7 January 1996
High Museum of Art, Atlanta

5 February–7 April 1996
Fundació "la Caixa," Centre Cultural, Barcelona

23 May–24 August 1996
The Irish Museum of Modern Art, Dublin

19 September–24 November 1996
Schirn Kunsthalle Frankfurt, Frankfurt am Main

LENDERS TO THE EXHIBITION

Bo Alveryd, Switzerland
Art Institute of Chicago
Beadleston Family
Bronya and Andrew Galef
Robert and Adele Gardner
High Museum of Art, Atlanta
Hirshhorn Museum and Sculpture Garden,
 Smithsonian Institution
Bernd Klüser
Mellon Bank Corporation, Pittsburgh
Museo Nacional Centro de Arte Reina Sofia, Madrid
Tom and Charlotte Newby
PaineWebber Group Inc., New York
Private Collection, Aschaffenburg
Private Collection, San Francisco
Sean Scully
Staatsgalerie moderner Kunst, Munich
Städtische Galerie im Lenbachhaus, Munich
Judith and Mark Taylor
Cindy Workman

DIRECTOR'S CIRCLE MEMBERS, 1994–1995

Charles C. and Eleanor A. Barton
Mr. and Mrs. John Treacy Beyer
Mr. and Mrs. Dameron Black, III
Elinor and William Breman
The Honorable Anne Cox Chambers
Miriam H. and John A. Conant
Mr. and Mrs. Thomas G. Cousins
Virginia Carroll Crawford
The Alfred A. Davis Family
Charlotte and Alvin M. Ferst
Mrs. Robert D. Fowler
Mr. and Mrs. Dan Garson
Mr. and Mrs. Roberto C. Goizueta
Mr. and Mrs. Holcombe T. Green, Jr.
Mr. and Mrs. M. Anthony Greene
T. Marshall Hahn, Jr.
Mr. and Mrs. W. Barrett Howell
Mr. and Mrs. Donald Keough
Mrs. Helen S. Lanier
Dr. and Mrs. Joe B. Massey
Morris and Ruth Dobbs McDonald
Mrs. O. Ray Moore
Mr. and Mrs. Rhodes L. Perdue
Mr. and Mrs. William C. Rawson
Mrs. Roy Richards
Mr. Xavier Roberts
Mr. and Mrs. J. Mack Robinson
Mr. and Mrs. Gary Rollins
The Selig Foundation
Mrs. William C. Wardlaw, Jr.
Mr. and Mrs. John F. Wieland
Mrs. Thomas L. Williams, Jr.

CONTENTS

FOREWORD
AND ACKNOWLEDGMENTS

As with any project of this magnitude, the results represent the combined efforts of numerous individuals who deserve credit and praise. In the case of this exhibition and publication, an impressive team of people were involved in helping to realize an undertaking over three years long in gestation.

To begin with, I must thank my former colleague James T. Demetrion, Director of the Hirshhorn Museum and Sculpture Garden of the Smithsonian Institution in Washington, D.C. It was while on the staff there that I commenced the research for this exhibition, enjoying his endorsement and encouragement. It is particularly gratifying that the tour of the exhibition begins at the Hirshhorn, since indeed this is where it all began. For me, I suppose this represents the "end of the beginning" of my transition time in moving from being Chief Curator of the Hirshhorn to Director of the High.

I must next thank my newer colleagues at the High Museum of Art. To begin with, Alison MacGinnitie, Museum Programs Assistant assigned to work closely with me on this project, has been exemplary in every detail of support and execution. Without her intelligence, persistence, clarity, and wit, most of the "doing" would not have gotten done, and certainly not with the special touch and follow-through.

Bill Bodine, former Associate Director for Museum Programs at the High and presently Deputy Director /Chief Curator at the Columbia (South Carolina) Museum of Art, played a critical role in maintaining the pace and serving as a sounding board for administrative questions throughout the organizational process. Marjorie Harvey, Manager of Exhibitions and Interim Associate Director for Museum Programs, manifested her astounding abilities to coordinate vast numbers of details and contributed her sensitive and imaginative ideas for installation design while maintaining extraordinary equanimity and her typically graceful sophistication. Frances Francis, Registrar, and Jody Cohen, Associate Registrar, demonstrated that rare combination of fastidiousness and tolerance which only top-notch registrars have, while supervising the logistics of budgets and implementation of transportation, insurance, and scheduling for the paperwork, consolidation, packing and shipping and, ultimately, dispersal and return of the works of art that constitute this exhibition.

Susan Sharrow, my executive assistant, contributed the invisible support to this project by managing my schedule and budgeting my time to permit a rookie museum director to continue on a major curatorial project. Gail Harris, previously executive secretary, assisted ably in the early phases of the Scully project in Atlanta. I need also to acknowledge my former assistant at the Hirshhorn, Francie Woltz, for getting this project rolling initially while I was still working there. Kelly Morris, Manager of Publications, proved consistently helpful with his advice and editorial expertise. Nancy Roberts, Chief Art Handler, and her remarkable team

of technically skilled and dedicated individuals (Gene Clifton, Evan Forfar, Mike Jensen, Vince Jones, Jim Waters) and Larry Miller, the High's Works on Paper Specialist, contributed their reliably secure and professional hands on the exhibition in Atlanta.

Karen Luik, Eleanor McDonald Storza Chair of Education, Joy Patty, Head of Adult Programs, and Ann Kelso, Head of Student and Family Programs, in our award-winning Department of Education, deserve recognition for conceiving and delivering a fine quality and range of programs to interpret and accompany this show. Rhonda Matheison, Director of Business Affairs, and Anne Baker, Director of External Affairs, and their team of colleagues in these two critical divisions of the High, are to be commended for their excellent management of operations, admissions, and security, and of development, public relations, and membership functions respectively. In particular, I wish to thank Ann Wilson, our Manager of Public Relations, and Betsy Hamilton, Manager of Individual Support, for their contributions to this effort.

I would be remiss if I were not to thank two individuals who have led the Board of Directors of the High since my arrival here three years ago and who have been vigilant in their support of me and this project: Richard A. Denny, Jr., who headed the search committee that ultimately brought me to Atlanta and subsequently served for three years as the Chairman of the Board of the High, and John F. Wieland, current Board Chair. These two individuals, and the legions of Board members who have boosted my spirits with their unflagging efforts on the High's behalf, are most deserving of my gratitude. I am especially grateful to Ron Brill, chair of the development team of the Board for the Scully exhibition, for his efforts on this project.

The High's Director's Circle came into existence upon my arrival in Atlanta in September 1991, and while it is in support of me as the Director of the High, it is clearly more generally supportive of the Museum's overall need for annual operating funds. The backbone of individual leadership in patronage of and philanthropic giving to this institution, the Circle has honored me—and Sean Scully—by underwriting this publication as its first official undertaking. My profound thanks go to all the members of the High Museum of Art's Director's Circle for their faith, generosity, and personal presence.

For the High, *Sean Scully: Twenty Years, 1976–1995* is more than simply another special exhibition we have organized and will present for three months. It also represents a historical achievement for this institution: it is the first time a show organized by the High has toured internationally. It is our hope that this is something we will be able to do with regularity as our Museum and city grow into more internationally recognized and active participants in a truly global world. For their participation on the tour of this exhibition, I am grateful to James T. Demetrion, Director, and Neal Benezra, Director of Public Programs, and Judith Zilczer, Curator of Paintings, at the Hirshhorn Museum and Sculpture Garden; Thomas Messer, currently Director of the Schirn Kunsthalle Frankfurt and formerly Senior Advisor to Fundació "la Caixa" in Barcelona; Imma Cassas, Head of the Fine Arts Department, and Nimfa Bisbe of the Fine Arts Department, of "la Caixa"; Declan McGonagle, Director, and Brenda McParland, Curator, of the Irish Museum of Modern Art in Dublin; and Hellmut Seemen of the Schirn Kunsthalle Frankfurt.

To my fellow contributors to this catalog, Victoria Combalia, Lynne Cooke, and Armin Zweite, I extend warm thanks. We obviously share a serious interest in Sean Scully's art. We also have in common the rather curious desire to attempt to state verbally what impresses and stimulates, yet inevitably escapes and eludes, us about the visual arts. Taking words, these fragile and powerful constructions, and attaching them to ideas about works of visual art is a most difficult and

marvelous form of communication, one which astonishes me whenever it is done with incisiveness and conviction. Each of these three writers offers us insights and perspectives that are truly valuable and original. It is owing to *their* art that Sean Scully's art becomes more accessible and appreciated.

To my wife, Diann, and our two sons, Moses and Amos, my loving thanks for their ongoing belief in me, for the tolerances they have and sacrifices they continue to make in order to support my pursuit of this and other professional endeavors. They have been extraordinary in helping me keep my spirits up whenever they waned or sagged from fatigue or self-doubt. These three people have made a contribution to this project that is impossible to define fully.

For all of his work on this show, Per Jensen, the artist's personal assistant, has made every step of the process significantly simpler. He has provided numerous members of the High's staff with various details and material throughout the whole period of the show's organization. Not only has Per been a collaborator in all phases of this project from day one, he was also the person responsible for initially introducing Sean Scully and me in 1982 when he asked the two of us to serve on a jury for artists' studios at P.S. 1 in Long Island City, New York.

I know I speak for all of the participating venues as well as for those who will enjoy and be challenged and inspired by the art of Sean Scully when I offer my sincere thanks to the lenders of the works. Not only do they put their personal and institutional resources at risk for over a year's duration, but they must also live without the nourishing and enriching presence of these objects over that same period. This is a most generous and thoughtful action, one which is deeply appreciated by all who experience the art in the span of the tour.

For a curator, there is no greater privilege than to work directly with an artist on any exhibition, and in particular on a survey of twenty years of his art. It is not quite as straightforward a prospect as one might imagine. Taking and shaping the manner in which an artist's work will be seen and assessed is a delicate matter, one fraught with anxiety and doubt for many artists. Understandably, artists are quite often more comfortable looking from the present and on into the future than they are with the rare glance back to review and reconsider their previous work. For some it can be awkward; for others actually painful and disturbingly disruptive. For many, however, it can be heartening and even deeply gratifying. While we do not yet know what effect this experience may have on Sean Scully, it is something of a risk for him just to venture into such a situation. To his credit—and certainly to my benefit—Sean has been actively involved in the process of planning the show, considering with me the various venues and—naturally—selecting the works for the exhibition along with me, never with any interference or second-guessing. Without the art of this outstanding creative force named Sean Scully, there would be no exhibition. And beyond this, coming to know Sean as a partner, friend, and provocateur (as well as a generous lender to the show) has been perhaps the most rewarding aspect for me personally and professionally. It is my hope that this exhibition and the publication you are reading will enable increased numbers of people to know and appreciate the rich, resonant, and rewarding art of this fierce artist whose work brings together so many of the vital dimensions of the European and American art that has engaged and depicted the spirit, mind, and experiences of being alive throughout the twentieth century.

Ned Rifkin
Director, High Museum of Art

INTRODUCTION
SEAN SCULLY: TWENTY YEARS, 1976–1995

Ned Rifkin

. . . I believe with elemental forms painted from deep within the self, it is possible to make something empathetic that addresses the architecture of our spirituality. I think of my painting as a kind of emotional glue.

Sean Scully, 1994
quoted in Victoria Combalia,
"Sean Scully: Against Formalism"

Sean Scully, the son of a barber, was born in Dublin in 1945 and emigrated to England four years later with his family. Growing up in a working-class area of south London, the young Scully took as his inspiration the American painters of emotional caldrons and sublime realms that captured his imagination at an early stage. In 1967, while he was still in art school, an encounter with a catalog of a Mark Rothko exhibition at The Museum of Modern Art in New York fascinated, bewildered, and forever changed him.

By emulating the Rothko paintings he had experienced as reproductions, Scully never again found a need to create paintings that were figurative or representational, as he had done previously in his art studies. Soon after this, he developed a reputation as a student with a distinctive discipline and conceptual frame for painting; around this time he came under the influence of the optical geometric paintings of British painter Bridget Riley. In 1969, during a trip to North Africa, he had an experience similar to ones that had been so instrumental in the development of works of artists as diverse in time and style as Eugène Delacroix, Henri Matisse, and Paul Klee: the overpowering light and engaging visual patterns of Morocco.

The tradition in postwar British art at the time when Scully was formulating his artistic compass was strongly figurative. The dominant artists were working in a figurative mode: from paintings by Lucian Freud, Francis Bacon, and Graham Sutherland to sculptures by Reg Butler, Elizabeth Frink, and Lynn Chadwick. By choosing non-objective painting of the kind that was emerging in the work of an international spectrum of painters such as Americans Frank Stella, Gene Davis, Agnes Martin, and Kenneth Noland, the Frenchman François Morellet, and the Venezuelan Jesús-Rafael Soto, Scully signaled that he regarded himself as belonging in a larger context even at this nascent phase of his endeavor.

At the outset of his career, commencing in 1968 after art school and then through 1972 while teaching in Newcastle-upon-Tyne, Scully's art is characterized by a grid system of bands and lines that intersect and pulse with a richly dense optical field. The illusion of space is activated via overlaps and color contrasts. The influence of the Op Art movement was clearly present. Beginning in 1972, with assistance from a prestigious fellowship, he made his first visit to the United States to attend graduate school at Harvard University. While in Cambridge, Massachusetts, Scully opened up to a decidedly more experimental mode for creating paintings. The following year, 1973, Scully was given his first solo exhibition in

London's Rowan Gallery, and proceeded to sell out the entire show. In addition, he received favorable notices, including some very complimentary comments from John Russell, then writing for the London *Sunday Times*. Over the next two years, Scully taught at the Chelsea School of Art and at Goldsmiths' College, University of London.

Another coveted award, the Harkness Fellowship, enabled Scully to return to the United States for two years beginning in July 1975. As he prepared for his trans-Atlantic journey, Scully created *Change* (right), a pivotal series of acrylic works on 22 by 30 inch (56 x 76 cm.) sheets of paper, signifying a major shift in his work. These paintings on paper prefigure larger canvases that he was to generate soon after his return to New York, where he lived with artist Catherine Lee, whom he would later marry. Composed of tightly woven webs of gridded, thin bands of taped-off colors, this series introduces the darker, spatially hermetic work that characterizes his early New York years. In many respects, this body of work reflects the influence of Ad Reinhardt's famous series of black paintings at the end of his life.

In New York in 1976 (the year that marks the beginning of this exhibition), Scully began showing his art in group exhibitions at the John Weber Gallery and the Susan Caldwell Gallery. The following year, he was given his first solo show in New York at the Duffy-Gibbs Gallery. This show featured a remarkably restrained sensibility that demarcates "ground zero" for Scully's art: *Horizontals: Thin Greys* [Plate 2], a neutral gray, square painting, made up of regular, horizontal lines of acrylic paint, light and dark values alternating. While some paintings from this time contain color—deep reds, browns, and blues (e.g., *Blue* [Plate 3])—the tone of the moment was dominantly deep and quiet. The series of black paintings that followed during the next few years, 1978–80 (e.g., *Brennus* [Plate 6], *Italian Painting #2* [Plate 5], and *Slate* [Plate 9]), reveal Scully's struggle

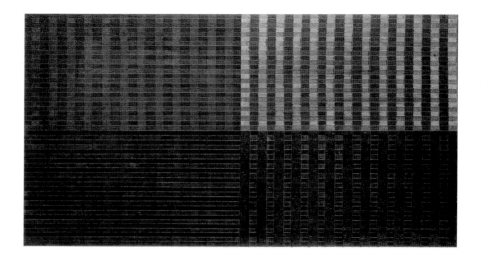

CHANGE DRAWING #42
1975
acrylic on paper
22 x 30 (56 x 76)
Collection of the artist

to define and play with nuances of values, distinctions between acrylic and oil paints and how they hold, reflect, and absorb light, and oppositions of horizontal and vertical linear elements. Little or no painterly touch is disclosed in these works. The system of organization is simple: regular widths of bands or lines placed immediately adjacent to one another; no space and only the slightest emanation of light out of the darkness.

Beginning in 1977, Scully taught part-time at Princeton University. Through this appointment he developed a friendship with another professor, the influential scholar, critic, and curator Sam Hunter. This proved to be an important alliance for Scully, both because of Hunter's overall knowledge of modern and contemporary art as well as for his close contacts in the New York art world. Two years later, Hunter would publish the first major article on Scully's work in the United States, a cover piece for *Artforum* magazine,

the most important critical journal for the cutting edge at that time.

Other important friends at this time included William Beadleston, a private art dealer who periodically purchased works from Scully when the latter was struggling for funds, and Charles Choset, a collector who gave the artist a monthly stipend for three years in exchange for works of art of his choice. Another friendship that had a telling effect on Scully was his sustained relationship (through shooting pool and visiting studios) with painter Robert Ryman, whose commitment to an extreme aesthetic position, realized in his exclusively white paintings, challenged and inspired the younger painter.

BACKS AND FRONTS
1981
oil on canvas
96 x 240 (244 x 610)
Collection of the artist

The year 1981 was a propitious time for Scully. He was able to see ten years of his previous work borrowed and organized for a solo exhibition at the Ikon Gallery in Birmingham, England. This experience must have affected him deeply and contributed to his need to push beyond what he had already discovered and learned about his work—and about himself. Having expunged almost every visual element from his paintings and thereby demonstrated the remarkable restraint and discipline that mark his personality and artistic temperament, in 1981 Scully began the process of introducing direction, color, space, and even touch or hand-painted surfaces back into his work.

Enough [Plate 13] reflects the artist's desire to break out of what had been a somber and rational time, grappling with the rigors of reason against the absurdities of the human condition. The visual animation of this and other paintings from this time testify to Scully's determination to ground his work in his own subjective responses to New York City and its pervasive chaos. Despite this element of hectic and dynamic energy, there is still a visible tendency

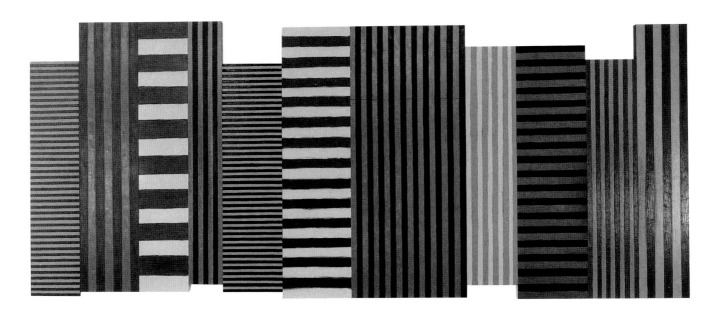

to find balance and equilibrium in even the most complex compositions. Increasingly, Scully's work indicated his desire to extract a more expressive result from his use of line, repetition, color, and painted surfaces.

Many artists who pursue a systematic or programmatic approach eventually get bogged down, somehow tire of and outgrow that method or orientation, and must seek a way beyond it. Sometimes the process can take a very long time. In other instances, there is what is often referred to as a "breakthrough" work, one that signals a change in direction, a transition that augurs a new dimension to a body of work. For Picasso, *Les Demoiselles d'Avignon* is certainly one: after Picasso finished the picture, he showed it to a number of friends, who were dumbstruck. As a result, Picasso took it off the stretcher bars, rolled it up, and stowed it in a corner of his studio for some time. Of course, this painting is now considered the pivotal piece in the evolution of Cubism.

Scully created *Heart of Darkness* [Plate 16], which can now be regarded as his breakthrough painting, in 1982. Having wrestled for over a year with the more visually active paintings represented in this exhibition by *Enough*, he moved his work onto a grander scale and into a new sphere of expressiveness with this one picture. One of his largest paintings to date (the earlier *Backs and Fronts* [page 13] from 1981 is nearly twice as long), this work is a culmination of many of the smaller and less successful excursions into the polyptych presentation that he had been exploring since the mid-1970s. Now, using subtle underpainting and hand-drawn lines defining and separating the horizontal and vertical bands of colors, Scully had arrived as a mature artist.

Subsequent works, *Angelica* [Plate 15] and *Angel* [Plate 19], have a resolve and a depth of content that are unparalleled in Scully's previous work. The combination of painting, drawing, composition, and structure attained a strained balance between elegance and awkwardness, between the precision of geometry and the irregularity of

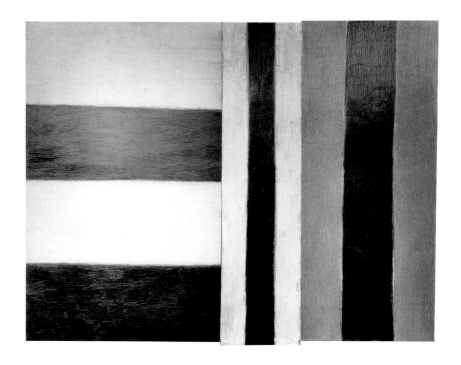

PAUL
1984
oil on canvas
102 x 126 (259 x 320)
Tate Gallery, London

the hand, and imbued the paintings with a profound sense of both vulnerability and power. With fresh clarity and purpose, Scully experimented more freely with compositional and structural concepts, breaking into asymmetrical assemblages of components while in residence at famed playwright Edward Albee's artists' colony in Montauk, Long Island, in 1982. Building confidence in his vision for non-representational painting at a time when subject matter and narrative painting began to attract the attention of critics, curators, dealers, and collectors, Scully emerged as a force within the New York art world, winning a Guggenheim Foundation Fellowship in 1983 and joining the stable of

the David McKee Gallery, an affiliation he maintained for ten years.

The year 1983 held both joyous and tragic events for Scully. Having married Catherine Lee in 1978, he was now able to secure American citizenship. Although he continues to maintain homes and work places in both London and New York (and recently opened a studio in Barcelona), Scully considers himself very much an American artist working within the context of American postwar art. The same year, Paul, his nineteen-year-old

DARK FACE
1986
oil on canvas
112 x 93 (284 x 236)
High Museum of Art
Gift of the artist in memory of his son Paul

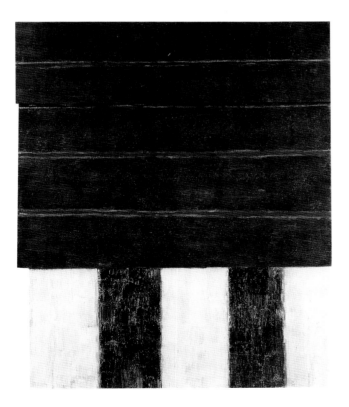

son from a previous marriage, was killed in London in an automobile accident. While his personal grief reached new depths, he was able to channel it into his work. In fact, one of his finest paintings of 1984 is dedicated to the memory of his deceased son and named *Paul* (facing page). Like *No Neo* [Plate 23] and *Murphy* [Plate 24], his work from this year contains a sensuality and light seemingly emanating from within. Arguably, the years 1983–86 were the most productive he had had to date in terms of generating a string of outstanding paintings— e.g., *Flesh* [Plate 25], *This, That* [Plate 26], and *Dark Face* (below left).

During this period, Scully received the kind of recognition with which any mid-career artist would be thrilled. Not only was he granted by his peers a prestigious National Endowment for the Arts Artist's Fellowship for painting in 1984, he was also selected by Kynaston McShine, Curator of The Museum of Modern Art, for the exhibition *An International Survey of Recent Painting and Sculpture*. The following year, Scully was given his first solo museum exhibition, organized by John Caldwell of the Carnegie Institute in Pittsburgh, which later traveled to the Museum of Fine Arts, Boston.

Unrelentingly, Scully pushed his work forward, creating relief-like paintings that projected and advanced planes, bearing all the while remarkable configurations of painted bands of color and subtle motion and weight. The will of the artist manifested itself with increasing muscle and determination. The paintings were becoming markedly more physical, to the point where they could stand freely on the floor without any need for support (although they have always been conceived to hang on the wall). Major museums were acquiring large-scale paintings by Scully, and in the face of many reiterations and revivals of earlier styles of American art, Scully took a stand against the artifice and superficiality of academicized conceptual art posing as abstract painting. Unabashedly Modernist in a time when Postmodernism

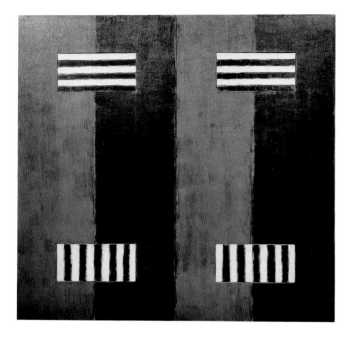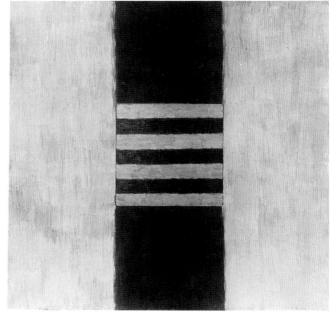

was the most trendy addition to the art jargon of the so-called avant-garde, Scully became known as a staunch advocate for what was being characterized as traditional or conventional abstraction. Like the great German painter Gerhard Richter, Scully enjoyed the debates and suffered the inevitable detractors.

Just as this success with his work was taking hold, Scully—always the rebel by temperament and recognizing the need continually to break out of whatever groove his art had gotten into—moved toward a flatter, more rigorous, less complex, and even smaller scale of working. A series of more austere paintings emerged in 1987, most notably *Empty Heart* [Plate 31]. While it is always difficult to determine the specific thrust or to quantify the precise emotional content of one of Scully's works, there is little question that this must have been a personally trying moment. Titles of major paintings like *Backwards Forwards* (above left), *Light to Dark* (above

right), and *Battered Earth* (facing page) bear witness to some kind of internal crisis.

What is uncanny about Scully, however, is the way he can repeatedly emerge resilient from the darkest times with apparent restraint and self-control to employ a richness of color and agile variations of symmetry, as in *Us* [Plate 36], along with numerous paintings of this quality and nature—e.g., *Nostromo* (1987, oil on canvas, 90 x 148 in. [229 x 376 cm.], Private Collection, Switzerland), *A Bedroom in Venice* (page 45), and *Pale Fire* (page18).

As he continued to hit his stride with these large-scale paintings of relatively simple composition, generally using one or two of his insets in a single field of vertical bands, Scully again moved to a less colorful, almost *grisaille* palette, in order to introduce a more complex compositional element. With *White Window* (page 19) and later *Why and What (Yellow)* [Plate 37], an emphatically more active intersection of vertical and

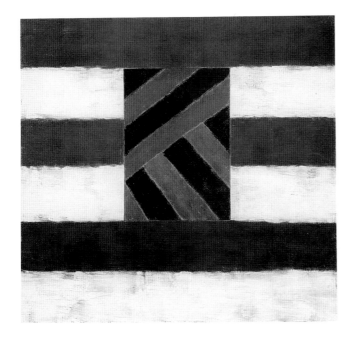

horizontal bands begins to appear with a single or sometimes a double inset or "window." In the latter painting, Scully also introduced an element of steel for the first time, something that would engage him further within a year's time. Sensing this to be another breakthrough picture, the organizers of Scully's next major touring exhibition, originating at the Whitechapel Gallery in London's East End, illustrated a detail of this painting as the cover of the accompanying catalog. This show toured to important museums and Kunsthallen throughout Europe, including Munich and Madrid. By this time, Scully had also had important, smaller solo exhibitions at the University Art Museum in Berkeley, California, the Art Institute of Chicago, and at Fuji Television Gallery in Tokyo.

These travel and exhibition opportunities enabled him to meet more people and to see and experience more places. With a number of trips to Mexico, for four years from 1987 to 1990, Scully nourished his seemingly insatiable appetite for exposure to new sources of visual stimuli. Some of his finest watercolors and works on paper are the result of Scully's daily efforts to assimilate what he was seeing and absorbing. While these were not created as studies for larger works, the seminal relationship between many of his pastels, watercolors, and prints and his major paintings has been important to the artist over the years. It would be a mistake to characterize these works on paper as preliminary steps in his creative process, since Scully is constantly working to realize visual ideas and to discover new approaches to making pictures. In fact, the joy of making watercolors —so simple in terms of set-up, so fluid in terms of medium—brings out an altogether different quality from that of the more labor-intensive oil paintings.

Two paintings from 1989 and 1990 represent an opposition within Scully's sensibility. *Africa* [Plate 38]

embodies the dark and combative dimensions of a working-class Irishman who has studied, disciplined himself, and battled physically to earn a black belt in karate, while being intellectually bright and articulate enough to teach at an Ivy League university. By contrast, *White Robe* [Plate 44] represents an enlightened, self-aware, and mature painter at the zenith of his art. The former has a dominant earthy tonality which is dry and scraped to reveal dark and ominous underpainting. *White Robe* is, in the artist's estimation, "a sublime painting . . . saturated with a kind of light that's bathed in a yellow dawn glow." Scully talks not so much about "dualities" in his work, but rather about the "contradictions" in the whole of his art: "I don't think that *White Robe* is about the possibility of failure. . . . It's about the possibility of perfection, but it's not quite perfect. But it approaches a great level of resolution. . . . I think there is an elegance to the painting which doesn't really exist in *Africa*, which is a much more brooding and chunky picture."

As the 1980s yielded to the beginning of the 1990s, Scully continued to experiment with fresh approaches to his paintings. A fine example of this is *Four Days* [Plate 42], which is unique in the artist's oeuvre in that it is like a "sampler" of various ways Scully has worked. (For a thorough analysis of this painting, please refer to Lynne Cooke's insightful essay elsewhere in this volume.) He also began to incorporate his insets into large steel frames rather than only into fields of painted canvas. This yielded some marvelous works, notably *Facing East* [Plate 45], a symmetrical diptych combining the warmth and vitality of the paint with the cold, gray metal (reminiscent of the Minimal art of the 1960s) that signals remoteness and distance. Whereas in *Spirit* [Plate 53] the artist deliberately chose to spray the steel with water in order to create the warm orange-brown color of rust, *Facing East* has the iciness that rolled steel often invokes. The insets in this painting, a simple solid red rectangle and a group of five vertical stripes of beige and black, are quite different from each other. The red inset is the artist's

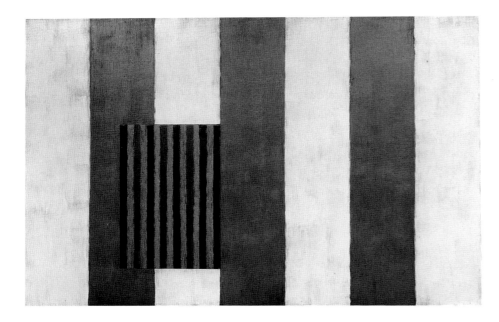

PALE FIRE
1988
oil on canvas
96 x 147 (244 x 373)
Modern Art Museum of Fort Worth

18

WHITE WINDOW
1988
oil on canvas
96 x 146 (244 x 371)
Tate Gallery, London

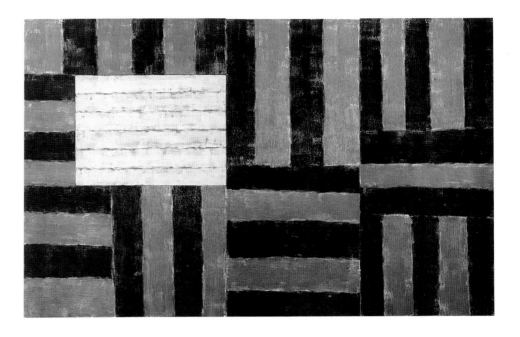

homage to Kasimir Malevich, the Russian utopian artist whose simple yet ethereal geometric abstractions were eventually thwarted by the totalitarian policies of the Soviet state. Indeed, with the steel frame surrounding the vertical stripes of the inset, there is an undeniable sense of imprisonment or at least confinement (the "Iron Curtain"?), a contrast that occurs in Scully's work periodically. The diagonally striped field which surrounds the red inset is also unusual in Scully's visual vocabulary, although one such panel is visible in *Four Days*, but there without an inset.

The artist made numerous variations with steel panels, but he was soon on the verge of another important change—a return to a motif he had explored quite early in his art. In 1991 he created a painting entitled *Tetuan* [Plate 49], named after a town outside Tangier where Matisse had painted. This painting boldly reintroduced what Scully refers to as the "checkerboard" motif: a brightly charged black and yellow expanse of

hand-painted small squares creates the dominant field into which is set a beautifully painted inset of thin horizontal stripes that stack and alternate colors vertically. (Scully had done grid paintings that appear very much like hard-edge checkerboards in the early 1970s.) Like Picasso's friends viewing *Les Demoiselles d'Avignon* in 1905 for the first time, upon first seeing this picture in the studio, this author responded with great excitement and remarked that it had some rather "zany" aspects to it. This observation seemed to disturb Scully, so much so that he returned to it and painted the yellow squares over with a bright red, which altered the overall impression and tone immensely. After a later discussion, Scully restored it to yellow, however now with a softer, somewhat more melancholic and less strident or exuberant quality.

For some time Scully had been interested in creating smaller, more intimate paintings that could have the power and impact of his large-scale works. *Uist* [Plate 46] is one of numerous such checkerboard paintings that

function somewhere between the larger works on paper and the full-sized oil paintings on canvas.

In her excellent essay on the artist's work, the Barcelona/Paris-based scholar, critic, and independent curator Victoria Combalia refers to the classical aspect that informs Scully's art. Among the most classical in its sense of balance and resolution is *Stone Light* [Plate 54]. This painting and *Gabriel* [Plate 55] are featured subjects in the incisive essay by German museum director Armin Zweite, reprinted in this catalog.

The most recent paintings testify to Scully's growth and maturity as an international artist. With *Magdalena* [Plate 56] he has reached a pinnacle of poetic evocation. One of an ongoing series of smaller paintings bearing female names, generally horizontal diptychs, each of whose panels has insets hovering one above the other, in many respects *Magdalena* is a refinement of his earlier *A Bedroom in Venice* (page 45). Here, Scully is more economical with his manipulations of elements and ingredients in order to put forth a succinct yet inspired portrait of a spirit.

Scully is determined to continue to mine the self-imposed, restricted vocabulary he has forged for his artistic expression. In a sense, it is the variations on a handful of themes to which he returns that induce us to marvel at his resourcefulness with a very confined range of visual tools. Scully has given a physical and emotional dimension to non-representational painting that is akin to Rothko's coloristic achievements in the 1950s and 1960s. Very few artists have managed to develop their vision with the consistency and tenacity that Scully has over the past twenty years, a quality that he attributes to his admiration for the great Dutch Neoplastic artist, Piet Mondrian, who, like Scully, emigrated across the Atlantic Ocean to New York to make some of his most exciting works, and, also like Scully, took inspiration from his love of indigenous American music (for Mondrian, jazz and "boogie-woogie"; for Scully, rhythm and blues and rock and roll).

The purpose of an exhibition of this scope is not simply to present the work of a particular artist in a full and cogent manner. It is also to make the case for the achievements that that artist has attained as being important within the larger context of the history of modern and contemporary art. It is clear that Sean Scully is an artist whose body of work has moved itself from the periphery into the center of contemporary discussions on twentieth-century non-representational painting. Given the fact that this kind of art has existed for only ninety-five years, it is likely that these twenty years of Scully's art will constitute an important chapter in the final report on this subject. It is the power of the work, in conjunction with the integrity of the project, that yields a richly penetrating contribution to our appreciation and understanding of how artists continue to make personal expressions that engage universal meaning.

TO HUMANIZE ABSTRACT PAINTING:
REFLECTIONS ON SEAN SCULLY'S "STONE LIGHT" Armin Zweite

More than any other artist of his generation, Sean Scully combines European traditions of painting with forms of aesthetic experience whose roots lie in America—specifically, in New York. This tends to encumber the reception of his oeuvre. From one point of view, based on a particular set of ideas and expectations, Scully's work appears insufficiently bold and radical: it seems to lag behind the sophisticated conceptions of art which emerged in the 1960s, ignoring contemporary developments and harking back to more traditional notions of painting. On another evaluation, which is no less one-sided than the first, his work is too unstable and hermetic. Both these views are to some extent justified; looking at their positive aspect, each of them says something significant about what happens in Scully's pictures. In his work, modern art seems to turn in on itself and reconsider its own founding principles. It is as if the basic concepts of abstraction were yet again being subjected to critical scrutiny, with the intention of enhancing the autonomous value of the artistic "means," of broadening the foundation of a rigorous pictorial strategy based exclusively on vertical and horizontal lines, of modifying the aesthetic of pure form, surface, and color, and recharging it with emotion. Thus Scully's work is the site of a highly ambitious undertaking—to put the rational operations of painting, guided primarily by the intellect, on a more sensual footing, and to challenge the predominance of the purely optical, but at the same time—a crucial point—to avoid any deviation from the purist canons of a highly restricted formal repertoire. This will require further elaboration.

Looking at Scully's oeuvre as a whole—his paintings, watercolors, pastels, and prints—one is struck by the exceptionally limited repertoire of motifs, comprising vertical and horizontal stripes of varying lengths and breadth, occasionally augmented by diagonal lines. However, one also notices an element of hesitancy and uncertainty; instead of being cold and rationally precise, the forms appear flawed by the repeated layering of color and the crudely artisan manner in which it is applied. This skillfully created sense of imperfection hints at a subjective impetus, but the individual peculiarities—the blurred edges and seemingly crumbling surfaces—give no indication of their meaning or purpose. With their coldly geometric structure, the paintings impose an enormous distance between themselves and the viewer. Yet their painterly energy somehow engages one's attention and touches an emotional chord. Scully's pictures generate a kind of aesthetic experience which can only be described as a paradoxical dual movement, away from the viewer and at the same time towards him, emphasizing and yet suspending the distance between subject and object. In the language of cliché, rationality is "cold" and emotion "warm." The fascinatingly ambivalent quality of Scully's pictures would seem to be based on a reversal of these ascriptions, as if the painter had succeeded in imparting warmth to the carefully calculated structure and at the

same time contrived to subdue the pulsating vitality of the color and paint surface.

Interpreted in positive terms, this ambiguity can only mean that the painter is attempting to subvert the art-for-art's sake syndrome and endow geometry with a human aspect. This is indeed the case: Scully's attempt to synthesize Pollock with Mondrian—marrying the all-over approach with the principles of order and balance and reconciling the relational with the non-relational—overlaps with his aim of tapping into forms of experience which have to do with everyday life as well as the world of art. This may at first appear surprising, but the artist has repeatedly emphasized his wish to liberate abstract painting from the ghetto of noncommittalism and hermetic isolation, and to incorporate in his pictures a reaction, albeit of a highly indirect kind, to the realities of the city, of nature, of the individual and society.

The marginal areas of Scully's work—one thinks, in particular, of his photographs from places such as Mexico—and his illuminating programmatic statements clearly show that, to him, the combination of vertical and horizontal lines is no mere formal exercise; on the contrary, he sees the motif as capable of functioning as a metaphorical expression of social reality. In a conversation about his experiences in New York, he remarked:

> You can tell from the way a construction worker nails a plywood sheet into place that no one is reverent. They simply do what works at the moment. Sometimes the metal patches on the sidewalk are even rougher. I see a sort of urban romance in the makeshifts people use to keep a place like Manhattan together, though of course that is the point—it doesn't exactly hold together. It's not contained. There's the grid of streets and the gridded buildings and then all the amazing things people do inside those grids and along their edges.

One need hardly add that Scully does not simply transcribe observations of this kind into his paintings, pastels, and watercolors, nor does he wish his work to be interpreted as purely illustrative, in the banal sense of seeing stripes as representing streets and buildings, with the blurred edges denoting the latent chaos of the city. The connection between the everyday world and the aesthetic sphere is only potential, a vague, hovering suggestion which is impossible to pin down in concrete terms—but one nevertheless senses that it is there. The obvious comparison with Mondrian may help to clarify this point, especially since his work is one of Scully's own central points of reference. Like Scully's pictures, the New York paintings which Mondrian made in the latter stage of his career do not simply mirror the street pattern of the city: the grids of paper strips transcend the realm of tangible reality. Mondrian regarded these works as manifestations of what he called "the fundamental law of equivalence, which creates dynamic equilibrium and reveals the true content of reality." And in 1937 he wrote that "painting and sculpture . . . being purely constructive, will aid the creation of an atmosphere not merely utilitarian or rational but also pure and complete in its beauty." Here, there is an obvious positive—even utopian—element: Mondrian's unshakable belief in the notion that the universal, as the fountainhead of art, could never be wrong. From this brief digression, it is clear that Scully takes a very different attitude to the world about him. Given the gulf between his thinking and that of Mondrian, all one can say for the moment is that the fragile iconography of his pictures appears to be based less on the reduction of form or the muting of color than on a set of barely identifiable associations whose status is uncertain: it is impossible to tell whether they emanate from the works themselves or are projected onto the pictures by the viewer. Here, one inevitably enters the realm of conjecture and guesswork, where final verification becomes impossible. But perhaps such

HAMMERING
1990
oil on canvas
110 x 174 (279 x 442)
Kunsthalle Bielefeld

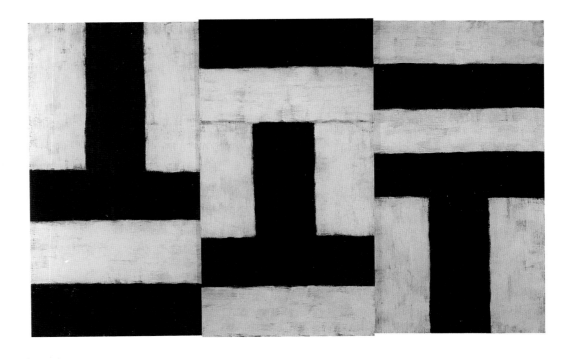

speculations are not quite as unfounded as they might seem, since Scully's aesthetic program is based on a model of perception that aims to subvert the dichotomy of subject and object, or viewer and image. Referring to Merleau-Ponty, one could say that Scully's pictures are not really "given" or presented to our perception; instead, we reconstruct and experience them by an inner effort of imagination. This is made possible by the fact that the work forms part of a world whose basic structures we have long since internalized, and the picture is merely one of their many potential actualizations. Although it is we who perceive and experience it, the work nevertheless has a transformative effect on our lives, because the human body is permeated by a movement "towards the world" and shares the same texture as other objects. With reference to the question of the extent to which the "consciousness of objects" and the "consciousness of self" become synonymous in aesthetic experience, it is

instructive to look at a specific example of the work of Sean Scully.

Stone Light [Plate 54] was exhibited for the first time in Paris in 1990. Together with *Hammering* (above), *Durango* (page 24), and *Gabriel* [Plate 55], it is undoubtedly one of the finest works Scully has produced to date. However, unless I am much mistaken, he has recently returned to the picture and revised it—something he does quite regularly. The sonorous, melancholy tone of the color has been lightened, giving the structure a greater clarity and immediacy. Looking at the work, the first thing one sees is a set of dark, almost black stripes with the heavy compactness of beams or girders, which alternate with lighter stripes of silver-gray. Secondly, one notices a separate area in the top right-hand corner with narrower and shorter bands of color. And thirdly, the viewer's gaze registers a juxtaposition of vertical and horizontal elements, the surface being

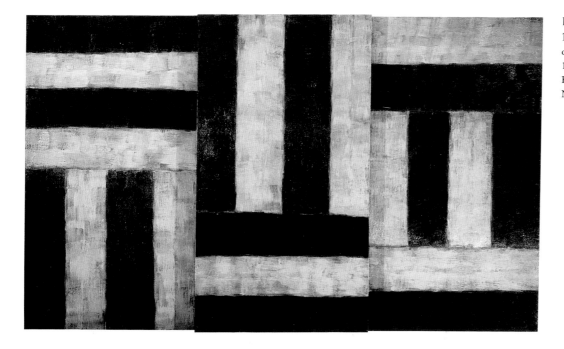

DURANGO
1990
oil on canvas
114 x 180 (290 x 457)
Kunstsammlung
Nordrhein-Westfalen, Düsseldorf

divided into roughly square blocks made up of four stripes running upward and sideways. Finally, there is also a vertical division into three sections of equal size, with the central area projecting out beyond the sides and into the space in front of the wall.

We are therefore looking at a triptych, a form with associations of pathos, and this realization makes it easier to decode the picture. The four vertical lines at the top left are repeated in the lower part of the central "panel," whose middle section similarly echoes the horizontal stripes at the bottom left. In inverted form, the same pattern is to be seen again in the lower part of the right-hand section. Altogether, then, there are five such fields, bounded in each case by two darker or lighter stripes. Two of the fields are made up of vertical stripes, and the other three are horizontal, with an interruption at one point in the sequence of light and shade. To restore the numerical balance, Scully has inserted a further vertical

structure in the top right-hand corner. The context established in the other parts of the picture intrudes into this section as well, but the code is modified. The alternating dark and light stripes are narrower and therefore appear longer, and there are seven of them, instead of four, which has a centering effect; a further important feature is the addition of red, the color which dominates the picture as a whole. Whereas the alternating bands of color in the other sections have a densely layered appearance, this field creates the impression of three dark stripes which seem to be superimposed over a red ground. But despite the axiality implied by the tripartite structure and the marked difference in color, this section is by no means isolated from the rest of the picture, like an image within an image. This is largely because, once again, the stripe is the dominant motif. The question nevertheless arises of what Scully is trying to achieve—synthesis or seriality,

unity or difference? Does the red field hold the composition together or break it up? Can something which is drifting apart also cohere into a whole? Both materially and aesthetically, the unity of the picture appears to remain intact: in the last analysis, its outward form and the structural relationships between its component elements prevail over the deviant proportions and the implied aggression of the color.

Here, it is useful to remember Scully's comments on the roughly nailed plywood sheets, whose purpose is to disguise a hole or provisionally hold something together. The red section in *Stone Light* has a similar visual function. Scully is evidently playing on the opposition between part and whole, rule and deviation, order and disorder, but instead of exaggerating the contrasts and exploiting them to the full, he merely hints at their presence. They are latent rather than manifest, but they nevertheless lurk in the background, as if they were ready to emerge at any moment and literally shatter the pictorial ensemble; alternatively, one senses that they might opt to disappear entirely and rob the picture of its attractiveness by turning it into a banal enumeration of shapes and colors.

In this context, it is also instructive to look briefly at one of Scully's more recent pictures. *Gabriel* [Plate 55], completed in the autumn of 1993, has a relatively restrained appearance. At first glance, the dominant tone is a silvery gray, which vaguely echoes Velázquez, Corot, and Manet. Apart from this, the work's most striking feature is the complexity of its formal organization, based on groups of three and four ocher and gray stripes, but with the addition of two double bands of color and a separate field with five short, thick lines. Unlike *Stone Light*, the picture comprises two sections, and the vertical dividing line in the center is scarcely visible; the constructive aspect appears stifled by the all-over principle. However, one senses that this impression may be deceptive. On closer inspection, the work seems to

center on the moment at which a crystalline structure begins to emerge, or to dissolve back into an amorphous conglomeration of particles. The extreme compactness of the composition makes it impossible to imagine that the carefully assembled structure of vertical and horizontal lines could ever extend beyond the boundaries of the picture. But here too, the architecture begins to vibrate from within, and one senses a kind of subcutaneous movement, as if the densely layered surface were on the point of breaking up. The ambiguity is heightened by the insertion on the right of a tightly packed group of horizontal lines in dark yellow and blue which lend the picture a heroic clarity and serve, despite the asymmetry, as a definite visual anchor. Thus the flexible structure tends towards firmness, repeating the paradox by which the static quality of this wonderful painting is offset by a latent impression of movement.

By introducing this subliminal element of dynamism, Scully continues to follow and develop the principles of Abstractionism, while at the same time inverting them and turning them, so to speak, against their original intentions. This can be illustrated by looking again at Mondrian, the predecessor to whom Scully owes so much. Mondrian was convinced, for example, that reality was governed by a more or less hidden set of immutable laws: "Not only science, but art also, shows that reality, at first incomprehensible, gradually reveals itself by the mutual relations that are inherent in things." Scully's pictures also address the idea of relatedness, but unlike Mondrian, he does not work from an assumption of preordained harmony, nor does he give any credence to the notion of an eternally valid ordering scheme; nor, above all, does he believe that painting has the power to transcend the terms of its own limited existence and arrive at a definitive interpretation of the cosmos. Instead of being anemic and aloof, his pictures strike one as vital and direct; his pictorial vocabulary is limited in the extreme, but he employs it in

such a way as to distill a muted pathos out of reduction and monumentalization. Scully can be seen as relying entirely on just two elements: the vertical and the horizontal, each of which is given a single attribute—the color is either light or dark. Yet his pictures have nothing to do with binary languages or primitive sign-systems; instead, they are fascinating and highly complex structures which foreground their aesthetic status and at the same time transcend their own chromatic and formal presence.

Summing up these initial observations, one could say that Scully achieves a particular kind of compositional economy, using a single set of forms and a palette of only two or three tones. Economy, in this case, does not imply simplicity; on the contrary, it generates a particular evocative power, stemming from an inherent contradiction. In *Stone Light*, the elements that initially appear simple are subsequently revealed as complex; repetition gives way to variation and multifaceted reflection; patterns coagulate into forms which tend, in turn, to take on an emblematic—or even covertly decorative—quality. Scully's pictures are always balanced on a knife-edge, seeking to reconcile the tension between part and whole, conflict and harmony, opaqueness and transparency, coldness and warmth, plane and space, expansion and restriction. There is a constant interplay of unity and diversity, an endless oscillation between seeming and actual repetition. This element of indeterminacy makes the pictures difficult to remember. Certainly, Scully's work is instantly recognizable, in the same way that one immediately recognizes a Mondrian, a Malevich, or a Rothko; and as in the case of these artists, each new encounter with his pictures yields fresh insights. The difference is that, in Scully's work, with its narrow repertoire of forms and attributes, the impression of totality dissolves into a multitude of individual elements which the viewer then has to reassemble and subsume by his own efforts under a more general

ordering principle. Structures emerge and dissolve, systems appear and vanish, order is created only to collapse in the same instant. Things which at first appear stable turn out to be highly fragile, and vice versa. With supreme confidence and control, Scully works through the entire range of possible oppositions.

This multiple dialectic is even apparent in the working of the paint. The tones at first seem congealed and opaque, but deeper layers of color lurk below the surface; the brushstrokes are definite and permanent, but the painterly gesture is emptied of individuality. And there is a particular kind of excitement at the seams of the paint surface, where the individual stripes and fields of color collide or gently nudge one another, creating narrow indentations and fissures, like miniature geological faults. Here, the pigment literally seems to tremble and breathe; the viewer's gaze wanders off into different areas, encountering a variety of obstacles and taking repeated detours. The range of possibilities remains circumscribed, to the extent that the initial set of axioms and rules largely continues to apply. Nevertheless, it becomes clear that these principles, too, are potentially capable of modification. This provides at least an indication of what Scully means when he speaks of "humanizing" abstract painting. Seen from a distance, the paintings seem to be invested with an unusual type of pathos; at close quarters, they reveal a subtle richness of texture. The pathos is far from empty, and the texture appears natural rather than overrefined. In this brilliantly successful synthesis of form and *peinture*, there is a subtle tension which betokens the controlling hand of a master.

Obviously, however, a painting such as *Stone Light* cannot simply be interpreted in terms of Scully's experience of living in New York, as if the work were no more than an abstract illustration of real observations. Scully's pictures retain an essential aesthetic autonomy; they belong to a sphere which has no direct connection

with society. Any such links with reality are purely metaphorical, and their existence can only be verified in structural terms. This, as I shall show, is entirely feasible.

Scully's aim of humanizing abstract painting has a quite elementary anthropological dimension. This is apparent in the deliberate roughness of execution: looking at the stripes of color, one could almost begin to think that the artist has tried to apply the color evenly in clearly demarcated sections but lacks the necessary technical skill to do so. This failure to achieve flawless perfection creates the kind of tension which always arises when amateur artists get things slightly wrong, and this is evidently just the effect Scully is aiming for. In this aspect of his work—i.e., in the application of the paint, but not, it must be emphasized, in the choice of colors or the composition—Scully's pictures create the impression of having been executed by an apprentice decorator or an unskilled DIY enthusiast. The perfect lack of perfection is, of course, a deliberate tactic, allowing Scully to preserve a remnant of spontaneity which can serve as a symbol of authentic, non-alienated experience in a coldly rational urban world.

In a lecture which he gave at Harvard on October 8, 1992, Scully himself provided an interesting pointer which confirms our interpretation. Referring to *Heart of Darkness* [Plate 16], a pivotal work painted in 1982 which takes its title from Joseph Conrad's novella, Scully talked about the right-hand section of the composition, a nervously quivering structure of vertical lines in black and yellow. One day, while on his way to buy paints in New York's Canal Street, the artist happened to walk past the entrance to a post office, painted with the usual warning pattern of black and yellow stripes. The painting of the stripes was so crudely energetic, so bursting with raw immediacy, that he promptly went into the store next door and bought exactly the same colors to finish off *Heart of Darkness*. This lends the painting a narrative

dimension, inasmuch as the artist was trying to respond to the vitality of urban life by incorporating something he had just seen into the picture.

Deliberately oversimplifying matters, this response can be seen as part of a long tradition of seeking out previously unused forms of creative potential outside the established aesthetic codes. The anonymous painter to whom Scully paid tribute by using the same colors—and even applying the paint in the same rough manner—is a legitimate successor to the anonymous tribal and folk artists whose work provided a source of inspiration for the Cubists and Expressionists at the turn of the century. By the same token, hard-edge, color-field painting and Minimalism can also be seen as established codes which Scully turns inside-out. The power of his pictures is partly based on this effort of subversion, which the followers of these other schools no doubt fail to understand, seeing it as evidence of half-heartedness, or even sentimentality, rather than as an act of sacrilege.

However, this point should not be belabored. There can be no denying that the application of color is important to Scully and has a determining influence on the impact of his pictures. Thus it is scarcely surprising to find that he himself cites a further line of tradition, rooted in the professional practice of art. He has a great admiration for El Greco and Velázquez, not so much because of their respective ideas about space, as on account of the way that the surface of their paintings articulates the large structures which give things shape in Western culture. Yet in his view it was Van Gogh who made the true breakthrough to modern art: "The sheer physical urgency of his need to paint broke down the pretence of pictorial depths. Everything stays on the surface. His structures become tangible. A blind person could read his paintings, and of course his subjects are extremely moving, sometimes, but his real power is as an abstractionist. The real poignancy and power of his art is in the way he worked the paint."

This twin reference—to the work of an anonymous unskilled sign-painter and, via Van Gogh, to the most sophisticated embodiment of painting as a self-reflexive medium—shows quite clearly that Scully regards painting as inherently embedded in convention and incapable of modernization. He justifies this view on anthropological grounds, by saying that painting is like running: the pace can be quickened or slowed, but the range of possible variations is extremely narrow. Of course, it is always possible to introduce additional obstacles or to concentrate on particular kinds of movement, such as jumping. But these are merely forms of specialization which do nothing to alter the basic fact of moving from A to B on two legs. Painting, too, is always the same: the brush dips into the paint pot and distributes the pigment on the canvas.

Nevertheless, as Scully said in his Harvard lecture, this essentially primitive medium has to be brought out of its isolation, its lack of contact with "real" life. And this, as Scully knows all too well, is a problematical aim, given the impossibility of reversing the semiotic turn in modern art. For Scully himself, there can be no retreat from self-reflexivity and the foregrounding of the means —rather than the content—of artistic representation: in his work, signifier and signified remain identical. The color, the paint surface, the individual forms, and general structure all refer primarily to themselves. Everything which transcends this purely pictorial reality—the associations and impressions to which the painting gives rise—is assigned to a sphere which has less to do with the material substratum of the picture than with the attitude of the viewer. As Scully says: "An artist who can provoke empathy is the one who simply completes your thought or makes visible our desire (yours and mine). I'm not trying to say anything different from what you want to say. I want to say the same thing."

What exactly does this mean? How can Scully want to say the same thing as a viewer whom he has never met?

It seems to me that the best way of resolving this paradox is to focus on the issue of how things are said, instead of what is said. The picture is not concerned with a specific perceived object and its aesthetic representation, but with particular ways of seeing which—as Scully suggests— have a trans-individual basis.

As we have seen, Scully does not only operate on the optical plane. His pictures have a strong physical presence, a haptic quality: they move outwards towards the viewer, and in some cases—as with the central section of *Stone Light*—they extend right into the space of the gallery. The paint surface is densely layered, and some of the pictures incorporate metal inserts which are set into the painted canvas. These elements all serve to activate the viewer's sense of touch. Here, Scully is not trying to escape the confines of the canvas or move into the genre of "combine" painting. His aim is simply to demonstrate that our perception of pictures is tactile as well as visual. The act of seeing involves the viewer's entire body, and each sense operates differently from its counterparts, their structures being incompatible with each other and with the rational insights of the intellect. The field of touch is more limited than the field of vision: feeling is not the same as seeing. Consciousness, however, is a continuous, active transcendence—the consummation, as it were, of seeing. To quote Merleau-Ponty once more, seeing is doing; it is an achievement which continually goes beyond its own point of departure. Seeing therefore only "comes to itself" in the perceived object, but it can only grasp itself with a certain ambiguity and obscurity, "since it is never entirely present to itself, for it loses itself in that which is seen." What we have, then, is an experience of Scully's pictures as an open totality which can never achieve complete synthesis, and an experience of ourselves as viewers whose subjectivity continually fluctuates. In conjunction with his pictures, Scully's initially puzzling statement therefore shows that neither the unity of the subject nor that of the object are "given"

in the process of perception; instead, they are both "presumptive unities on the horizon of experience": "Regarding the idea of the object, and that of the subject, the aim must be to rediscover the fact of my subjectivity and at the same time to uncover the object *in statu nascendi*, to find the primal layer of experience from which all ideas and objects originate."

If I understand Scully correctly, his work goes beyond Minimalism, with its well-known aim of eliminating all formal relationships from the work and replacing them with functions relating to space, light, and the perceptions of the viewer. Minimalism can be said to dramatize the viewer's own inner experience by placing it in a spatial relationship to a particular set of objects. This aspect can be seen in Scully's art, too, although it has less importance for him than for the work of a sculptor. In his highly complex structures, Scully preserves exactly what the Minimalists reject. His work is a living refutation of the following comment, taken from Robert Morris's *Notes on Sculpture*:

> Every internal relationship, whether it is set up by a structural division, a rich surface, or what have you, reduces the public, external quality of the object and tends to eliminate the viewer to the degree that these details pull him into an intimate relation with the work and out of the space in which the object exists.

With Scully, the reverse applies: the viewer of his paintings enters into their structure and yet remains distanced from it, to the extent required for seeing to attain self-presence in the thing that is seen.

Does Scully's attempt to transcend Minimalism amount to a retrograde step? With regard to the phenomenology of perception, certainly not. It seems to me that, by engaging with the past, Scully is in fact looking forwards rather than backwards, with the aim of creating works which will eventually form part of a future history. His specific achievement could perhaps be said to consist in synthesizing things which are inherently incapable of synthesis: *Stone Light* is only one—particularly fine—example of this. In a situation where our mental and physical grip on the world is continually loosening, Scully sums things up and draws conclusions, preserving the immediacy of life through an effort of abstract construction. He does this in a subtle, roundabout way; as we have seen, his pictures contain only remote echoes of the reality to which they allude in covert structural terms. Economical yet complex, they are bound by tradition but reach out beyond it. Nearly all the features I have mentioned are traditional: the use of oils, the working of the paint (unusual though it may be), the devices of formal reduction, repetition, and variation, the conflict between structured composition and seriality, the contrast between shape and pattern. A singular, fascinating, and continually stimulating aspect of Scully's work is the spiritual aura which it evokes. In this respect, Scully deviates sharply from the approaches of other artists who were important early influences: Barnett Newman, for example, whose hermetic pictures categorically exclude the viewer; or Ellsworth Kelly, whose pure rationalism produces a form of aesthetic experience which is entirely detached from other realms of existence; or Mark Rothko, with his romantic urge to lure the viewer into his visual snare. Scully's pictures are unique in that they do not merely repel or stimulate or seduce the viewer; they do all these things simultaneously. The gaze is presented with a complete freedom of aesthetic choice, and in the act of seeing, it becomes plain that there are no rules or guidelines to follow. One can only agree with Carter Ratcliff's comment that "by being as clear as he can about ambiguity, he [Scully] provides grounds as firm as possible for selfhood that, because it is modern, can only be shaky."

This correlation between firmness and fragility is the true hallmark of Scully's work. His pictures

metaphorically demonstrate the process through which reality is fictionally constructed by means of projections, backdrops, conventional signs, images, and leitmotifs, via the operations of repetition, displacement, reflection, and variation. This way of fabricating reality is summed up in one of Nietzsche's characteristically poetic images, which, as a meta-statement, neatly describes the attitude that informs Scully's painting:

> Here, one can scarcely help but admire man's genius as an architect who succeeds in erecting an infinitely complex cathedral of concepts on shifting foundations, a cathedral built, as it were, on water. However, with foundations such as these, the building has to be like a spider's web: delicate enough to float on the tide, but strong enough to resist being torn apart by the wind.

In Scully's case, the cathedral is built of visual images. Metaphorically speaking, his pictures, too, stand on shifting foundations, as infinitely fragile and complex structures. At first sight, they appear simple, and this enables us to reconcile them with our own aesthetic perceptions, but once we begin to analyze them, they recede from our grasp.

With a certain perplexity, one realizes that Scully's work recapitulates an entire century of painting. His austere emphasis on formal reduction indicates an attempt to achieve a kind of grand synthesis; but this, as the artist himself knows, is a futile hope in a world whose horizons are steadily darkening. The roads to Utopia have all been closed, and there is no place left for the dreams of a Mondrian. For a painter like Scully, who rejects the anything-goes mentality of Postmodernism, there is only one option: to become a latter-day Sisyphus, stubbornly clinging to the idea of order in the midst of chaos, yet undermining any form of coercion through the sheer vitality of his work, which in turn brings him

up against new obstacles. The impact of his pictures is ambivalent and characterized by the inherent simultaneity of sadness at continual loss and euphoria at continual gain. It is this dialectic which mutes the pathos of the paintings and tempers the subliminal melancholy with hope. This conjunction of opposites runs right through his pictures and permeates every last nuance of color and form. It constitutes the core of human feeling which is the basis of his exceptional stature as an artist.

Translation: John Ormrod

Originally published in *Sean Scully: Paintings and Works on Paper* (Munich: Galerie Bernd Klüser, 1993). Reprinted with permission.

SEAN SCULLY: AGAINST FORMALISM

Victoria Combalia

One of the major difficulties any reader of the critical literature on Sean Scully has to contend with is a sense of uneasiness over three issues: the artist's "traditionalism" in contrast to more radical options; his relationship with the history of art, especially with Mondrian; and finally, the possible content of his work.

In a 1993 piece on the painter (reprinted in this catalog), Armin Zweite writes:

> From one point of view, based on a particular set of ideas and expectations, Scully's work appears insufficiently bold and radical: it seems to lag behind the sophisticated conceptions of art which emerged in the 1960s, ignoring contemporary developments and harking back to more traditional notions of painting.[1]

What "point of view" is the critic actually referring to? To my understanding, it is none other than the progress of art, whose most basic—and in a way degrading—variant is that of fashion. Although critics supportive of Scully may not share this criterion, it is common that they begin their articles with a comment on his possible "traditionalism." It is as if, in one way or another, they wanted to find a justification for the artist's decision to work in the field of abstraction.

Naturally, the critics are in the habit of mentioning the position of the artist himself. In his declarations Sean Scully usually adopts an attitude in defense of painting as a medium and abstraction as a language. In a recent conversation he commented:

> If you think about what's going on in all these new trends . . . Richter, Polke, etc. . . . all is in terms of double identity. My work, by comparison, seems absurdly direct with its fixation on being honest: "this is painting"; "this is a brushstroke": it is a kind of manifesto.[2]

Evidently Scully takes a stand for a particular type of painting, but I am not convinced that one can qualify his position as conservative. On the other hand, this seems to be the opinion one gathers from an otherwise splendid text by Zweite about the artist. He writes:

> Scully regards painting as inherently embedded in convention and incapable of modernization. He justifies this view on anthropological grounds, by saying that painting is like running: the pace can be quickened or slowed, but the range of possible variations is extremely narrow.

Later, however, the critic states his own position:

> It seems to me that, by engaging with the past, Scully is in fact looking forward rather than backward, with the aim of creating works which will eventually form part of a future history.[3]

And he is right.

In my opinion, it is strange that there are still those who, at the dawn of the twenty-first century, think in terms of progress in modern art, in other words, of a succession of movements that will supersede one another, based on small formal contributions. Rather, seen with the perspective that a century affords, I would consider that Modernism has laid the foundation for some new languages, based, for example, on anti-illusionism as a formal device and expression as an aesthetic category (or better, if we are to provide a contrary example which would begin with Duchamp, based on anti-expression, the removal of the subject), and that what we see around us, at the close of the century, is simply exploitation of these discoveries. This "exploitation" does not entail a mechanical or literal continuation of the theories of the early avant-garde movements, but variations, akin to musical variations, that arise from differing cultural contexts. This is similar to what occurred with Mannerism, which reinterpreted Classicism from a perspective that, at the beginning of the sixteenth century, could not support, let us say, an idealized vision of the individual as center of the universe.

Moreover, the scope of Modernism's formal innovations is such, its radicalism and variety so evident, that it seems totally logical to us that their foundations be exploited one hundred years later. If the classical orders of architecture have remained effective for so many centuries, why wouldn't the signs and premises of abstract language remain so?

In short, it is not a question of continuity or lack of continuity where trends are concerned, but a question of the intensity and quality of the works of art that are appearing at the end of the century. Today, a neo-conceptual artist can be as academic as an abstract artist: it is not the style that determines his modernity, but the precise manner in which he employs it. The theme is not new; Poussin had already advised that:

La nouveauté en peinture, ne consiste pas principalement en un sujet jamais vu, mais en une disposition et une expression bonnes et nouvelles, et ainsi le sujet, de commun et vieux qu'il était, devient singulier et nouveau.[4]

[Novelty in painting is not to be achieved by seeking out a new subject, but rather by employing a good and new manner of arrangement and expression so that the subject, however common and old, is made new and singular.]

It is neither the dilemma between abstraction and non-abstraction that determines the modernity of Sean Scully, nor the dilemma between narrow/wide bands and whatever other imaginable theme, but his capacity to use these two ingredients in a non-academic way, and not merely out of subservience to his predecessors, and the fact that he is an artist capable of conveying, with this language, a content that speaks to the viewer at the end of the century; and that ultimately surpasses, as with all interesting works of art, the sphere of self-expression to attain a universal dimension.

As the years or centuries pass, Mondrian, Rothko, and Scully will undoubtedly be put in the same category, just as Duchamp and Beuys will find themselves grouped together, although rigorous historians may insist on the qualification that there were those who laid the morphological foundations of a given style (geometric abstraction, or the importance of gesture and idea in the works of art, respectively) and those who later explored the avenues of this language, endowing it with their own personality and bringing to it a new intensity. This is exactly what I was referring to when I said to Scully: "Imagine for one moment that one of your viewers said to you: 'You do nothing more than exploit to the point of satiation Motherwell's *Little Spanish Prison.*' How would you answer this person?" "Well," Scully replied,

"The painting is fantastic, great, one of his best paintings. But there is a difference between implication and achievement. . . . He did this little painting. What I have done, historically, is to explode the possibilities of it."

Scully and the History of Art

The gaze of the artist is a complex mechanism that includes the memory of what has been painted or sculpted; and so painting is also, in the same way Hegel would say that philosophy is, above all, the history of philosophy, the history of painting. The work of Scully contains numerous references to art of the past, even though they don't appear in a mechanical way, but as a kind of reverberation. Scully is a "painter's painter," and his work, when observed, evokes not only perceptions of other paintings, but also the continuity of a long tradition of pictorial questions.

Other critics have cited references by the artist to authors of the past, both remote and recent.[5] Our text aspires to complete these critiques, in the belief that Scully's allusions to the history of painting possess a significance and dimension beyond mere formal borrowing.

We need only recall the early references the artist has made to other painters. The first, chronologically speaking, is the reproduction, seen in his school, of *Boy with Dove* by Picasso. This "first painting" is always present in the visual memory of every artist; his first encounter with art, some of whose characteristics will perhaps survive in his later work: "When I did start to make art later," he recalls, "I painted black lines around the figures." But for Scully it was not only this, but also the example of painting as a balm and refuge: the change from an Irish neighborhood to a neighborhood of immigrants in London, the conflict and violence of southeast London caused him such trauma that the vision of this painting was "the only thing that alleviated my otherwise miserable existence."

Later, when he experienced the "revelation" of Van Gogh's *Chair* at the Tate Gallery (currently in the National Gallery, London), Scully commented: "Van Gogh was (for me) a spiritual example, in his profound honesty." Just as Cézanne was for Picasso, Van Gogh constituted for Scully a moral example. Scully values three qualities in Van Gogh, qualities he would like to share: the painter from Arles is "direct, physical, and profound." And if we are to point out a concrete influence, one could suggest the yellows of a work like *All There Is* (below).

From 1965 to 1968, Sean Scully studied at Croydon College of Art in London. There, one of his professors explained art in a way that the young artist would remember all his life: Ron Howard talked about

ALL THERE IS
1986
oil on canvas
106 x 84 (269 x 213)
Collection of Bo Alveryd, Switzerland

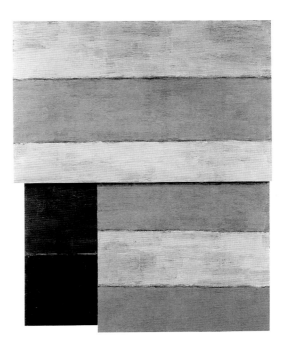

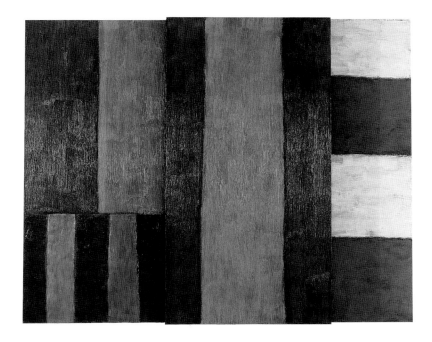

TO WANT
1985
oil on canvas
96 x 118 (244 x 300)
Justin Smith Purchase Fund, 1985,
Walker Art Center, Minneapolis

the way Fragonard or Pissarro painted "as if he were talking about the way someone would make a brick wall."[6] Perhaps this concept survives in the way in which Sean Scully places one brushstroke next to another, with visible order and continuity, or in his custom of alternating wide stripes with horizontal and vertical brushstrokes. Clearly his own life would provide, much later, another visual source for the strong sense of constructiveness in his paintings: not only the industrial architecture of a city like Newcastle-upon-Tyne, but also his time as a construction worker. To put one brick next to another and open windows "gives one ideas for one's work," acknowledges the artist. Moreover, beginning in 1987, Scully frequently "opens" windows—squares, rectangles—which are entities materially and physically separated from the rest of the painting.

The art of Scully—I am referring to the works after *Heart of Darkness* [Plate 16], of 1982, at which point he initiated a manner that, with slight variations, has survived until today—is produced by the combination of two great principles: the rigor and order of geometry and the expressiveness of texture and color. If we are to seek the origins of the strong expressive charge of his paintings, we must look, first, at his own temperament, passionate and strong as one might expect to find in a characteristically Irish Irishman. But this state of mind has obviously been nurtured by historical sources based on this aesthetic tradition:

> When I began in the Arts School, I began painting from the figure and I worked in a style that was extremely influenced by the German Expressionists. So, in fact, the paintings that I made when I was in the Arts School looked like '80s paintings. . . . I had a teacher who had a wonderfully big influence on me, but also I was very attracted to people I loved: André Derain, Matisse, Karl Schmidt-Rottluff, and Emil Nolde.

ONCE
1986
oil on canvas
96 x 111 (244 x 282)
Collection of Janet de Botton, London

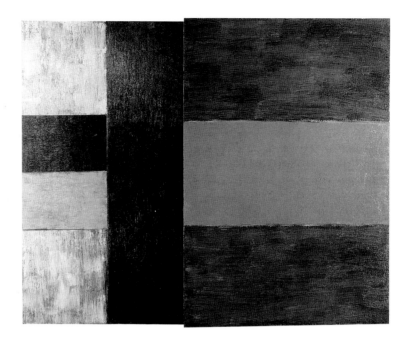

Derain fascinated him by his mixture of secondary and tertiary colors along with other vibrant ones. This possibility is sometimes used by Scully, as occurs in *To Want* (facing page) or in *Once* (above) in which vibrant oranges or reds are mixed to browns and grayish-blues. And his watercolors, in spite of the strictness of his motifs, have some of the refinement and sensuality of Nolde's watercolors.

Leaving aside his fleeting interest in other artists in his formative years, Scully believes that there are three great names in the art of the twentieth century: Mondrian, Matisse, and Rothko. What I would like to emphasize is this: the reason for Scully's interest in these artists is not only to be found in their particular ways of combining colors and forms, but also in their conception of painting, their particular position on the meaning of art. This meaning of art is a genuine ethical and conceptual "stand," certainly very different from recent trends that base their premises in the very self-referentiality of art. Both are

options that can be sustained in the ample language of Modernism. But let us not jump to conclusions.

"What attracted you to Rothko?" I asked Scully.

I was very attracted always to what I would call "major," something major. What Rothko did was to take something that was as monumental as possible and fill it up with a kind of paraphrased deep emotion that was in the old master paintings. But it was incredibly reduced and elemental too. That is what I try to do in my own work.

Scully saw reflected in Rothko his own desires: to attain monumentality and emotion by very restricted means.

Referring to the formal characteristics of his own paintings, Sean Scully describes what he appreciates in artists from the past, some of whose characteristics he would like to emulate. One of the characteristics of his own works, for example, is the "blurred" or "indefinite"

quality of the border of his color bands, on the one hand, and of the original way of placing the painting, with its brushstrokes mixed with black or white, so that the resulting color is never flat (see for example *Flesh* [Plate 25], *Uist* [Plate 46], or *Magdalena* [Plate 56]):

> It is all connected with the idea of mystery and my lack of interest in a certain kind of dogma. What I am interested in is something eternal, classical, and at the same time something that it is deeply humanistic. I think Mondrian's paintings are a little bit bordering on fascistic, which is something that bothers me. . . . When you have something that, in a way, is incomplete, unfocused or unclear, the person looking at the painting is empowered to complete the painting. That is what I found very important in the work of Matisse. Matisse's paintings are more fragile than those of Picasso. Picasso is a more powerful artist; Matisse has a different kind of strength. The strength to allow the audience to be more active in relation to the completion of the painting. It is like an audience participation. The same is true of Rothko; I don't know if it is true of my work, but I would like to have that character in my work.

Scully actively involves in his art this invitation to the viewer; the viewer should go beyond mere observation: "I don't want to make things just to look at; I want to make things that make people react, act."

But the concept of the indefiniteness of the contours, that leads us to look for examples in art history (Titian, El Greco, Goya, Courbet, the Impressionists), is not reduced to being a formal characteristic. When asked what other painters he admires from the past, Scully responds:

> Cimabue and Masaccio. They also have soft edges. I think there is a relationship between Rothko and Cimabue. [In Masaccio] the edges are kind of soft,

aren't they? There is a point where the edge seems to tremble: at the point of contact one senses the tragedy of life can be felt along that edge.

As we see, there exists in Scully a continual flow or passage from formal procedure to content, or, to phrase it another way, the formal traits are endowed with the capacity for becoming metaphors about the world. The late work of Titian has this quality whereby a formal characteristic possesses the capacity to constitute itself as a metaphor about the world. "The later Titian," I commented to Scully, "also possesses this indefiniteness,

Francisco José de Goya (Spanish, 1746–1828)
SEÑORA SABASA GARCÍA
c. 1806–11
oil on canvas
28 x 23 (71 x 58)
National Gallery of Art, Washington, D.C.
Andrew W. Mellon Collection

this blurry quality of his figures, as if they were to disintegrate in the same way that in the world there is no definitive truth." To that Scully responded: "It is a moral imperative to have the strength or the tolerance to be able to live in the world without wanting definite truths."

Although it is Titian who inaugurates this "loose touch" painting, other artists have displayed this taste for indefiniteness and the tactile quality of the painting. When we observe how certain color bands are painted by Scully, we think of how Goya paints the jacket of *Don Andrés del Peral* (National Gallery, London) or the shawl of *Señora Sabasa García* (facing page): the black and ocher brushstrokes of the latter, superimposed lightly one on the other, and with an almost vibrating effect, bring to mind *To Want* (page 34) by Scully.

The influence of Spanish painting on our artist has been corroborated by the artist himself: "I realize how Irish I am. My artistic influence is Spanish, Italian, and American, not English at all." And although it is sometimes necessary to take national characteristics in art with a pinch of salt, it cannot be denied that, in this case, Scully shares with the Spanish manner of painting the traits of sobriety and profundity, sifted through the pure sensuality of the paint, through the pictorialness of artists such as Goya or Velázquez.

Velázquez is, in effect, another artist that Scully has observed with great care. Even when he talks about other painters, he refers to the manner in which Velázquez paints. Thus, when speaking of the *Little Spanish Prison* by Robert Motherwell, he suddenly exclaims:

When I saw the painting—in his retrospective at the Guggenheim Museum, long after I did my stripe paintings—I realized that all these stripes were painted different! All the grays, the whites, were painted like Velázquez; like flesh, like skin. He put this crazy little red patching; it is a disturbing thing in it, an imposition on this field.

We must bear in mind that Scully possesses a work entitled *Flesh* [Plate 25] whose grays remind us of Velázquez and contrast with a rectangle of a totally fleshy rose. Scully continues to comment on Velázquez:

I love his passionate restraint. There is something rough and simultaneously refined in his paintings. They reflect the human condition of the heaviness and physicality of the world and our elevated idea of ourselves. His color is delicate (especially with the *Infantas*) but it is also somber. There is a light in his paintings, but at times it is almost buried by the power of the brushstroke. His is not an easy, delightful light, it is a light with brutality and realism: which gives it a nobility.

Another reference to Velázquez can be seen in Scully's concept of space, although the painter related to Carter Ratcliff that what he considered important about Velázquez was his textures, not his spatial effects.[7] But when studying the windows that Scully "opens" in his paintings, one inevitably thinks of the open space in Velázquez's *Christ in the House of Martha* (National Gallery, London) and of his genius in suggesting a multiplicity of spaces within the represented scene: we recall the mirror in the background of *Las Meninas* (Prado, Madrid) and the ambiguous central space in *The Tapestry-Weavers* (also in the Prado).

But let us return to the concept of indefiniteness. Indefiniteness, taken to its extreme, leads to disintegration. Although it may strike us as odd, Scully admires the work of Monet: "The other artist that I have loved very much is Monet . . . [particularly] the *Cathedrals*. Because it is like stone melting. (Remember that I called one of my paintings *Stone Light* [Plate 54].) They are monumental but vaporous at the same time."

This continuous appeal to the monumental and the evanescent, qualities which may appear mutually

exclusive, but which are found in Goya, Courbet, and Monet, without a doubt reflect a vision of the world shaken by the crisis of Modernism. At one point Herbert Read stated, referring to Picasso's *Guernica*, that a monument in our day could not be anything but negative; neither can painting propose, at the end of the twentieth century, a Classicism of pristine clarity. If there are traits of Classicism in Scully's paintings—and we shall see them—these traits are to be constantly contradicted by an "imperfect," "vulnerable," "dirty" factor. Today, one cannot appeal to mutating truths: whatever is orderly and balanced in Scully stands out against a background awareness of the fragile and heavily contradictory nature of the modern world. In the sphere of the sciences, the universe is studied today taking into account concepts such as complexity, chance, or disorder; in the sphere of ideologies, the dream of the revolutions is not dead, but it is now highly disputed. Not by chance, Scully has stated that his paintings have been constructed in the same way as the Mayan ruins: "I am building the same way, but I am building a work that trembles."

Perhaps this is what he also admires in Matisse— the open, the incomplete quality which the artist relates to the concept of feminine energy:

What interested me in Matisse was the repetition in it, the use of pattern in it, the decorative. He fills up space, he decorates space, he punctuates space. There is an awkwardness in his painting. . . . I thought that what was so exciting about Matisse and Rothko was that, in a way, they had a more feminine energy than Picasso, in the sense that they had the ability in their paintings to have things not be finally, emphatically, concluded.

And when I asked him why he thought this is a feminine trait, he told me he reached this conclusion based on his own experience in life:

I am talking about feminine energy, that can be in men too. It seems to me that a masculine energy is more about force, power, and energy; it has the power of certainty but it also has the stupidity of certainty. That is what I think Mondrian doesn't have in his work; I love the structure and the profundity, but the mystery of the uncertainty, of ambivalence, of things not being quite nailed down, is what is so deeply moving and human to me in Rothko and Matisse.

It is interesting to remember, however, that Mondrian himself had written in his *Notebook* of 1914 of the masculine and feminine principle, considering the artist as he who possesses both:

Being that the masculine principle is represented by a vertical line, a man would recognize this element (for example) in the trees in a forest. He would see its complement (for example) in the horizontal line of the sea. . . . All of this is completely different in art because the artist is made asexual. As the artist can emit together the masculine and feminine principle, and as he is not representing nature directly, from that is derived that a work of art is more than nature.[8]

Like all the followers of Theosophy—a theory inspired by Hinduism and founded by Madame Blavatsky in 1875—Mondrian believed that happiness, harmony, and balance resulted from the union of two contrary elements: the masculine and the feminine, the positive and the negative, the spiritual and the material. In spite of the simplicity with which Mondrian expresses his ideas in this kind of aphorism, certain basic principles of oriental philosophy, such as that of the coexistence in the universe of contrary forces, are now widely accepted. The idea that art transcends reality is also in Scully's mind

St. Matthew
BOOK OF DURROW
7th century
fol. 21v., 11 ⅝ x 5 ⅝ (29.5 x 14.5)
Collection of the Board of Trinity College Dublin

re-enunciated from his own theories, such as the idea that art has no sex since it integrates in itself both energies, masculine and feminine.

Finally, there are many other references to the history of art in Scully's work: I would like to cite the Irish miniatures in the *Book of Durrow* (above) with which Scully has been perfectly familiar since the 1970s. And the same can be said for the other arts for which pattern is fundamental: not only other miniatures, but especially Mayan and African art. The trace of Mayan art appears in clear form in many of his works,

whose principal compositions are not as much that old aspiration of synthesizing the all-over painting of Pollock with the rigor of Mondrian, but the bas-relief. The idea of the frieze, on which motifs can extend horizontally beyond the physical limits of the painting, is present in works such as *Why and What (Yellow)* [Plate 37], *Africa* [Plate 38], *Four Days* [Plate 42], *Stone Light* [Plate 54], or *Gabriel* [Plate 55]. To my mind, there are few works in which we can speak of a compositional principle of all-over painting in this period of Scully's art after 1982. If one of the characteristics of all-over painting is the absence of compositional hierarchy, and thus of a specific motif or various motifs that attract our eye, then the art of Scully, with its rectangles of colors different from those in the background, can only occasionally be qualified as all-over painting. Or, to be more precise, there occurs a particular phenomenon with Scully's works: their great size makes the relationship between work and viewer enveloping, inviting him—as occurs in Rothko—to "enter" the work, and it is there where we see this effect of all-over painting. However, when the works are smaller or are reproduced, the compositional—and in some way hierarchical—order is made more evident. In these circumstances the rectangles, with colors that contrast with the background and have the virtue of creating spaces that retreat with respect to the rest of the painting, powerfully attract our attention. And when these rectangles or "windows" are properly viewed, they function, to use Carter Ratcliff's expression, as "visual anchors." And although some of them are placed asymmetrically, they are points of attention, fixed, localized, and stable. That is why we think it is more adequate to talk, for many of these works, about a "frieze" or "bas-relief" effect.

Content: An Architecture of Emotions
Scully has alluded on numerous occasions to the emotional content of his painting, but, as is common

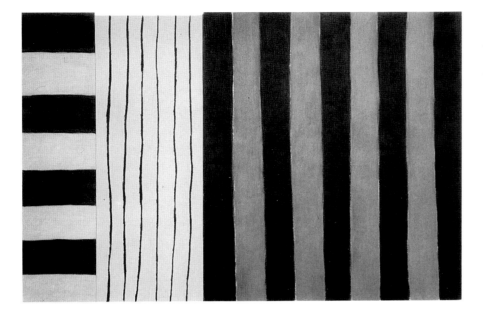

BY NIGHT AND BY DAY
1983
oil on canvas
92 x 142 (234 x 361)
Collection of Cooperfund, Inc.

with many artists, he refuses to give explanations that could seem excessively literal with regard to emotions or life experiences.

Carter Ratcliff approaches the problem:

Scully says that "putting a brushstroke down and claiming that it registers emotion is a desperate thing to do." This remark invokes the melodramatic ideal of unconditionally truthful expression. Reluctant to exploit that fiction, Scully declines with finesse to help us to ascribe feelings to his textured stripes. [With regard to] *By Night and By Day* [above] . . . Are these panels bleak, happy, and angry? Why though, should red and black express anger? Why not contentment, serene but intense? . . . If the fiction of truthfully expressed emotions is so flimsy, what hope is there for painting as an expression of the artist's existential state? Or for conveying any meaning whatsoever?[9]

Once more, we find ourselves confronting a symptom of anxiety at the root of Scully's work. It is a well-known fact that color symbolism is subject to cultural norms (for the Japanese, for example, the color of mourning is white), but that the virtue of art stems from the artist's ability to suggest new metaphors within the guidelines of comprehension. If for Kandinsky yellow evoked the sound of a trumpet, we don't all have to agree; a color is read within a determined frame of reference, in which—in the aesthetic experience—there is always the possibility of a subjective reaction different from the other. That our regard is subjective does not cancel, as Kant points out, the communicative capacity of art: and it is this quality that art possesses of being subjective and universal at the same time, that makes it possible for these "emanations" from the artist's mind to become comprehensible signs for whoever has sensibility. This is why Scully reminded Ratcliff that he was not "interested in self-expression": "My works are not only about me. I want them to deal

with something larger." It appears that the critic with his questions indirectly translates some of that fear, so peculiar to the Anglo-Saxon culture, of being branded as subjective, metaphorical, and ultimately literary.

On the other hand, from Scully we have nothing but certainties. On a basic level, in his comments about other artists he always makes claims for the expressive tradition. For example, there is his emphasis on honesty and sincerity: "Van Gogh's chair looked so honest, as if anyone could have painted it."[10] Similarly, referring to Rothko:

> I decided that Rothko has answered the next
> question in the history of art. . . . Because his work
> was very honest and frank and quite minimal.
> . . . So, it was modern and old at the same time.
> That was what I tried to do in my own work.

We need not remind ourselves that appealing to honesty and integrity in expression is to appeal to the romantic category that extends from Friedrich to Van Gogh and, in our century, from German Expressionism to American Abstract Expressionism. Moreover, Scully is perfectly aware of the theoretical position that this signifies in the North American context:

> [I am] getting away from the whole Greenbergian
> idea of abstraction as design, which did a tremendous
> disservice to the cause of abstract art. It took away the
> notion of the painting being an expression of life.[11]

In effect, in the United States the "Greenbergian" criterion impregnated the critical language of the '50s and '60s, but also affected the work of the artists themselves (especially up to the arrival of conceptual art, although the Formalist theories are a dominant tendency in the United States). In fact, Formalism is a vast Anglo-Saxon current that has its origin in many other authors (i.e., in Roger Fry) and is prolonged in writers such as

William Rubin and his followers. Figures such as Meyer Schapiro or Leo Steinberg, whose analyses integrate the Formalist interpretation in the womb of a history of ideas, are rare in the United States. However, beginning in the '80s, an interpretative current has arisen that, in an attempt to dispute the limits of Formalism, studies the work of art taking into account variables such as genre, race, or a particular ideology. There are numerous examples of interpretations of interest, but the ghost of mechanization, that is to say, the literal application of some theoretic principles—now governed by feminist or Marxist criteria—dangerously watches over these texts of new criticism. It is actually as if the critic, at a certain point, could not approach questions of a more philosophical kind, or would draw back from those that did not have a visible and concrete answer. Such is the case, it appears, with the interesting article by John Caldwell entitled *Sean Scully: The New Paintings*, as quoted above. Caldwell points out the differences between Scully's and Stella's art from 1958. He recalls the famous assertion made by Stella that "what you see is what you see," which reduced the artistic proposal to a strictly formal one, and he points out: "Today Scully's method is the opposite; he asserts the material existence of his canvases and the surface of his paint." All of this is true, but the surpassing of what could be read as Formalism (the art of Scully at the beginning of the '70s) is not only based in the defense and explicitness of the "materialness" of the paint. Could we say the same about Goya or Titian—i.e., that they emphasize the painterliness in their paintings? Moreover, to insist on the materialness of the painting could be susceptible to multiple readings: see the last paintings by Richter (exhibited in New York in September 1993) for a completely self-referential discourse.

And, perceiving that there exists another dimension to Scully, Caldwell relates his art to the concept of the sublime in Burke.

The situation Scully is describing, looking out at an immense space, is very similar to E. Burke's description of the sublime, the mixture of terror and awe inspired by an enormous, desolate landscape. [But] his approach to the sublime differs from that of most twentieth-century artists in being strongly linked to the real world. One is tempted to call Scully's spiritual dimension the Matissian sublime in that Scully's canvases, though abstract, are profoundly steeped in actuality, and their transcendent power comes from the physicality of their light and color.

Caldwell offers a fine interpretation of Scully, citing with accuracy the concept of the sublime (although we could recall that, in the Kantian sublime, there is an inability to dominate the forces of nature, even if our moral freedom is superior to its omnipotence), but later the author tells us: "There is no sense in Scully's work of the visionary, at least it implies the vaporous and insubstantial. He insists that his paintings are real, and not romantic substitutes for spiritual presences."

And why, we ask ourselves, couldn't Scully's paintings be romantic substitutes—in pictorial code—of spiritual presence? Why does there exist in North American or Anglo-Saxon culture this aversion to speaking of a spiritual dimension, and why is any attempt at transcendence equated to "vaporous and insubstantial" means to something less pictorial? There are works such as *Gabriel* [Plate 55] or *Magdalena* [Plate 56] in which the viewer effectively feels this metaphysical dimension, attained as much by means of clarity—the kind we associate with super phenomena—as by the "vaporousness" of the brushstrokes. Curiously, Scully refers to his whites as, in some way, ill-fated:

There is something about Spanish painting and also in Italian painting: the use of white. White represents spiritual life, lightness. And I see my whites as a tragedy [because] they are never white, they are kind of dirty. One of the most literal reasons for this interest in the spiritual, for the ultra-worldly, are the paintings that refer to angels (*Angel* [Plate 19], *Angelica* [Plate 15], *Angelo* [Plate 59]): an angel is a person that works in the threshold between the corporeal and the temporal, so I made them with two realities: one part [is] just drawn with oil pastel and the other part is painted.

Now, I do not want to stress this critical oversight of Scully's painting, but only to insist on this theoretical oblivion of which the artist has been an object, particularly because the painter himself has made frequent allusions, especially in these last years, to the spiritual dimension in his painting. It seems to us that Scully is similar to seventeenth-century Spanish and Italian painters in that the spiritual dimension is firmly anchored in realism (as occurs with Zurbarán or with St. Teresa of Avila).

In a text for an exposition in Trento (1994) about spirituality in art, Sean Scully writes: "There are two zones of reality. One is the mundane and the physical in which we are condemned to live, and the other is the zone of Art."[12]

This spiritual dimension in which Scully situates art possesses eternal qualities and others that have varied with the passing of centuries:

There is a certain static characteristic to what we have called spirituality. Certain aspects of it cannot change, since it will always refer to what we cannot see but only feel through the power of imagination. This process will always be the same. But our concept of spirituality is being modified in a way that amounts to a revolution, since what it is tied to, connected to, represented by is in an endless

process of change. Two hundred years ago it was close to impossible to contemplate spirituality without referring to religion. However, since then the development of the human ego has become self-referential, self-obsessed, and disconnected from notions of external authority in spiritual and emotional matters, because since the discovery of self-analysis (a celebration of the unconscious) our ideas of spirituality have become anarchistic. . . . Our sense of certainty is gone. My own view of spirituality is based upon uncertainty. . . . My notion of spirituality is connected to an intensity of empathy and identification with human life.

And in a text sent on May 10, 1994, we read:

Abstraction. The architecture of our spirituality is in ruins. There are many kinds of Art that you can make—political, topical, environmental, etc., etc. But I want to make an art that addresses this major problem. I think abstraction is best suited to this. Somehow they go together. Not all abstraction can deal with this, not at all; most of it not at all. But I believe with elemental forms painted from deep within the self, it is possible to make something empathetic that addresses the architecture of our spirituality. I think of my painting as a kind of emotional glue. Perhaps they have a way, or can find a way, to attach themselves to things in our lives, that need to be held together. Without being informationally or categorically specific in themselves. But I hope that "ethically" I can work with those elements whose relationships are ruptured.

Here spirituality unites itself to emotions. Some of the key words of this text are "glue," "attach," and "things that need to be held together": Scully, then, contemplates painting as an expression of feelings that precisely concern cohesion, the union of what is dismembered. Painting would be like a reflection of relationships—that, besides their mere formal constitution, could be considered human or social—contradictory, more or less conflict-ridden, in tension. All of that is not that far, finally, from that harmonious desire, longed for by Mondrian, for whom opposing lines, as we have seen, were metaphors for human principles. The only difference is that Scully's vision of the world cannot be as utopian or, in a way, as innocent as that of Mondrian (an "ingenuousness" or elementariness that gave him, on the other hand, the genius of his style).

There are many paintings by Sean Scully that allude to interpersonal relationships or can be read in this light. A painting such as *Us* [Plate 36], from 1988, directly opposes feminine horizontality and masculine verticality. According to the artist: "It refers to the notion of human relationships and their interaction on a plane—but also, importantly, to the space between them. There is a masculinity and a femininity embedded in all my work."[13] It is precisely the emotional and human dimension of Scully's works that Lynne Cooke deals with in a piece published in 1989:

Through such conjunctions of strongly assertive, physically massive units filled with often sumptuous and blazing or burnished color, Scully invokes situations of power. Relationships of dominance, intimidation, competitiveness, rivalry and dependence permeate his works of the early eighties.[14]

And later on:

Scully focuses on relations centered in power and hence on issues of domination and control. Yet like Rothko he does so in ways that invoke not just

bodily but also sexual and psychic states. That such relationships have recently become key issues in discussions of gender, race, ethnicity, and class cannot be coincidental.[15]

Is it possible that the author sees, in the supremacy of the large color bands over the smallness of the rectangles or in the ample zones of color compared to the thinner lines, a metaphor for the battle between the sexes? In any case, the emotional element also permeates other forms and other works: it is also present in the joy and sensuality of *The Bather* (page 49); in the psychic conflict, expressed in the greens and blues of the river or lagoon of *Narcissus* (page 67); in the conflict between life and death in *Flesh* [Plate 25]. I don't know if it would be going too far to assert that, if there was a suggestion of protection—and its reverse, domination—in the works of the early 1980s (where panels overlap one another), at the end of the decade and at the present time these relationships have made a new appearance in the form of a greater stability on the one hand, and a greater understanding of the complexity of relationships on the other. A new, more mature sense of balance, aimed at safety, but that has assimilated and accepted the multiplicity of this world which surrounds us. Is this a new metaphor for human relationships? Without a doubt.

The Classicism of Scully: Composition

If I have spoken up to this point about history and the possible interpretations of Scully, I cannot fail to mention the classical component in his work. Because in Scully the rule always amends or corrects the emotion, or, inversely, it is the emotion which amends or corrects the rule.

If it is true, as Gombrich would say, that there are only two currents in the history of Western art, classical and anticlassical, to which would Scully correspond? In one of his commentaries about art history, and about the stripe, Scully affirmed:

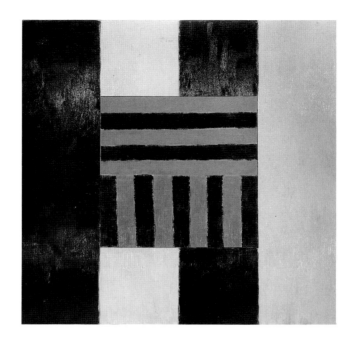

A HAPPY LAND
1987
oil on canvas
96 x 96 (244 x 244)
Collection of Janet de Botton, London

The stripes are part of the large structures that are what represent us and our culture for all time. You see these structures first in Cimabue, Giotto, Masaccio. Then the structures disappear. The tradition is broken as Michelangelo and Caravaggio get interested in the space around figures. The Baroque is a matter of theater. But the mainstream never disappears completely. Artists continue to give expression to the large structures, keep trying to get to the heart of them.[16]

In his opposition to Rembrandt, Caravaggio, and the Baroque in general, repudiated for being theatrical, Scully is indebted to the classical tradition. This, we recall, is

based on those guidelines coined by Vitruvius: Order, Arrangement, Eurythmy, Symmetry, Propriety, and Economy. As for the famous system of polarities coined by Wölfflin (in which Classicism would be linear, flat, a closed form, multiple, and clear), it is evident that, in spite of the brilliance of his statement, this is not totally operative. The majority of the examples do not possess all the qualities required by Wölfflin. And Scully, in this sense, would be the master of contradictions, for he is at the same time linear and pictorial, light and dark, with open and closed forms. However, it is the aspiration toward harmony, the sense of internal order that scaffolds the composition, that confers a classical sense on the work of Scully. If the large format of his works and the emotional force of the colors produce an effect of atmosphere in the viewer, as if he were invited to "enter" into the works, with what order, nevertheless, is this

holistic effect controlled! The composition tends to be balanced and symmetrical, or follows Mondrian's principle of displacing the weight to one side (as occurs in *Flesh* [Plate 25], *Stone Light* [Plate 54], and *Africa* [Plate 38]). Centrality is present in works such as *A Happy Land* (facing page), *Us* [Plate 36], *Empty Heart* [Plate 31], *A Bedroom in Venice* (below), *Facing East* [Plate 45], *Magdalena* [Plate 56], *Lucia* (1992), and *Pabbay* (1992). The brushstrokes go in the direction of the line or, at most, as we see in the "checkerboards," in an interweaving of verticals and horizontals.

If we are to think about a reference to history, Scully's rectangles with their different colored bands bring to mind a long tradition, inaugurated in the Trecento, of the rectangular fabrics—embroidered or plain—that served to emphasize the dignity of the Madonnas and that were another version of the throne. Aside from this balance, it

A BEDROOM IN VENICE
1988
oil on canvas
96 x 120 (244 x 305)
Museum of Modern Art, New York

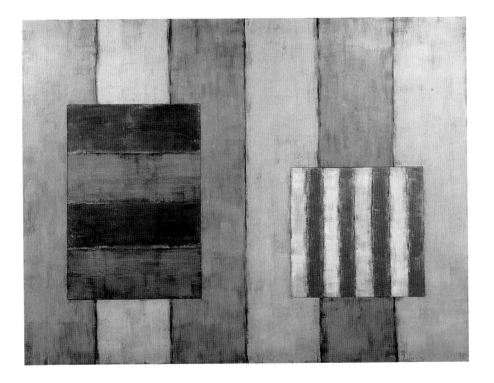

is the colors and ambiguity of these "open" spaces that fill the work with mystery and that help the viewer to perceive a given emotion. Sometimes, it is as if in these rectangles or squares the action or a particular atmosphere were trying to condense itself: the blues of the Venetian lagoon and maybe the fabric of a curtain (or of a gondolier's suit) in *A Bedroom in Venice*; the rectangle interpreted as the figure of the angel in *Gabriel* [Plate 55]; the atmosphere of heat in the orange of *Tetuan* [Plate 49]; or, by contrast, the cold and northern light of *Uist* [Plate 46], with a yellow that recalls Whistler or Manet.

Scully borrows from Matisse, most especially, this opening of spaces within a space:

He paints many windows. He is there, in Nice, painting a beautiful woman and a window. He needs the woman *and* the window. And this is something cinematic. That's why I like the cinema so much: because there are many kinds of reality in it. If I wasn't a painter, I would have been a film-maker.

In another explanation about space in his paintings (which gave rise to the association of Caldwell with the concept of the sublime), Sean Scully stated:

Imagine standing on the edge of the world, if the world was flat [where you] could see that amazing immense space out there and at the same time— you haven't fallen off—realize that you are standing on the edge: that's the kind of situation that I am trying to maintain in these paintings.[17]

On the verge of the abyss, but without falling; in a continuous situation of risk, but controlling it. This is the attitude that Sean Scully takes toward painting.

NOTES

1 See Armin Zweite, "To Humanize Abstract Painting," in this catalog, p. 21.

2 Conversation with the author, June 26, 1994. (If another source is not indicated, all the artist's comments quoted here originate from this conversation.)

3 Zweite, this catalog, pp. 28, 29.

4 Quoted in Bellori, *Le Vite dei Pittori*.

5 Especially Carter Ratcliff, "Artist's Dialogue," *Architectural Digest* (February 1988); Maurice Poirier, *Sean Scully* (New York: Hudson Hills Press, 1990); or John Caldwell, *Sean Scully: The New Paintings* (Pittsburgh: Carnegie Museum of Art, 1985).

6 Cited in Poirier, p. 14.

7 Carter Ratcliff, *Sean Scully and Modernist Painting: The Constitutive Image* (London: Whitechapel Art Gallery, 1989), p. 19.

8 Quoted in Michel Seuphor, *Mondrian, Sa vie, son Oeuvre* (Paris: Flammarion, 1956), p. 117.

9 Ratcliff, 1989, pp. 25–26.

10 Ibid., p. 11.

11 Quoted in Judith Higgins, "Sean Scully and the Metamorphosis of the Stripe," *ARTnews* (November 1985), p. 110.

12 Communication with the author, July 18, 1994.

13 Ibid.

14 Lynne Cooke, "Sean Scully," *Galeries Magazine* (1989), p. 61.

15 Ibid, p. 63.

16 Ratcliff, 1989, p. 17.

17 Caldwell, p. 20.

SEAN SCULLY:
TAKING A STAND, TAKING UP A STANCE
Lynne Cooke

Perspective, as a concept in the realm of visual art and visuality, connotes a system for representing space illusionistically, a way of making a picture that ensures that the depicted place corresponds to how it is allegedly seen in the phenomenal world. So thoroughgoing, so ubiquitous, has this pictorial system become in Western culture that the fact that it depends on a constructed point of view, on delimited bodies standing at a particular location, and that it is, in Hubert Damisch's words, "a structure of exclusions . . . a series of refusals" has often gone virtually unheeded.[1] Attention focuses instead on its supposed objectivity and autonomy: *perspectiva* said to be *naturalis*. Learning the code, including learning to occupy the optimum position for viewing the image, became "second nature" to Western audiences as illusionistic systems of representation increasingly permeated post-Renaissance visual culture.

So rapidly did perspective assume a normative, canonical position, so quickly was it theorized and codified, that it soon dominated both the practice and the interpretation of subsequent art. Only recently has it begun to be recognized that certain Quattrocento artists, anticipating later protagonists, may have manipulated this system alongside other illusionistic tropes including foreshortening. Uccello, for example, was formerly regarded, and at times admired, as a "primitive," that is, as an artist who failed to master and control fully the various burgeoning schemata required to achieve a coherent, cohesive pictorial space. Currently, however,

his apologists argue that he subtly and deliberately manipulated pictorial conventions and codes for expressive ends. The resulting idiosyncratic and far from seamless image conformed (it was believed) to the ranging eye of an observer, including the turning of his or her head in order to survey the whole image. Such anomalies, however, were rare assaults on an increasingly orthodox fixed standpoint.

The abandonment of illusionistic space in much late-nineteenth-century figurative work preceded the move to abstraction. After the Second World War, with Abstract Expressionism, a fully optical pictorial space, as distinct from the illusion of a plastic one, began to prevail. Often, American paintings approached mural scale, becoming fields that delimited and confined space to a shallow optical margin. Barnett Newman, for example, desired that his audience view his large canvases from up close, in order that they be "in the picture." In such works there is no single prime vantage point. Also, perception is destabilized since the expanse of the pictorial field far exceeds that of the visual field. By making it impossible to take in the whole from the close proximity of the preferred vantage point, the painting constructs a space that locates the viewer "here," in real time, at a specific place.[2]

That Newman was admired above all the Abstract Expressionists by Minimalist artists of the next generation was prompted by not only the radically abstract character of his vocabulary, but equally by the

phenomenological basis of his work, located as it was in the particulars of actual time and real space. The positioning of the viewer in relation to the object, and the relation between the object and its spatial matrix, took on new and critical significance in the work of Robert Morris and his peers. While issues relating to abstraction, materiality, and objecthood correspondingly engaged certain painters customarily aligned with the Minimalist objectmakers (notably Robert Ryman and Robert Mangold), normative conventions—the received habits of visuality, legacies of the Renaissance—regarding the primary vantage point were neither radically altered nor challenged in their art.[3] In their paintings, as in those of De Kooning, who alone in the Abstract Expressionist cadre worked exclusively within the conventions of an easel format, and those of Rothko, who in most of his work also preferred a vertically oriented rectangular surface, basing his dimensions in large part on those of the human body, it is assumed that the spectator will adopt a conventional centered, static viewpoint.

Sean Scully's work has been considered a synthesis of aspects of Abstract Expressionist and of Minimalist art, a fusion of the transcendent aspirations of the one with the physicality, objecthood, and quiddity of the other. While there is a certain truth in this claim—as Scully's own admiration for Ryman as well as his reverence for Rothko might attest—its adequacy as an account of the younger artist's particular achievement is questionable. The romantic, heroic aspirations of the former group of artists *vis-à-vis* the role of painting do undoubtedly underpin his endeavors, informing his ambitions for painting and confirming the seriousness and sense of moral imperative that galvanize his own project. In his works, as in theirs, irony has no place, though self-consciousness necessarily does, for his is no naive or unwitting continuation or resuscitation of an earlier, less problematic enterprise. Whereas uncertainty took an existential cast in the art of the Abstract Expressionist

generation, manifesting itself in a preoccupation with the "tragic and timeless," the vision encapsulated in Scully's art is, although similarly dislocated or fractured at heart, now undercut with a sense of fallibility. An often dissonant edginess, realized in the guise of negotiable rather than finite relationships and in a provisional, temporal positioning, permeates his art notwithstanding its rugged assertiveness.

Significantly, this sense of dissonance is in origin fundamentally different from, and even at odds with, that stemming from the much vaunted crisis in contemporary painting.[4] For that crisis is met typically with irony and doubt. Quotation, appropriation, parody, and pastiche abound in this fraught Postmodernist domain, where the "unqualified act" that Harold Rosenberg once championed as the basis of Abstract Expressionist endeavor can no longer be legitimately found. In its place, as Benjamin Buchloh contends, "the spectacle of painting made visible in its rhetoric" prevails.[5] Yet if self-reflexivity is a current condition of informed pictorial practice, it need not, however, lead to a solipsistic dead end, for through the very act of apprehension there may—as Gerhard Richter, Ryman, Scully, and a few others demonstrate—be a way to circumvent the endgame situation that beleaguers contemporary painting and to embody a metaphysic. If the terms of that metaphysic are open to redefinition in each case, sociologist Georg Simmel's argument that spatial relations are simultaneously the condition and the expression of relations between individuals acting in history (whether real or imagined) remains relevant.

Four Days [Plate 42] is a quatrain of discrete panels which have been abutted, each of which may be read as composed of black and white stripes. Differences between these elements stem from the breadth of the lines, their orientation, and the area they cover. In this context the third panel from the left is read as a fragment, a close-up of a striped surface, whereas elsewhere it might

be viewed as a section of a checkerboard. On this occasion family resemblance allows its identity to be taken on faith. Dynamic, dramatically bold, and assertive, these equally sized panels vie with each other for attention. The viewer's eye roams the surface trying in vain to knit the components together, to reconcile these four well-matched, robust adversaries into a single cohesive image. Geared as it is to heroic bodily dimensions in scale as well as composition, *Four Days* challenges the limits of perception.

Far from geometrically regular, these hand-drawn bands were made and remade countless times as Scully dragged viscous pigment across the canvas. Edges bleed, revealing vestiges of resonant color beneath; forms fluctuate, imbuing the whole with a sonorous weight quite different from the optical scintillation characteristic of more regular geometric banding, including Scully's own earlier quasi-purist works. That Scully talks of the "making" rather than the "painting" of a picture is telling.[6] At the beginning of the 1980s his brushstroke acquired great gusto: paint is now put down like "stuff." Together with the palpability of the paint, the richness of interplay between black and white is equally important in fixing the experience as particular and specific, far from the generic or representative. Once attention is paid to the making, to the building up and forming of the surface, the rate of assimilation slows down, in marked contrast to the "instantaneousness," the "given" character, of the artist's works of the 1970s. For the ways in which Scully renders the stripe in each of his works from the 1980s makes the process an integral part of every painting as it rarely is in purely geometric, Constructivist- and/or Minimalist-derived work. The provisional, circumstantial, mutable, even contingent aspects of the making become, in turn, analogs for the nature of the relationship the viewer develops with the work itself.

THE BATHER
1983
oil on canvas
96 x 120 (244 x 305)
Collection of Bo Alveryd, Switzerland

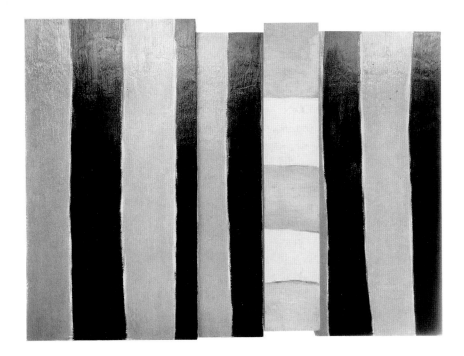

Whether the surface plane is composed of actual panels, as in *The Bather* (page 49), or of only apparently shifting planes, as in *Four Days*, there is an intractable physicality and immediacy to Scully's work that is undeniable. This invasive presence is enhanced by the forthright jutting of the painting off the wall. For years Scully has used wide stretchers, some 3 or 3½ inches (75–90 mm.) deep, which separate the painting definitively from the plane behind, a separation reinforced by the strong shadows which inevitably form along its sides or beneath. Since he never paints the outer edges, raw canvas is always visible on the sides. In this way he prevents the objecthood of the painting, its volumes and mass, gaining priority over its planar aspects. His work consequently remains about surface, or surfaces-in-apposition. Even those side planes within the overall configuration that are perpendicular to the surface remain planes, and through the play of illusion join, bridging the ninety-degree angles that separate them into a continuous, if "warped," surface. Thus, though the painting obdurately enters the viewer's space, it is a space controlled by the frontal planes even more than by the literal perimeters of the work itself. In this it is very different from Minimalist wall sculptures, such as Donald Judd's bullnose metal reliefs which, in requiring that the observer adopt a sequence of different viewpoints from various angles, orchestrate a kinetic, phenomenological experience in spatial as well as subject relations. Shifts in the frontal zone demarcated by a Scully painting require only relatively small adjustments, adjustments that never take one outside the boundaries of the overall frame. Nonetheless, these uncommon angles are sufficient to jolt the spectator's awareness of what has tended to be overlooked in much contemporary painting: the dominance, indeed governance, traditionally embedded in the single viewpoint. The typically fetishistic position of the disavowing, disembodied spectator is hence qualified, even undermined, if only momentarily. In

this way, too, Scully constantly pushes the burden of interpretation and apprehension back onto the spectator, who cannot simply suspend disbelief, to immerse him- or herself in reverie and contemplation, but is propelled into consciousness of the reciprocity at the core of any act of interpretation. At the same time he challenges by implication the heuristic power of the perspective configuration (and of its modern offspring) which, within the registers of representation, has been taken to be constitutive of the (centered) subject.

The struggle toward reconciliation, balance, and even order established in *Four Days* is quite differently parsed in *The Bather*. Its surface is no longer composed of a unified, continuous plane, for the elements are neither aligned physically onto a flat surface nor do they cohere visually onto a single pictorial plane. Buttressed together into a composite entity, their surfaces now some 8 inches (20 cm.) apart, they may be physically integrated yet remain manifestly in tension. Moreover, if the viewer moves even marginally from a central viewing point, additional unexpected perspectives open up and come into play, for the sides of each projected panel have also been painted, and hence an oblique vantage point reveals somewhat different relationships linking the elements. Not only does shifting one's ground reveal other connections—other, and sometimes overriding, sets of relationships in the composition as a whole—but also these relationships themselves are differently cast depending on whether the spectator moves to the left or to the right of center. In requiring different orientations it sets up a discontinuous relation with the surface. Hence, a full understanding can only be put together incrementally, for a sequence of subtly but unexpectedly mutating connections is established as the spectator moves around the painting, traversing its extended visual field, connections that cannot be, or could not have been, presumed or presupposed from a central static position.

Sean Scully has likened this disjuncture to breaking the fiction of the paintings, as Bertolt Brecht did in his plays, or Samuel Beckett in his scripts.[7] In Scully's work these effects of overlapping, disruption, truncation, and interference arise from the juxtaposition of discrete elements, a procedure that in part raises the question of how resolution is achieved, how the artist brings sufficient closure to the work to render it finite, acceptable, and convincing. Ultimately, much depends on an effect of oppositional or competing forces temporarily held in tension, if not stilled. But it is crucial to this end that the dimensions of most of his works are such that they fit within the beholder's visual field when viewed from a centered frontal position, although, as seen in *The Bather*, not all may be revealed from that vantage.

The act of integrating the parts into the whole requires an act of memory, over and above the experiential. By situating apprehension in time—that is, by revealing crucial aspects of the work through a durational unfolding—Scully might be supposed to be exploring narrative relationships. Through these infractions and transgressions of the instantaneity and presentness associated with much contemporary abstraction, a temporality is introduced into the experience. Notwithstanding this effect of duration, narrativity is finally forestalled: the composition is expressive primarily in relational terms, literally and metaphorically. Moreover, whatever residual narrative traces might be threaded together, they are always subordinate to the implications revealed in shifting viewing positions. Compared with the rigid if ideal governance of the work enshrined with a one-point perspective system and carried over into much abstract art, Scully's approach opens up a play of contingency, a necessarily provisional or negotiated assumption of positions on the part of the viewer.

Scully has accounted for his preference for the stripe, in all its mutability and manifoldness, in diverse ways. He has remarked on its ubiquity, and on its "boringness": "the stripe for me is a vessel for getting on to other concerns without distraction."[8] What the stripe becomes in his hands is, above all, an utterly familiar element, one capable, nevertheless, of sustaining virtually infinite permutation and variation. Coincident with its almost limitless potential is its protean referentiality. Yet while it must be open to the diversity of associations brought to it by different audiences, the process of experiencing a work is still structured and regulated. In this way are constituted the genres or picture types whose generic character, for Michael Bakhtin, signifies the collective, cumulative meaning of things that evolve over time and through the mutations of the social orders. Here, for him, lies the foundation and guarantee of objectivity, and the basis of the truth content of representations.[9] To claim that these are abstract paintings is neither to say that they are non-referential, nor that they are exclusively self-referential. Each immediately and inevitably invokes other instances, other usages of this iconography in the history of modern art, for Scully recognizes that an exchange of cultural information takes place via the art-object. Hence, whatever else it does, all his work refers simultaneously to itself—as abstraction—and to its own traditions, and it does so without entailing exclusivity. In this, too, his works differ tellingly from Minimalist art which attempted to "bracket out" all referential properties as extraneous traditions or assumptions, in order to examine the object in its primary state.

Yet as a motif the stripe, for Scully, has the added advantage of largely precluding not only issues of self-expression and gesturalism, but of figure/ground relationships. As found in *Africa* [Plate 38], pattern overrides, and effectively eliminates, a positive/negative interplay between elements, and thereby maintains all activity up against the surface plane. Yet Scully simultaneously employs a bevy of compositional

strategies to interrupt the continuity of this very plane. Stripes are arranged so that, as *Africa* demonstrates, adjacent edges with the same color link up, so uncannily blurring the boundaries between sections, or two components the same size echo strangely when one is light-dark-light, the other dark-light-dark, but otherwise identical.

Color, as David Carrier has argued, exists literally in and of itself in Scully's art.[10] It embodies the surface, rather than appearing *on* the surface: that is, it seems less a property of the skin, the outer layer, of things than a material element *tout court.* In monochrome painting, sustaining the surface tension across a broad field usually threatens either to turn the whole into a wall-like stele, or, alternatively, to dissolve the plane into luminous fluctuating optical space. With his deft arrangements of intersecting stripes, Scully eludes both traps, the surface taking on a tense quiddity as a result of the interweaving, truncation, and taut juxtaposition of fragments seen often as if in close-up. Thus, like texture, color serves to imbue his paintings with a concreteness very different from the "remoteness" that Scully finds in most abstract painting. At the same time it serves structural ends. Much admired as a colorist, Scully in fact permutates black through the majority of his works. Pure blacks, composite blacks, near blacks, blacks shot through with the rich hues of previous layers permeate his palette, as they did that of Matisse in various periods of his career.[11] Yet black in Scully's paintings usually functions architectonically, imparting tremendous structural strength and robustness to the work, for in his dealings with color, spatial relations tend to be accorded preeminence over issues of expressivity, notwithstanding their memorably sumptuous, brooding, blazing, or burnished effects.

If the stripe has long held a multitude of possibilities for Scully, narrowing at times to line, expanding at others into bands, zips, zones, vectors,

even blocks, in his most recent paintings it has finally metamorphosed into tesselations on a checkerboard. *Union Grey* [Plate 62] and *Union Green (Catherine 1994)* (facing page) incorporate what are now—compared, for example, with the formerly ambiguously truncated stripes of *Four Days* [Plate 42] and related paintings— incontrovertibly patterns of squares. In this new move, which may be likened to a game plan, Scully raises the stakes by setting up a double identity in each work, as if two halves of different boards had somehow become conjoined into one. The dimensions of the squares on each panel are slightly different, the squares on the right seeming, despite their abrupt truncations, larger in scale than those on the left. While the ranges of association these paintings can evoke are inevitably different from those generated by works composed of stripes, their very ubiquity once again leaves the allusions open-ended, fluid, and, ultimately, of little real import.

"If the painter has chosen to prohibit the imaging consciousness from giving itself free rein . . . it is for the purpose of awakening in the spectator an uneasiness in which the perception of a painting should be accompanied," Damisch argued of Piet Mondrian's art.[12] In each of the Dutchman's works, he contends, the demands of the specific relationships between components are so complex, so rich, so subtle, and so particular that one is brought back to attend to the actualities of the work, in place of any generalized image it might be thought to invoke. Something similar occurs in Scully's art, where nuances of color, proportion, scale, and pattern are critical to the experience of the work.

In these latest oils, perhaps more than ever before in his oeuvre, it is the very minuteness in the differences between the aligned elements which proves so telling. The gulf, the unbridgeable physical chasm between the two panels, each a double square, 4 feet by 8 feet (122 x 244 cm.), literally splits the painting, sundering the whole. "One cannot give way to reverie in front of a

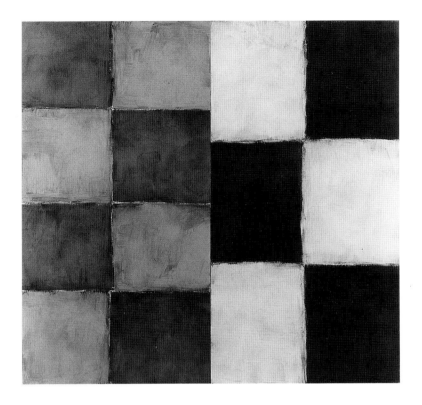

UNION GREEN (CATHERINE 1994)
1994
oil on canvas
96 x 96 (244 x 244)
Collection of the artist

Mondrian painting," Damisch asserts in words applicable to Scully's art as well, "nor even to pure contemplation. . . . [T]here comes into play, beyond the sensorial pleasure . . . some more secret activity of consciousness, an activity by definition without assignable end, contrary to the imaging activity which exhausts itself in the constitution of its object."[13] For this "imaging activity" always, he contends, fails to deal with the actual concrete work, substituting an illusory picture of it in its stead. Faced with the literal rupture of the surface in *Union Grey*—

strokes at the truncated edges of the squares rush off the surface in contrast to those of "complete" squares where the brush turns, maintaining the parameters of the unit intact—unity falters. The fault line or fissure that symmetrically bisects this unmistakably pure square format produces disunity within unity, or a unity deferred.

More than previous works in Scully's repertoire, *Union Grey* and *Union Green (Catherine 1994)* invoke the specter of the grid, that contemporary counterpart to the perspective configuration in traditional figurative art, and the Modernist structure *par excellence.* In recent art the grid has conventionally been employed as a means to dispense with narrative, to structure the work in terms of transparency, containment, and simultaneity. By means of that simultaneity, it eliminates figure/ground distinctions in favor of the continuous immediacy of a purely optical spread. Moreover, by enframing the work and ensuring its closure, it heightens presence into presentness. A holistic gestalt, it appears to be outside duration, temporality. By invoking and simultaneously disrupting the grid, Scully deprives his viewer of what Rosalind Krauss terms "the security of a unitary vantage." In fracturing the painting he also fractures the centered viewer who strives vainly to encompass all as a whole: the ambiguous positive/negative of the pattern, doubled by the pairing of similar though differently scaled partners, once more sets up a rupture, an uneasiness. Krauss contends that "the grid not only displays perfectly the conditions of the *visual*—the simultaneity of vision's grasp of its field, dissolving the spatial (tactile) separation of figure against ground into the continuous immediacy of a purely optical spread—but also repeats the original, antique terms of a desire for objectivity and extreme clarity."[14] By subjecting this paradigmatic Modernist structure to a series of revisions and reformulations in these works, Scully sunders the physical unity, and renders inconsistent the whole. The succession of kinesthetic viewpoints required formerly in works such

as *The Bather* has been replaced in *Union Grey* by an irreconcilable oscillation between the two halves of a closed entity, itself a perfect square, and since neither of them can gain preeminence, it is doomed to unresolvable, unstable flux.

It is not only fortuitous but felicitous that Scully's latest compositions, in bringing a (fissured) gameboard to mind, also invoke the strategic model that theorist Hubert Damisch uses for his analysis of the situation of contemporary painting. For him, as Yves-Alain Bois explains: "Like chess pieces, like phonemes in language, a work has significance, as Lévi-Strauss shows, first by what it is not and what it opposes, that is, in each case according to its position, its value, within a field— itself living and stratified—which has above all to be circumscribed by defining its rules."[15] Damisch employs the metaphor of chess to suggest that in each case what is being considered is whether the painter is "engaged merely in a single match that would take its place in the group of matches making up the *game* of painting," or whether he or she is "returning to the very foundations of the game, to its immediate, constituent *données*, [which] . . . would then represent less a new development . . . than a new departure, a resumption—but at a deeper level and, theoretically as much as practically, with more powerful means—of the match begun . . . years earlier."[16] Thus, the question becomes "one of the status that ought to be assigned to the *match* 'painting,' as one *sees* it being played at a given moment in particular circumstances, in its relation to the *game* of the same name."[17]

Scully's recent paintings, especially, bring this question into the foreground in vital and eloquent terms. Nonetheless, this frame of reference cannot be read as their exclusive content, for at the same time they continue what has become an abiding preoccupation with the positioning, and hence with the construction, of the subject. Questions of dominance, intimidation, competitiveness, rivalry, and dependence not only permeate his work of the 1980s but govern the viewer's relations with it. As in his most recent works, these situations seem precarious rather than finitely resolved, constantly subject to change and eruption. For Scully renders the terms of the relationship between the viewer and the work of art not only negotiable but assertively, if candidly, explicit, setting forth the conditions of control, grandeur, power, and menace, together with their allure, eloquently, vehemently, and memorably.

1 Hubert Damisch quoted in Rosalind Krauss, "The /Cloud/," *Agnes Martin* (New York: Whitney Museum of American Art, 1993), pp. 160–61.

2 In 1981, at the moment he forged his mature vision, it is significant that Scully assayed a field painting. Twenty feet (6.1 m.) long and composed of eleven individual panels, *Backs and Fronts* takes the form of a processional, sequential work. Unlike Newman's works, it is composed of part-to-part relationships, relationships that hypothetically might be extended without end. Thereafter the artist resumed a scale and format that, although monumental, could be encompassed within the static viewer's field of vision.

3 Even when Ryman cantilevers a work out from the wall, the (conceptual) impulse is what prevails. It is hardly necessary literally to shift one's vantage point in order to apprehend the work.

4 See, for example, Adrian Searle, "Introduction," *Unbound* (London: Hayward Gallery, 1994).

5 Quoted in David Batchelor, "Behind a Painted Smile," *Frieze* (May 1994), p. 21.

6 Judith Higgins, "Sean Scully and the Metamorphosis of the Stripe," *ARTnews* (November 1985), p. 106.

7 Carter Ratcliff, "Sean Scully: The Constitutive Stripe," *Sean Scully: The Catherine Paintings* (Fort Worth: Fort Worth Museum of Modern Art, 1993), p. 21.

8 Quoted in Steven Henry Madoff, "A New Generation of Abstract Painters," *ARTnews* (November 1983), p. 82.

9 See Michael M. Bakhtin, *Problems of Dostoievsky's Poetics* (Ann Arbor: University of Michigan Press, 1973).

10 David Carrier, "Color in the Recent Work of Sean Scully," *The Aesthete in the City: The Philosophy and Practice of American Abstract Painting in the 1980s* (University Park: Penn State Press, 1994), p. 246.

11 Scully's reverence for Matisse has been stated on numerous occasions, of which the following is typical: "Matisse is very important to me because of the idea of putting one set of things up against another set" (Higgins, p. 108). One of Matisse's most radical compositions, *Interior with Eggplants* of 1911, offers a telling instance of this, containing as it does a welter of decorative pattern welded into a taut monumental structure, a vivid precursor for Scully's later procedures.

12 Damisch, quoted in Yves-Alain Bois, "Painting as Model," *Painting as Model* (Cambridge, Mass.: The MIT Press, [1990] 1993), p. 248. This text is much indebted to the arguments of Yves-Alain Bois in his book *Painting as Model*, and in particular to the chapter of the same name which is devoted to an exposition of Hubert Damisch's theories on painting.

13 Damisch, quoted in Bois, p. 248. Scully's admiration for Mondrian should also be invoked. In the following comment may be gauged the play of allegiances between the two: "[O]ne of the things that shuts you out sometimes [from these classical works] is that they are so right . . . there is no room for us." ([1987], Carrier, p. 260).

14 Krauss, p. 164.

15 Bois, pp. 254–55.

16 Quoted in Bois, p. 256.

17 Ibid.

Sean Scully's New York studio, November 1994. Photo by Fred Scruton

INTERVIEW WITH SEAN SCULLY

Edited by Ned Rifkin
(conducted in the artist's studio on May 20, 1994)

NR The show really begins with *Horizontals: Thin Greys* [Plate 2] in 1976—the most minimal, colorless, systemic painting. Is that the *tabula rasa* for your work?

SS That's a good phrase. When I committed myself to coming to America, my reaction was extreme. When I arrived, I had had somewhat of a career and somewhat of an image as an artist. And I decided instead of trying to hold onto that, and play a kind of in-between game, I would really be an immigrant and I would start with nothing; I would start with *tabula rasa*. That's not even black, it's gray . . . doesn't even have the passion and mystery of black—it's emptied out. I got rid of everything in my work except the one thing that was just before ground zero, and that was a stripe. But the stripe in this is not crossing over itself, it's not making a grid, so you don't get the pleasure of space, you don't get that sort of orgasmic twitch as one band crosses over another and makes a little visual caress.

NR So this really is a point of entry in so many ways. You eliminated space. What precedes this has illusion.

SS Yes, the grid paintings do have illusion and they have a certain degree of opticality.

NR In 1976, what was going on in your life?

SS Well, I came to New York in the summer of '75, and I took a long time to get started. I had to find and build a loft. And Cathy [Lee] was here with me, working,

and there was a lot of struggle, but there was a lot of excitement. And I wanted to really embrace the United States.

NR Does your work from this time have any relationship to Ad Reinhardt?

SS Yes, to Ad Reinhardt, to Sol LeWitt, to Agnes Martin. In fact, I asked Sol LeWitt to look at my work and he very graciously came around, which impressed me. He's a very nice person. His generosity was followed up immediately by artistic stinginess, and he said he couldn't see my paintings because they weren't directly on the wall. So I said, "You mean if they were more like yours, you'd like them better?" So he said, "Yeah." And I said, "Okay, that's great, thanks."

NR You didn't mention Robert Ryman.

SS What I admire about Ryman is his extremeness, being an extreme person myself. I believe that is a true artist. But with Ryman, it's not really anything specific, formal. I was very interested in all the Minimalists at that time. And I thought that was the most interesting American art. That was much more interesting than color field, because color field moved towards a kind of academic decoration. However, Minimalism is also academic. By that I mean that it's economic, like Rothko or Newman, but it doesn't have the same level of ambition. It doesn't have their mysticism or emotional range: it's art for puritans. But at least it has the

advantage of being visually edgy, of having a kind of austerity, so the austerity gives it a sort of ethical, moral edge. But I'm not any longer a disciple of the Minimalist ethic. In fact, the work that I did subsequently is a direct attack on it. And it still is.

NR What can you say about the introduction of color in *Blue* [Plate 3] from 1977?

SS *Blue*'s got proportion, and the reintroduction of the grid, subliminally. The proportion of the object is in the vertical and it's covered in a horizontal motif, so that's a grid right there . . . grid thinking. I'm thinking about more activity along the edges by lengthening the edge, by making the edge where the stripes end longer than the edge where they have a passive relationship. So I've lengthened the other edge where there's conflict possible, or where things are cut. That's a major element in all my work, the edge. The way things abut, or the way things are cut, abbreviated, truncated.

NR What about the widening of the band?

SS Well, I remember that had something to do with the lengthening of the area. And I stretched out the image because I very often think of the painting surface as elastic, a skin. Because for me it's always metaphorically represented the skin of culture, what you paint.

NR Well, we'll get back to that, because as your scale increases and the works become sometimes architectural, sometimes almost analogous to the body, the skin, and the touch, become much more intimate. There's still a kind of non-touch orientation toward your surface at this point.

SS Yes, there's a neutrality there. I deliberately brushed out all the brush marks. I got rid of them.

NR You used the word "image" before, in passing, but I wanted to seize upon that for a moment. Did you see these as images, even at *tabula rasa*?

SS Yes. It's the most fundamental image the eye can come up with. These are the skeleton of the body.

NR Are you really talking about your paintings retrospectively as putting flesh on the bones?

SS Yes. And that's how I see post-Minimal painting also, which gives it a kind of a use. Historically speaking, Abstract Expressionism has yet to be equaled. The two options are Formalism and post-Minimalism. Formalism led logically to a kind of elaboration, inferences of the decorative, the perfect design. I can see how it seemed quite logical that you could build on those achievements, that you could formalize and rationalize and aestheticize the achievements of those earlier artists. But I think that what the post-Minimalists did was more interesting, because they took it down further, and it allowed the building-up process to be of more interest, because what happened to the color field, the Formalists, is not of interest—not interesting paintings, psychologically. They look good, but the relationships are too logical, so it had to get perverse in some way, which is what this does. Sometimes things have to be hard in order to get back to what seems a similar position, but it's informed by the trip.

NR When you refer to the post-Minimalists, about whom are you speaking?

SS Well, I'm really referring to the ones I already named: Agnes Martin, who is a very important artist (and she's important to all of them), and, of course, Frank Stella's black paintings, which are very important.

NR They're very important to you?

SS They're very important to me because they showed me a way of achieving a kind of emotional power, even though he would probably deny that.

NR The one other artist I'd like to ask you about is Jasper Johns.

SS I think Johns is extremely interesting. He did something that I've always been interested in and that in some way my work is based on. He took banal imagery and gave it a kind of European surface complexity. It was quite brilliant—like the flags. Those were the best things he ever did. And also those cross-hatch paintings were fabulous, too—one is reminded of Cézanne and his sense of structure in building the surface. Johns's sense of Modernism and tradition is very interesting to me. And also the kind of psychological edge on his work is of great interest to me because I think that's how I work . . . that's how I think about art.

NR Has Johns directly influenced you in other ways? Has his work inspired you?

SS I'm not interested in his tradition; I'm not interested in Pop Art. The way I see it, there are two major strains: Duchamp on one side, and the Formalists on the other, or what one might call "high art"—Matisse, Mondrian, Rothko—and I'm clearly on that side.

NR You used the word "mystery" when you talked about using black. What drove you back to removing color?

SS Well, here I think I'm adding something subjective. The gray paintings I see as more neutral, but when I start doing the black paintings, then I'm getting into a kind of nocturnal mystery. With *Brennus* [Plate 6], there's a romanticism that is backed up by the title. Brennus was a Celtic warrior who led a revolution against the Roman Empire. They eventually lost, of course, because they were fighting a huge, mechanized war machine. But they even built a big wooden city, which no longer exists. It was a major revolution.

NR And does this painting somehow represent your sense of place or position?

SS No. Sometimes I use titles to acknowledge or pay tribute to something. It could be a book, but it's not a book about me or a book I would have written or could write; it's something that I appreciate and I want to pay a little homage to it.

NR A Celtic revolutionary against the big system sounds awfully personal.

SS My whole stance is against the way things are going—against dehumanization, post-humanism, deconstructionism, etc.

NR This is a bigger painting.

SS Yes, they did get bigger. Around the time I was painting *Brennus*, I started to get bigger ideas of content, or perhaps more heroic ideas of content. Obviously, heroism and romanticism tend to be somewhat linked. But I also started to get ideas about the emotional wallop that you could put in a painting. I had actually started to find something in art that I could have continued with, because I like these dark paintings very much. And I could have made them for a lot longer.

NR When we discussed the painting as we were selecting it, you talked about the brushstroke.

SS The paint is starting to get active. It's an oil painting. That's very important. I think of the color in *Brennus* as fat—it's brown and black.

NR Fat?

SS It's a color that can carry association, that represents more than light. It can also represent a kind of substance, whereas the color in *Blue* is a color that really only represents light. There's an addition of the idea of body. Because those colors could refer to earth, dirt, bark, rock . . .

NR Organic material.

SS Yes, that's dark. Where *Blue* refers just to the sky or perhaps water. It refers to elements that don't have

much physical weight. In *Brennus*, it starts to become night material and has a body to it.

NR Did the change to oil paint come as a result of your wanting to activate the paint more?

SS Absolutely. Because I suffered like crazy when I tried to introduce oil paint. It was such a struggle. It was driving me nuts. I spent a very long time trying to be able to use it because I had the aspiration to introduce surface and the organic animation of oil painting, but I couldn't stand its imperfection and its disobedient nature.

NR Let's move on to *Italian Painting #2* [Plate 5] which comes the same year as *Brennus*. It's an oil painting that has three parts vertically. Describe it in terms of what the three different panels are about.

SS Well, it's no longer an all-over painting. It's a painting with zones. And it's striped/not striped/striped, but still very much connected to process. You know, my paintings around this time were very connected to process. I think the artists who make art with such a strong relationship to method are saying something more than just that the image they end up with has to be arrived at through a way that has integrity. It's getting back to the question of whether the means justify the end, or whether the end justifies the means. And the argument of a Process artist is that the means justify the end. And this puts me in dialogue with a certain kind of conceptual approach to art . . . a ritualistic approach, a procedural approach to art, as opposed to a purely aesthetic approach. I do believe that Process Art came out of a strong desire on the part of artists to make more than mere art, more than mere artifacts. It came out of a strong desire to show that the way you do something is very important. So it's a moral, ethical stance; the process should be evident in the result, and it should have a relationship to the result which is still in the work.

So, in *Italian Painting #2*, what I've done is: on the bottom square, I painted it a color. On the top square, I painted it a color. Then I taped up the bottom square and I taped up the top square, and then I painted a whole painting. And then I took the tape out—there's the painting.

NR So the shift has a kind of dynamism, vertically speaking? And it has to go through the shared space?

SS Exactly.

NR So there's an equilibrium.

SS Yes, the mystery of the painting comes out of its attempt to reveal itself, to reveal its procedure.

NR In some way, this harks back to some of the optical things that you took in, I would think, because the middle square becomes a receiver for after-image. I know that Bridget Riley was very important to you, at one point—in trying to advance some of the method of optical painting, the space was eliminated, but you kept the vocabulary.

SS You've hit on a very important part of my relationship to Op Art and my reservations about Op Art. Again it revolves around this issue of what is ethical. Let me just say that the middle square was meant to be a place of reorientation, of reconsideration. It's a mediating place.

NR Why is this called *Italian Painting #2*?

SS Because [art critic] Joe Masheck suggested the title. It has to do with Italian concerto music. Active, passive, active. It was quite active, very slow, quite active again.

NR So it had to do with music and not visual art. Have there been other points in your painting where music was important?

SS Well, I called one of my paintings, *Stay* [1979],

after a record, that famous one, "Stay . . . just a little bit longer," by Maurice Williams. It's an awesome record. And you know, *Hammering* [page 23] is named after Bob Dylan's song "Chimes of Freedom." He has a moral passion that I find very attractive. The line in the song is "Mad mystic hammering." I took off the first word and considered "Mystic Hammering" for a while, but in the end I was left with one word: "Hammering." I think it's perfect for the painting; it describes its sound and its insistence, though not its light.

NR Well, let's get back to *Italian Painting #2*.

SS What I love about Op Art is not the fact that it is optical. Or what I loved about Bridget Riley's painting was, first of all, she set a very high standard in England, which is a country that doesn't appreciate the kind of art she makes, and still has not fully acknowledged and continued to support her. But what I loved about her work was its intellectual, structural rigor, not the fact that it played tricks on your eyeballs. It wasn't the result that I liked, it was what was behind the result, and that was what I got to in my own work. It was the procedural honesty and self-criticality that I admired so much.

NR Where is the title *Slate* [Plate 9] from?

SS That refers to a stone, which is very interesting because I've recently called a major painting *Stone Light* [Plate 54]. So here I think the color is getting stronger, but there's no way, at this point, for me to keep the structural discipline that I've got and explode the color without making something objectionable. Because when you explode that color more, you're going to get something that's visually tricky. Then I would have lost the poetry and mystery of the painting.

NR *Slate* is a diptych horizontally, but it's still a vertical painting. I'm very interested in the way you started conceptualizing the conjunctions. There are a number of paintings from this series, 1980, that are vertical-horizontal diptychs. This particular painting has what I think is a very important rupture in the conjunction of the two, which is something in the more recent checkerboard paintings today. Is this where it begins?

SS Yes. I mostly made the sizes of the canvas by putting my arms out, and I know when I put my arms out to the wall and I just go like this, that's 28 inches [71 cm.]. And these are 28 inches. They're meant to be figural. And this one gets to be a little bit more like Bigfoot, in that respect, you know, he's sort of a basketball player in size. It's higher than I can reach. It starts to get a little bit larger than life-size. It's quite a monumental painting. There were a lot of paintings that I made around this time that were much more modest in scale, when they have to do with the figure, the body. And then I started to deal with the idea of the double figure, the duplex. Or the relationship within mankind—male and female, good and evil. And that is really what I'm interested in in art, and I'm always confronting that. And that's deeply embedded in my work. In these, the fact that they're split—they're split, and yet they retain a figural presence.

NR Well, the oneness is balanced as the division. Are you saying that part of the unity is by definition in relationship to division in conflict? That the concept itself doesn't exist without the manifestation of separation and conflict?

SS That's precisely what I feel because I believe that any other concept of unity is false. I'm trying to do something in relation to what I see that we've actually done. I believe that unity has to take into account rupture, the possibility for internal discord, and I think that's a much more useful model for us to follow and to be able to understand ourselves.

NR What you just described struck me as directly corresponding to what a stripe is to a field. In other

words, it's an intrusion, it's an echoing, but it makes itself distinct.

SS Yes.

NR And yet, by so doing, it also defines the something else. I know you've talked about the use of the stripe and I've seen all the photographs of the railroad tracks and what struck me was that you were taking it from what you see. It's all over, it defines the world in so many ways, so it's a natural motif. But philosophically, it's something else, too.

SS Right. You see, for me, a natural motif and a philosophical motif are the same thing, there's no difference. Because my work is based on structures that I believe express human nature. My work is deeply urban and it's very much about human nature. It's about trying to penetrate into these fundamental structures that we use. For me, it is a natural motif, it's what I see. But I don't just see it as a visual motif. I see it as communication, as an expression of human nature, and I see it as a kind of unconscious and conscious intentionality, everywhere I look.

NR Now, go back to *Slate*. Slate is a color, it's a material; what else is it meant to evoke as a title? Or what else does it mean to you as a title?

SS Well, it evokes the idea of a wall or something that is permanent, and close to being silent, but not silent. These paintings are on the edge of not saying anything; but if they are saying something, it's something that's very austere, a little bit druid-like. It has to do with the relationship between having an austere position and having something very active going on. But the expression in the painting has to be dug out of it, like a hieroglyph, the way something might be carved into a wall. If you want to work, you can get something out of it. And if you don't want to work, you can pass by.

What I wanted to do in these paintings was press down on the expressiveness of the painting. So I was causing a kind of pressure. Something happens when one is listening to music that is very austere. Like Zoltán Kodály's cello sonata. It's so powerful, and yet it's too much for most people, and that's why it's not commonly known, but it's one of the greatest pieces ever written for cello. It's an unaccompanied cello sonata. The pathos of the work is caused by the inability of the medium to completely express the ambition of the artist.

NR Well, it's interesting that you think of the cello because of the melancholic timbre of that particular instrument.

SS It's the expression of being covert, being pressed down, being held down, causing a kind of pressure and causing also a kind of pathos. I mean, there's a sorrow in the painting, or a sadness.

NR How does this relate to your personal sorrow?

SS I think my sadness is actually more empathetic and universal. It's about the sadness of the world. I'm a very exuberant person, but the world has made me into a sad person, too. I mean, things that have happened in the world have had an effect on me. And I think that permeates some of the things I do.

NR So what accounts for the visible shift in your work from 1980 to 1981?

SS I had a complete change of heart about the kind of art that I wanted to make, and about what art should be doing. Earlier I was trying to cut down the size of my audience. Later I wanted to make work that was more generous, more obviously available, that wasn't so exclusive, wasn't so austere. I didn't make the audience pass an IQ test in order to look at the paintings. And also, I was completely fed up with the pretentiousness of New York Minimalism, the refinement, the effeteness of

it. I thought it had become a kind of elitist, upper-class activity. What I wanted to do was put back into painting its ability to communicate. I wanted to put it all back in. But the question is, how can you put it all back in and make the paintings vital without making them retrogressive or without making them simply decorative? I went through a period of extreme denial, extreme austerity, before I exploded. I think I was building up knowledge and information during that period. Here, I put as much into the painting as I could. That's why it's called *Enough* [Plate 13].

NR Now that I've heard your explanation of the change, it also seems to have a double meaning, which is "enough" of the other. It seems emphatic as well as descriptive.

SS Yes, you know, it's a little manifesto, this painting. It's loaded up and it's a bit compressed and centrifugal. Now it's unabashedly compositional, it's got all these different colors in it, it's got different paint surfaces in it, it's got overt color in it, it's decorative, it's full of pleasure—in a fairly frontal way, it's got all the things in it that I was leaving out earlier.

NR It's also optical, again—there's almost an optical buzz to it. In a way it's just turning up the volume of the conjunction and the conflict that we saw in earlier work. It's not "all-over" in that same sense, but it's more active than any painting you had done up to that point. Did you refine from this, then?

SS I made paintings that were more simple than this as a result of this painting.

NR I think this is where I start seeing Matisse more clearly.

SS Absolutely. No question.

NR Did you see a Matisse show or look at a painting? Was there anything that prompted that?

SS No, there is always an element in my work that could be seen as decorative painting.

NR With Matisse there is that wonderful tension and balance between the richness and the austerity.

SS Right, that's what I've got going here. It's systematic and rigorous in the way the stripes are put down and in the way it conforms to the drawing method that's used in the other paintings, but it's used in a way that is completely wayward.

NR It's really an exuberant painting, a reaction or response to a kind of dead end; you wanted out. There's also such a playfulness to it that I would almost think something changed in your life—something happened that got you out of the darkness and into the color and light and animation.

SS I can't think of an event.

NR I think there is a long way from *Enough* to *Heart of Darkness* [Plate 16], one of your major paintings from the early 1980s.

SS And also a return to darkness. And a much more austere painting.

NR *Enough* looks very taped and measured, whereas you start seeing the hand-drawn and wavering lines at this point in 1982. In 1981 there was still a very geometric kind of restraint, even though it was exuberant.

SS I think it's taped and not taped. Even though *Enough* is a little manifesto, it may have even been a bit of a false start. The exuberance in this painting is the exuberance of the visual. Earlier you used the word "optical." The exuberance in *Heart of Darkness* is something deeper. And that is what I was trying to get at for years and I didn't know what it was. Well, when I said "something deeper," I'm really referring to its physicality—the way the areas are painted. And that is

a massive development. *Heart of Darkness* is definitely a declaration of intent, because of the way this area is painted in relation to that, that is expressing content in a way that I hadn't managed before.

NR A lot of things are happening between *Enough* and *Heart of Darkness*. A new scale, a monumental painting, emerges.

SS The length of the title and the ambition of the painting seem to be somewhat related. The painting is referring to something very immediate and specific. It's a book [*Heart of Darkness* by Joseph Conrad] I was reading while I was making the painting.

NR And there is a left-to-right reading of the painting.

SS Right, so all the things that were in Minimalism, I thought, all the inhibiting, restraining politeness of Minimalism, is just out the window now.

NR Yet what you're doing is taking the vocabulary of Minimalism that you once employed in a way that was purposeful and toward content, and you're expanding upon that: instead of stripes, they become musical strings, they become things that really do vibrate and resonate. There's really a sound coming off of them. Whereas *Enough* is dizzying in the optical sense, *Heart of Darkness* is very calming and linear—it's a journey.

SS So what a painting can refer to is becoming much more permissive around this time and all those rules that people were building up around Minimalism are out.

NR Another aspect at work is that all these elements are separate parts that have been bolted together.

SS Not all of them, there's separate parts and not-separate parts.

NR Okay, so that's part of your strategy at that point, but you didn't yet know what to do with them. It became

a collage or an assemblage, but in *Heart of Darkness* you eliminated a lot of the complexity. Then these become architectural, they start to refer to walls, buildings, and ladders.

SS *Heart of Darkness* is much more evocative than *Enough*, which is an optical painting about visual overload. When you look at *Enough*, you look and think about the painting. When you look at *Heart of Darkness* or subsequent paintings, I want people to think about things other than painting—to think about the way human beings are or something that you've seen.

NR Was *Heart of Darkness* the breakthrough painting? How did it evolve?

SS There is no question that *Heart of Darkness* was the achievement at that time, the premier painting from that moment.

NR You continue to use black and a kind of bruised yellow. Yellow is a very difficult color for painters, but you've managed to use it in a way that's very important to your work.

SS You know what yellow is? That's the color of madness. Quite perfect for me. And it's also the color of sex—"I am curious, yellow." It was because yellow was supposed to be the barometer of sex. So maybe sex and madness are somehow related.

NR I find *Angelica* [Plate 15] one of the finest pictures from this moment.

SS What I loved about doing both *Angelica* and *Angel* [Plate 19] was the idea of doing something that is about drawing and painting in a purer sense within the same painting. *Angelica* has one side of the painting that is really like a blackboard with drawing on it. *Tabula rasa*.

NR Is that actually paint or is it oil stick?

SS It's oil stick. Because that makes it more of a drawing. Paint would have made it more of a painting. So this fat body says sensuality, light, etc., etc. On the left side is a drawing and on the right side is a painting, this beautiful emptying out. It's skeletal, but within the same painting.

NR Once again you've got the vertical diptych, going back to *Slate*. It echoes and reconsiders that conjunction of two after having done the three, like *Heart of Darkness*. You go back to the two.

SS Yes.

NR You've made it so much richer.

SS Right, after learning. Because, you see, what I didn't want to do was simply advance my work through elaboration. I think that my talent is not that great, but I think that the management of my talent can be very great. And also my passion and my sincerity and my empathy are very great. I have a little talent in relation to Picasso, in relation to Matisse. But the management of my talent is what has enabled me to get this far. And now I set that in relation to something. I question myself a lot.

NR What you're talking about goes back to the proving grounds of Minimalism and the method of refinement by elimination.

SS Yes.

NR Which is still a practice that works for you.

SS Oh yeah, because I think that has a lot to do with a sense of morality.

NR And discipline.

SS Yes, and it's a questioning. It's saying: "Let's look at what it is when it's naked, when it's got its clothes off. Let's look at that."

NR What prompts making another picture, *Angel*, so similar to *Angelica*?

SS Well, I just wanted to make one that was more ethereal, lighter.

NR Did you ask yourself what would happen if you reversed "the blackboard"?

SS Exactly; and then, of course, it wouldn't be a blackboard anymore. It would refer to a piece of paper. That's what this portrays, it's a large piece of paper. I got the idea for the color on the other side from looking out of the window of an airplane, looking at the clouds, on the way back from Pittsburgh. I was obsessing about the painting. Sometimes I meditate about paintings for a long time before I make them.

NR When you say you "meditate," what do you mean exactly?

SS Well, I hold the painting in my mind. You know, my little TV screen I have in the front of my brain that's full up with paintings.

NR Again a question about a title: *Murphy* [Plate 24]?

SS "Murphy" was the story of a kind of Irish lunatic by Sam Beckett. He was a real mischief-maker, and had a kind of austere, mad exuberance, and I thought that's what that painting has. Sometimes I find the titles in the making of the painting. I was reading the book while I was painting. At this time the expressive, sculptural, figural, compositional possibilities of my paintings were exploding like crazy, and in this year I traveled an incredible distance. *Murphy* has a darkness about it, but it also has a real crazy exuberance. Again, with this yellow, and yellow is a color that I use, for some reason, instinctively. It's got a red halo around it, the yellow.

NR And then the inset refers back, in some ways . . .

SS To a drawing I did, to the linear idea.

NR It's like a drawing, which is actually a painting, supporting the painting, which is like a wall.

SS So it's the embedded line at the bottom. It refers to drawing, but it's a line that's embedded . . . in paint. It's the line that's left. It's painted, so it works rather like the mortar between bricks. It takes a long time to get these things to work, because in a strange way my formalism is daring. It's very tied to the tradition of painting, but it's also daring because I don't really know if things are going to work out. And again, maybe it's because I'm not very talented that it takes me such a long time to get things to work out. You know, there's something, also, about "firsts" that just can't be beaten. It can be improved upon, but it can never be overcome because it's always going to have something that the subsequent paintings don't have.

NR The freshness of the discovery.

SS I'm tenacious, because if I can't get it to work one way, I get it to work another way.

NR That's what was exciting about *Tetuan* [Plate 49].

SS *Tetuan*, that's the one I backed down from. But I was shamed. I was shamed by *you.*

NR By *me*?

SS By *you.*

NR How was I shaming you?

SS Because you said something very challenging. You said to me, "You should trust yourself." After I changed it. After I calmed down. And I thought, "Shit, I've gotta pick that one up." Well, I got it back. I got it back in my own way.

NR *Narcissus* [facing page] . . .

SS In a way, it's about the same thing: pressure. A massive pressure of these column-like forms, of the architectonic forms. And everything is contriving to put pressure on this, this little area here. And the same thing is happening in *Murphy*. The interesting thing about *Narcissus* is that the massiveness of the forms, the horizontals and verticals, is subverted by the way that they're rendered, because they're rendered with a lot of atmosphere, a lot of paint surface, and very little sense of solidity. That's something that I'm doing all the time, of course, except in this painting it's taken to an extreme point.

NR Actually, I believe it starts in the small bands, you see a lot of staccato, a lot of rhythm in the application. But then in *Angel* you begin to see what I call "traction" of the paint.

SS Well, at the time, you know, I was quite interested in African masks, which tend to have a large area above, which is a forehead, and then the face is a flat plane that's set back below it. That's a typical device that the African mask-makers use in a lot of these paintings, like *Dark Face* [page 15], which was referring to a mask.

NR I hadn't really thought, even with *Dark Face*, of a mask. But it makes a lot of sense. And, of course, I've been in here and I've seen a number of these African pieces you have.

SS My paintings are very much about power relationships, or they're about things having to survive within the competition, composition . . . the composition is a competition for survival. It's interesting that something small can stand up and be in a composition, dynamically, and have to deal with something much bigger. There's a sort of equal relationship there.

NR Is this the beginning of the panel insets?

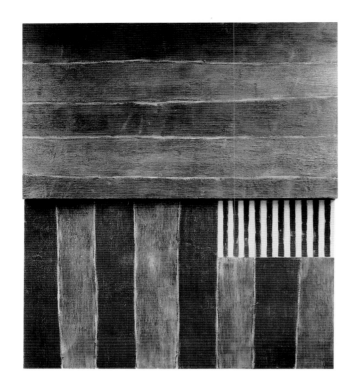

NARCISSUS
1984
oil on canvas
108 x 96 (274 x 244)
The Edward R. Broida Trust, Los Angeles

SS At some point, the insets lose their relationship with the edge of the painting, and it happens first in *Enough.*

NR *Flesh* [Plate 25] from 1985.

SS Sex.

NR Before, you talked about skeletons and . . .

SS This is the opposite. This is all about flesh. Paint always has represented the skin of culture. It's interesting because it has a relationship to this idea of skin, and a lot of my paintings are about different kinds of skin,

different kinds of paint surface—you know, like different whites of paint.

NR Define the difference between "skin" and "flesh."

SS Flesh is overt. It's a magnification of the term "skin." Flesh has aspects of sensuality and sexuality that skin doesn't necessarily have. Skin is a technical term, but flesh, I think, is not.

NR Tell me about the brown rectangle on the lower right.

SS Well, again, it's like, it's kind of like a foot . . . or a step. You know, like, a front doorstep. You've got a huge building, and the front doorstep, and the pressure is brought down on this little architectural element. A foot and a step, it's the same thing.

NR *This, That* [Plate 26] from 1986.

SS It's a similar compositional idea. It's about two elements, "this" and "that," and it's about a contest for survival. Again, it's about the pressure of architectural or architectonic mass bearing down on some other element. A lot of these ideas could be seen as metaphors for human survival in an urban environment. In other words, the physical, sensuous, fleshed-out line bearing down on the fragile drawn line. That was the idea for the painting.

NR Why did you change it? Did the idea not work?

SS There is a difference between the art I was making in the '70s and art I was making in the '80s. It simply wasn't an exciting enough painting. And I think that the idea of the painting was stronger than the painting. So what had to happen was that the painting had to overcome its idea with a reason for being. It's elemental, isn't it?

NR *Empty Heart* [Plate 31] really represents an important change, doesn't it?

SS Yes. In a way it's about a kind of poetic or emotional devastation. The center of the painting, the heart of the painting, is empty. It's barren. There's slightly more color on the outside than there is on the inside; the pinky color on the outside is a little more related to nature than the color on the inside. And the color on the inside is really kind of a ragged Minimalism that also turns in on itself, so it goes nowhere, because it contradicts itself. It's canceling itself out. And it's in black and white. And it's painted in a way that cancels out its own direction—it's going nowhere.

NR It's plus and minus.

SS And it's stuck in the middle of the painting. And it's not colored.

NR Is this when the insets really float or enter into the field?

SS Yes, this is one of the first. This is really very austere.

NR What's going on that informs this painting? Will you elaborate on the title *Empty Heart*?

SS It's got something to do with the inability of abstraction to express certain things. But it's not a celebration of that. It's very austere, but it's not a celebration of its austerity. It's regretful, because it refers to passion—it refers to heart. So it's an austere painting made with melancholy. There's a lot of melancholy in my work.

NR One thing we didn't talk about with regard to *Empty Heart* is that, after *This, That*, you've also flattened the work substantially. There are no projections. In the case of *Empty Heart* there are no joining objects.

SS Very often, when I change direction in my work, or when I make a modification, I tend to make it a kind of a personal manifesto, like I did with *Enough*. And I

take it quite far. And then I allow myself to add again. *Empty Heart* represents a fairly extreme reaction to paintings like *This, That*.

NR So where does *A Bedroom in Venice* [page 45] fit into this equation?

SS Well, the relationships become a lot more dynamic again. You know, by having two insets in the painting of different sizes, the possibility for visual complexity and for variety is heightened. I've got three elements again and, like *Heart of Darkness*, the elements are rearranged; that's so you have a definite background/foreground situation, or you have doorways and windows; and now it refers to architecture, it refers to a bedroom. The title actually was taken from a Turner watercolor, *A Bedroom in Venice*, where he painted the room. It had a couple of windows and he more or less left them as negatives, he never bothered to fill them in; so what he was interested in was the room and not the outside, and the two parts missing were windows.

NR That's not very typical of you to render in a direct way.

SS No, actually, I wasn't; I was reminded of it while I was painting it. I had it in mind; I saw it and I thought, "That's very interesting that he would do that," because his work is so much about making a kind of orchestral sound to my mind. You know, making an atmosphere. And this broke the atmosphere.

NR Your painting is very atmospheric as well.

SS It's extremely atmospheric. The major difference between *Empty Heart*, which has a kind of austerity and refers to austerity—this I would call more melancholy. But, almost, there's a comforting quality to this painting. It's not an aggressive painting, by any means. It's one of my least . . .

NR It's wistful.

SS I was going to use the same word, it's wistful. But it does have a kind of melancholia about it, and it's got an area where the paint is scraped out. And that always represents a kind of negative to me. You're taking away the skin, you're just leaving the vestiges of what once was a painted surface. This is scraped.

NR There's a kind of rawness.

SS Yeah, there's a rawness, and there's a kind of . . . well, it's a sense of loss, because it's scraped.

NR The connection, for me, is Rothko.

SS Oh, no question. He's a huge influence on me. I think if you have Mondrian, if you have Matisse, Mondrian, Rothko, then you've got my work. Those are the three—there are others. But in this century, I think if you put those three together, you can pretty much get my work out of that.

NR And yet, you were talking about Johns and Stella earlier. Why aren't they included in this group? Is it the proximity of generations?

SS No, it's nothing to do with generations. It's just that I don't think that Johns ultimately is an artist whom I can really join with because his work is conceptual. It has the influence of Duchamp.

NR But you cite Mondrian, even though his work is often dry or theoretical in some respects.

SS Yes, but it's about the spiritual.

NR But there's a kind of regimen to that work which I don't think you share, you see.

SS No, I'm absolutely against it.

NR There's a tyranny of that.

SS Yes, I would use the word tyranny. The tyranny of the perfection, the perfectionist.

NR Is your work about imperfection?

SS Very much so. And it's about inconsistency, too.

NR But done in such a consistent way, which is ironic.

SS I have to nurse what talent I have . . . and there have been a number of artists like that—Cézanne is certainly one of them. He referred to himself that way. He said he had "My little thrill," and that's what I have. It's the same thing.

NR *Why and What (Yellow)* [Plate 37] from 1988 certainly shares quite a bit with the earlier paintings. Suddenly your composition has become much more complex again. *Enough* is reborn here.

SS That's why I say there is, on some level, a relationship with Johns. But when you're looking at Johns's work, you are always having to work again with the painting. And there's something interesting about that for me, that with modern painting you can make paintings that require the same degree of attention and are as emotionally complex as paintings from the history of art. And Johns manages to do that, and he's the only one I can think of who really does that, as a major Modernist. And I think there's something of that in my work.

NR The title, *Why and What (Yellow)*, is very provocative —you've already talked about yellow being a color you associate with madness. "Why" and "what"—together they become almost desperate. And the relative activity— almost nervous collision, offset intersections, and things that occur in this painting. What about it all?

SS I think you've read it very well. You've said it all.

NR What is going on between the relative serenity of

Us [Plate 36] and then, not too far after that, this kind of chaotic composition . . . what's going on?

SS There's a massive amount of uncertainty attached to my conviction. I think my sensibility or my world view is about a kind of polarization, and that's what makes these things happen in my work. You see, the work is very even in quality, but some of the emotions being expressed in it, the way I go from one painting to the next, is kind of amazing. I ricochet off. And this is quite a violent reaction to the wistfulness of this other painting, which is probably what it was. Now, with *Why and What (Yellow)*, everything's fractured. It's as if that painting fell off the back of a truck and broke, and I had to put it back together again, but I couldn't remember how it went back together.

NR Well, here's a perfect opportunity to talk about the fact that, while you became an American, during this period you returned to London and took up a new residence, a new studio, and in a sense, embraced the duality of your own existence, began developing more and more activity for showing your work in Europe as well as the United States. Do you experience other dualities? What you once called *This, That* is again presented to us, but now, there are two insets, look at what the insets are in this. One's a painting and one's an object.

SS *This, That* is more assertive; *Why and What* has, as you said, a desperate questioning quality. And the painting is ugly in a lot of ways. I mean it's beautiful-ugly.

NR It's kind of brutal.

SS It's brutal is what it is, yeah. It's a brutal painting, and the red and the blue, for me, represent health in a certain way. The metal panel is something that's aggressive, that's puncturing the picture plane. It's this kind of rusty rot that a metal . . .

NR It's almost like a sign, isn't it?

SS It's almost dumb. It's a dead end, and it's a sign with nothing written on it. It's like you're driving along and you want to go to Lyons and you come to a T-junction, and there's the sign, but there are no letters on it.

NR It's very existential.

SS Yes, well, that's what it's about. It's about abandoning you in the middle of the painting. The whole painting is so directional, and suddenly there's no direction. I put that in this painting because it's aggressive and my reaction to the painting is aggressive. Not only are these forms about ancient architecture, but they're also computer-like.

NR *Africa* [Plate 38], which follows this . . .

SS One of my favorite paintings. It has a smoldering light, and if anything, it's a study . . . it's a study of a claustrophobic plus-minus system that's oppressive, that's humid and oppressive. All those earth colors are literally made out of dirt. And that's why I made the painting out of it. I made it out of rocks and dirt. And that's what these colors come from—ocher and sienna and umber. They're all cheap, because you can make them from here to doomsday and they're never gonna run out. You just take stuff out of the ground, grind it, there's the pigment. It's as simple as that.

NR What about the inset in *Africa*?

SS That's hope. It's a window, in the traditional sense. If you take that window out, that gets back to something like *Slate*. It's monumental and it's the color of the earth. It has light in it, but it's a light of dusk, close to death— the death of the day. In this painting, the window doesn't operate as forcefully as it does in *Narcissus*. But I think this painting has that kind of strange, emotional wallop.

NR After having worked in a flat manner, what's the significance of the stepping back of one of the panels?

SS I wanted to make the insets and what they do more evident. There's another painting that was painted around the time of *A Bedroom in Venice* called *Us* with four insets. I got rid of the physicality and the sculptural stuff to make the insets more evident, and when I went to do this, I was, in a way, bringing together the fractured surface and the single element. *Africa* has got one inset in a field again, so it refers back to *Narcissus*, it refers back to *This, That*, but it's got a fractured field. In a way I'm always bringing things back.

NR Tell me about the title, "Africa."

SS The painting just sort of had the light of dry earth. Really I was referring to North Africa.

NR *Four Days* [Plate 42] seems to be a unique painting.

SS It's actually a painting that's repainted. Or it's a painting that was painted in 1980 that didn't work out. It was about the idea of the narrative—the running narrative, or the idea of the sequential, which brings out an interesting preoccupation of mine. I'm very interested in film, as you are, and I'm interested in the relationship between film and painting, as was Matisse. And if I wasn't a painter, I'm sure I'd be a film-maker. I've often had ideas of making films. And what I love about film-making is the way time can be represented, and the way that location and time and weather and context can be altered in a split second. It's so lean, unlike the theater where you have got to clunk around all these stupid bits of furniture. The other great thing about film is you can represent whispers, which you cannot in the theater, because they can't hear you. This painting is cinematic. The equal nature of the pieces is like film frames. They're all the same size, they're sequential. They just run along. So I tried to paint the painting in 1980 because I loved the idea so much. But I didn't know enough to do it. And then, in 1990, ten years later, I remembered about this painting, and I just wanted to make the painting. It

doesn't have to have any babies, but I find the idea and the resolution of the painting so satisfying.

NR Why wasn't it called "Ten Years" then, rather than "Four Days"?

SS Because painting doesn't have to represent real time. It can represent fictional time, and the thing about painting is it's got enough real slog in it anyway, which makes it antithetical to the modern world as we both know it. The title and the idea for this painting came out of a conversation I had with a friend about a film. The real title of the film is *Four Nights of a Dreamer*, by Bresson, but during the conversation he always referred to it as "Four Days." I was thinking about sequential time and the passage of days. The way that the passing of time sets up a grid in which our lives take place. I worked on these panels literally over about four days, and when they were finished I put them together. They're all exactly the same size, so there's no hierarchy: I wanted to make pure sequence.

NR Would you elaborate on the third panel of *Four Days*?

SS This represents the first time I started to think about checkerboard recently. Although I have to say that the paintings I made in the early '70s—1973 and subsequently—were checkerboard paintings. They're gridded, but they're gridded within a nine-square checkerboard format. Also, there are some other paintings that are with colored bands that are painted over checkered backgrounds. And they started out as checkerboard paintings. I was aware, as I was making those paintings, that one day I was gonna make checkerboard paintings.

NR You were relating the third panel in *Four Days* not only to checkerboards, but also to the vertical triptych of *Italian Painting #2* [Plate 5]?

SS I did three *Italian Paintings*. That seemed perfect,

divided in three. So I made three of them. And at the time I made this, I remembered thinking, "Ah yeah, I could have made a checkerboard painting out of this." And the way I would have done it is this: I would have painted these four panels black and white, separately, and then just put them together, so the checkerboard would have been broken by the physical divisions. It could have been a fantastic painting. And I still might do a painting like that.

NR You always seem to go back to black and white. Before you paint, do you draw on the canvas in charcoal?

SS No, with an oil stick.

NR Like *Heart of Darkness* [Plate 16], *Four Days* is very emphatically read left to right.

SS I got the idea for this painting, and the reason I was obliged to paint it again, was because I got the idea from Chuck [Choset], who was the film critic for the *Boston Globe* at one time. We talked a lot about film and we talked about painting. The beautiful thing about film is that it's like a dream, because it's a celluloid dream, which is why I love film so much. I think it really is very true to the way that we dream, because it's not encumbered by physicality.

NR One experiences film in darkness and it's brought to life, literally. And life and light are synonymous.

SS That's very interesting. And maybe that's the reason I love it so much, because I am terrified of the dark. For instance, when I go into my bedroom in there, there's a lamp next to the bed, so what I have to do is turn on the office light, and then I go to the middle of the room with its pool of light, and then I go to the bed, where there's a little light next to the bed, and I turn that on. Then I come back out, I turn off the office light, I turn off the big light and I've made it to the bed. That's what I have to do if I'm on my own.

NR In *Four Days* the diagonal bands appear. These are unusual in your work. Why is it so rare and how are they used here?

SS The reason I don't use the diagonals much is because the diagonal is everything that is in between the horizontal and the vertical stated, whereas I've come to believe that in my work, the best way for me to represent everything in between is *not* to state it, to capture it by stating the two ends, and somehow imply everything in between. The diagonal insinuates itself, that's another thing. It's an insinuating form. Or it is a form that is not elemental. And my work has become very much about elemental forms.

NR *White Robe* [Plate 44] from 1990.

SS *White Robe* is a response to another painting I made called *Black Robe* [facing page]. *Black Robe* is a Brian Moore book about a Jesuit priest in North America, and about the trials and tribulations of his life. "Robe," as opposed to "skin," refers to materiality, the idea of the material, painting material, or the paint as material— paint representing material or being material. It's not as sexual as *Flesh*. And the other thing I like about this painting is that it's also a response to *Why and What (Yellow)*, but it's not as tortured. I think it's quite a sublime painting, and it's obviously saturated with a kind of light that's bathed in a yellow dawn glow. And the windows have obviously a harmonious relationship with each other, whereas the windows in *Why and What* are discordant and troubling and disturbing. This is a much more harmonious painting, a much more resolved painting.

NR What is going on with the two insets, similar in look but different in size and position?

SS There's a lot of a kind of mirroring or duality in my work, this being the same as that, this being

repeated, or not quite repeated, and this painting is just more of that. In *White Robe*, the two sides of the painting are the same, but they're not the same, because one area is disproportionate in relation to the other. This field is not in proportion with the rest of the painting, so there's a disturbance there and the two sides of the painting are perhaps the same, or made out of the same material, but then there's a slightly strange thing going on with proportion. And there is in all of these plus-minus paintings. So I see the paintings full of positives and negatives. They're really about contradictions. The surface is about contradiction with positive-negative energy. But the painting has a kind of calmness about it in relation to some of the other ones, or in relation to *Why and What*. It has, however, a certain kind of dynamism. I think pure symmetry is entirely uninteresting.

I wanted to be active rather than passive. And I find perfection in pure symmetry very passive and pacifying. I just don't think it's of much use; it's never been of much use to me. It's like something that you appreciate. I don't want to make a painting that somebody just appreciates. I want to make a painting that really somehow empowers the person looking at the painting. It can be through provocation. It can be through the possibility of failure. I think in my paintings there's a possibility of failure in a lot of them, which I find interesting.

NR How does this relate to *White Robe*?

SS I don't think that *White Robe* is about the possibility of failure. I think it's too secure. It's about the possibility of perfection, but it's not quite perfect. But it approaches a great level of resolution.

NR How then do you read the insets?

SS I see them as a materiality in light, and I see the drawing in it as something that's like an argument reinterpreted, as a structure reinterpreted. They are, in

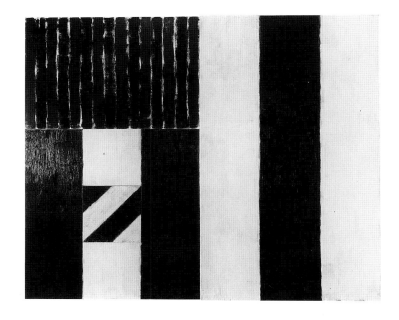

BLACK ROBE
1987
oil on canvas
100 x 120 (254 x 305)
Museo Nacional Centro de Arte Reina Sofia, Madrid

fact, just about the same proportion as the rest of it, or they could fit in with the rest of it. They're painting in the negative, so they return to the drawing idea.

NR *White Robe* impresses me as a culmination painting.

SS This is a painting where I was sure of myself. I could make a lot more paintings like this, and I sometimes wonder whether I should or shouldn't be doing that. The idea of making many masterpieces. This is a big question mark for me.

NR Because of the fear of imitating yourself?

SS Yes, the reluctance to cash in on your own advances. So I tend to move along, and then I enter into a period of achievement, and this would be in that period.

NR *Facing East* [Plate 45] is a very different painting from the following year, 1991.

SS Like *Why and What (Yellow),* this painting is full of questions.

NR A smaller picture, I think the only one in this show where you use a steel panel as a field. This painting has got so many different things about it, it seems like an experiment.

SS Well, this is a language painting. Basically, what you've got is two sides, one echoing, contradicting the other. It's a painting that is really questioning the identity of the component parts, so there are stripes on the left making the whole field, and the stripes on the right in the window, an echo. The stripes on the left are of course different. They're oriented differently. And then there's another kind of relationship going on that has a kind of equivalency, between the steel, which is solid material, and the red, which is solid material, but a different material. One is made one way, one is made another way. So I think there's some sort of poetic relationship between these four elements in the painting, so that they somehow coexist together, and they question, affirm, and question each other's identity. So this is really about language, it's about identity.

NR As in our discussion earlier, the mask-like quality comes across in this painting.

SS With the two eyeballs.

NR *Facing East,* and the facing is, of course, more than looking a certain way, it's also the facing of a building.

SS Yes, and it could, well, if you're facing . . . it certainly can involve your whole body.

NR The use of "east" in the title implies . . .

SS Europe—I was painting in New York and I was thinking about Europe when I painted it. I was thinking about making a painting with what has been called recently an American iconography which is, in fact, not an American iconography, it's a Russian iconography. Gray steel represents the East and the Iron Curtain. Steel factories. It's not a technological culture, it's an industrial culture. It's a late-nineteenth-century, early-twentieth-century culture, in relation to the West.

It's more about things going backward and forward, but it's definitely about different zones . . . it's about changing zones, you know, going from one reality into another reality. It has something to do with Malevich. I was thinking also about that, definitely. So I remember I had him on my mind when I was thinking about that red square.

NR What about the actual painting, the putting down of the paint?

SS It's agitated in there. Frenetic, yet kind of feathery. There is a kind of uncertainty about it, a certain fragility about it.

NR Why did you choose to use the steel? Not in this painting, but in general.

SS Well, it has something to do with the idea of a frame. A frame seems to do two things: it seems to protect, but it also isolates. And it also incarcerates. I mean, it's an aggressive material in relation to the paint. And it's an industrial material. And I'm using a culture material, and it's getting us back to my conversation earlier about skin. What is the meaning of that skin? What does that skin represent? And steel represents armor, especially gray steel, it represents armor, it represents industry, it's aggressive, and at the same time, it's very beautiful. So it has this kind of duality about it.

NR It also formally relates to Minimal art, again.

SS It relates to certain kinds of Minimal sculpture.

I haven't really seen it used in painting before. But this is a frame from somewhere else. And this isn't really a frame that one would use if one wanted to beautify that little panel. This is an overpoweringly large frame, which dwarfs the inset and challenges its existence.

NR Can you discuss *Uist* [Plate 46] and explain why it is important?

SS This is one of the first checkerboard paintings to work out. It has a relationship to *Africa*; here, the light is on the outside and night is on the inside.

NR It's also a smaller picture. At some point in the early 1990s, you started to make a lot of smaller works. What motivated this?

SS There was a period in the early '80s where I made very small works—little works on wood. They were tiny paintings. And then in the mid-'80s, I made some paintings that were about 24 inches [60 cm.] square, and they were all square paintings. And these paintings were the first ones that I was able to make that weren't miniatures, that were small paintings that could stand up in their own right with the big ones. I started to make them at about the time I introduced the checkerboard. I made several of these paintings, and they allowed me to get to bigger paintings that have checkerboards on them.

NR And *Uist*, what does that refer to?

SS It's an island. All the small paintings are named after islands.

NR Is *Tetuan* [Plate 49] actually the first of the big checkerboard paintings?

SS Yes.

NR What does the checkerboard signify?

SS The checkerboard and the stripe are ways of breaking up space, of locating space. And it also relates

to the idea of a game board, up there, as well, where things happen. And the grid . . . it relates to many things. It relates to the wall.

NR Within the squares, there is opposition and direction.

SS Yes, there's opposition and turbulence and struggle within the shape, so the shape becomes an opportunity for the self to assert itself more. Within each square, the relationship between the brushstroke and the motif is anarchistic, as it is with all the checkerboards. Each checkerboard, now, could be seen as an "all-over" painting. Each one of these squares could be a painting. But when you make a stripe, the stripe follows the form. Or at least it does in my work. But when I make checkerboards, the paint can go anywhere.

NR I've been very conscious of that ever since I saw the first version of *Tetuan*.

SS It's very significant. The shape, the structure itself, no longer provides a direction. The stripe provides the direction and the shape. Therefore, the way it's painted has to do really with giving you a kind of sexuality, an identity, and a physicality.

NR What is the sexuality involved here?

SS It's the way the paint's put down. When you paint, it's got a lot to do with your sexuality, your identity. It certainly does in my case. And when the shape does not provide direction, then the sensuality has to provide its own direction, so it becomes disconnected from the shape, so the possibility for expression and interpretation in the way that the shape is painted becomes, in fact, more *act*. So what's happened is that the balance of power within the work has changed. The checkerboard is quite significant in that respect.

NR You have been making checkerboard paintings and steel frame paintings at the same time. Could you discuss these as concurrent methods of painting?

SS In *Facing East*, or any of the metal ones, you have a greater sense of placelessness. And when you break the motif, then you really have two elements with different natures, and one is stuck in the middle of the other, so it doesn't have that kind of brother-sister relationship that the stripes have to each other. This would seem to go on at the same time. So there's much more, there's a much stronger sense of the self, I think, being cut adrift.

NR When you first did *Tetuan* (repainted twice, actually, so it dates 1991–93), having done *Uist* previously, what was the experience of painting this?

SS It was painted just after I made a film on Matisse, and Tetuan is the name of the town where Matisse painted, in Morocco. So I was thinking about Matisse, and I was thinking about the decorative or the ornamental, so one can also see this as a floor with a mat on it.

And I did another one at the same time called *Mata-Mata* [right], its sister painting, which could again be seen as a floor with a mat on it. Mata-Mata is also a city near Tetuan which I visited at that time, and I was thinking a lot about that, about walls, blankets, one thing on another thing. And there is the thing about the self, too. But then, the nature of something, and the way something is painted, has very much to do with the self, the human, the human being that painted it.

Now, *you* said something interesting about this painting, and this painting also involves real loss because a yellow square is actually missing. And that never happens with the striped paintings. The remnant of the stripe is there. Might be just a little bit of what's left on the end, but here we've got an entire shape that's missing.

NR And there's something upsetting about that.

SS *Spirit* [Plate 53] is an interesting painting for me because it's so intensely physical and what it refers to is something that has nothing to do with physicality. But to quote John [Caldwell]—he was writing about my work

and he said my work was curious in that it was about metaphysical matters, but nobody had attempted to do it with such physicality before. And I think that's something that runs through my work. In other words, I believe, probably, that you get to the spirit through the physical, or through the sensual, or through being in the world.

NR The horizontal repetitions of these forms . . . it's tempting, as it has been in earlier works of yours, to talk about ladders that you can climb on.

SS That's right, you've used that term a lot, you've referred to them as ladders. I'm glad you brought that up, because they could be seen as staircases. Flattened out staircases or ladders. In other words, vehicles for

MATA-MATA
1991
oil on canvas
84 x 110 (213 x 279)
Private Collection

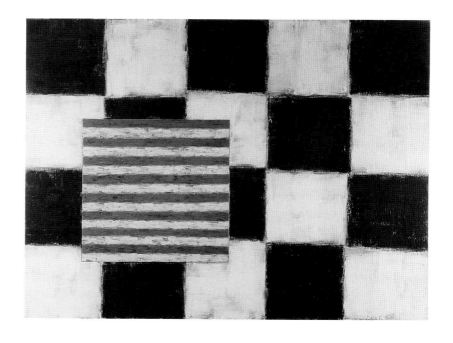

ascension. And that's a very interesting and true point, especially when you get one that's quite compressed in width. I mean, you really are getting something that is like a ladder.

The other thing that strikes me about *Spirit* in particular is that they're like tablets, because of the way that they're set in like Egyptian tablets, or you know, when you go down to Mexico to the Yucatán and you see these stones and they're just set into the ground, set into temple walls.

NR I was going to ask you to use this opportunity to talk about your use of black and white. You're always exploring the range of that, and I wonder what that signifies for you, because here, in *Spirit*, you've got the warmth of the steel and you've given it some life, through its own organic change. What is the black and white? You come back to black and white all the time, so how is it for you? What does it represent?

SS It's the absolute color equivalent of the horizontal and the vertical. So when I'm doing something in black and white that's horizontal and vertical, I am at my purest. I am at my most fundamental, my most unworldly, probably, my most unsensuous, and perhaps, my most spiritually ambitious, as with *Empty Heart*.

NR I always feel that it becomes more conceptual, but it may be more spiritual, also.

SS It becomes absolutely divorced from the sensuality of color in the world, the sensuality of nature. And indeed, it does become more conceptual, but then that may be a way of making it more spiritual.

NR Let's go back to *Spirit*. Here you have three different "tablets." The left panel has this floating ladder or staircase, the second panel has these four verticals; and then, last, again, if you read it left to right, you end with a full panel, which you originally didn't have. Why did you change it? And what was it originally?

SS Originally, it was three steel panels with three painted panels set into it. And at another point, the steel panels were separated. So, as I worked on the painting— and the painting took a very long time to make—I started to put the pieces together; and once I put them together, then I started to want more interaction between them. So, the relationship between the idea and the actuality of the painting, or the resolution of the painting, starts to become quite interesting at a certain point. On this painting, as it matured, it deviated from the original idea and started to make an idea of its own, the idea of something that could be read like a page in a book or a tablet, and ending up with a change of identity, life. It also has something to do with the idea of pregnancy full-blown and the actualization of an idea, the realization of an idea.

Now, the white is what I would call distressed white. And the black is never really quite pure black, you know, it tends to be a little more brown, or a little more blue, and all that black, using black as a color, comes out of the black paintings that I made. But the answer to that, I think, is very simple. The reason that they're not absolute in their whiteness or blackness is because I do not make absolute paintings. I'm against the idea of absolute painting.

NR *Stone Light* [Plate 54] has been extensively discussed in Armin Zweite's essay. However, I think it's important for you to talk about this painting. You've alluded to *Slate* before.

SS Yes, well, that's what happens with my work, that there's an endless process of cannibalization and recycling and reinterpretation and material being reused, over and over and over again.

NR The title *Stone Light*, as I recall, is a contradictory kind of thing. I mean, there aren't any stones that give light *per se*.

SS I was really thinking of the kind of light that you get in semi-precious stones which I think is stunningly beautiful—there's something profound about it. It's a light that has a certain nobility, or a solidity, which is what we can't have, because we ourselves don't have solidity, and we live in a world of water, and we see light and we have light around us. We've even worshiped light as a species. But we've never been able to have a light that's solid, and in a sense, that's what that alludes to: a light that's solid.

NR What is the allusion of the red?

SS It's another zone. It's a change from purity and the idea of the abstract, it's black and white again, and at my most conceptual. And then I . . . instead of following it through all the way, like I do on *Hammering* [Plate 23], I return to the world of blood. Stone. It's six huge checkerboards, isn't it? Six huge areas. These also make a triangle.

NR Do you see *Gabriel* [Plate 55] as a spiritual painting?

SS Oh, incredibly so, yeah. And you know, Gabriel is also one of the archangels whose sexuality was supposed to be up in the air, though she was probably female. I was thinking about the sound, the pure, clear sound in the air, and I thought *Gabriel* was a beautiful title for it. It's a very harmonious painting, and it's a painting that's about a kind of ravishing beauty, and it's meant to be delicate and monumental.

NR *Magdalena* [Plate 56] is one of the most ravishing paintings you've ever made.

SS Around this time, the paint has become very gentle, and they're very fleshy, creamy, milky, sunlit, pale, and they tend to be non-threatening.

NR Do you not believe that some of this back and forth dialectic in your work has to do with your own emotional state?

SS Oh, it has everything to do with my emotional state.

NR Is it compensatory or is it reflective of it?

SS I think it's reflective of it.

NR *Magdalena*, on the other hand, is a name that's associated with sublime agony.

SS The whole thing about these paintings with double insets, I gave them all names of women. I thought of them as quite figural. And there's *Mariana, Helena, Eve, Petra*.

NR Are those real people, any of them?

SS No, they're archetypal names, they're names that are in history, although Helen was my grandmother. . . . I always wanted to make a painting for her, because I loved her so much, admired her so much. And I changed it to *Helena*, so I turned it into a kind of archetypal name. It's the female within myself. It's painting something that has a kind of feminine aspect to it.

NR Part of the double idea?

SS Yes. There's a lot of things that I can continue at the same time in my work. It doesn't bother me at all that there are several strains to my work.

NR *Ukbar* [Plate 58] is one of the selections from 1993–94. Now what does the name refer to?

SS It refers to a place that doesn't exist. It's in Borges's *Ficciónes*. It's an essay and it's called "Ukbar." It's about a search, it's a story of real and non-real, actual, fictional searches for a fictional place, and so reflects a place that may be fictional. So it's all about uncertainty. It's all about the reality of uncertainty. And I think that there's a lot of that in me and there's a lot of that in my paintings.

NR *Ookbar* [facing page] was painted before *Ukbar*. Tell me how one painting generates another and what

OOKBAR
1993–94
oil on canvas
96 x 144 (244 x 366)
Collection of the artist

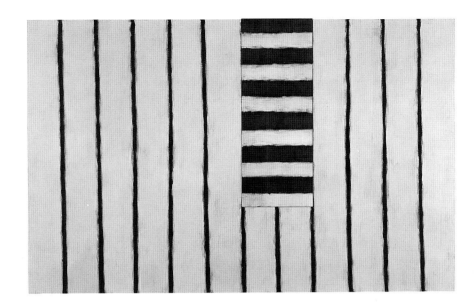

their relationship is, because this is not unusual for you —to create things that are close and yet different.

SS No, I very often do that. And usually it's to do with what I consider to be the inadequacies of the first, or the unanswered questions of the first. With the first painting, *Ookbar*, I felt that it would be interesting to make the relationship between the ground (or the large area) and the figural element dropping in from the top more extreme. So that would mean, obviously, making the area that drops into the painting more solid, and making the rest of it more fragile. So I made the color more uncertain and I made the lines more uncertain, because you'll find those lines, the lines on *Ukbar*, are narrower than they are on *Ookbar*, which is more robust. It's a more frontal, convinced painting. I don't mean it's a better painting, but there's more range in this painting.

NR What color is *Ukbar*?

SS It's a kind of pale, gray, green, yellow.

NR Describe for me the relationship you have to your working on paper.

SS I'm very interested in the way something can be manifested differently according to its physical nature, according to the technique with which it's rendered. I think that has a profound effect on the image, and what the image means. The pastels, those big pastels that I make, are very monumental. And they have a dryness. The material is pressed into the paper over and over and over again. Behind glass, they're blurred, they're indistinct. They have a physicality, but they have the physicality of powder . . . or chalk, whereas the paintings are shiny, inherently shiny. In other words, a pastel doesn't really have a skin. It's full of air. You know, a pastel, one doesn't get the sense with a pastel that it has an outer skin, that it has a beginning and an end. It seems, well, it's powder, so one is chasing its outer and inner extremities when one's looking at it, because you don't really know where it starts and where it ends. But with the skin of oil paint, you do.

And the watercolors are about the extreme absence of physicality. They really are as close as a painter can get to pure light, an effortless, physically effortless vision. And that's what's really interesting about them to me. I like them because of their extreme relationship to the paintings.

NR Yet they're also a laboratory for you to try ideas out, because you can envision from those things, can't you?

SS I can put down many ideas very quickly with the watercolors. And also with the watercolors, you know, you can give it a kind of monumentality. Some of them look like visionary paintings. But I think the idea of the lack of physicality in the watercolors is crucial to their nature, that the white paper is shining through the watercolor the whole time. And it's pure pigment, it's pure pigment suspended in a small amount of gum arabic and it's floated onto the paper.

The paintings have to have their own life. You can answer some questions with a watercolor, or you can get a reason to start with a watercolor, or with a pastel, or with a little line drawing. But that won't take you the whole way. You know, painting at a certain point is going to have its own identity and its own place in the world, in its particular size and shape and everything. Now, the watercolor for *Ookbar* is really pretty close.

NR Tell me one more thing about *Union Grey* [Plate 62]. As much as you enjoy your paintings, I always get the feeling that you get very excited when you look through the watercolor books.

SS Well, the watercolors are very, very personal to me.

NR Also less laborious, I would think. There's got to be a labor of painting a canvas that is eight feet square, and it's physically demanding.

SS It's very physically demanding.

NR In the show, *Union Grey* thus far is the only major painting that's purely checkerboard.

SS Now this painting relates to *Magdalena* in that respect. It's awash in its own fragility. What's interesting to me about this painting is that the right side of the painting is almost helpless. It has a helplessness about it. It's starting to come apart.

NR You know, it comes back to that vertical diptych. However, I see this as a painting that is not about serenity, but is about something slipping away, as you described it.

SS Yes. It's about the fragility of the structure. I do see it as two panels, I do see it as a different kind of light, one side to the other.

NR Characterize one or the other in terms of light.

SS The one on the right is a silver light. And on the other side, you get a stronger sense of night. I don't see it as pessimistic. I think it's extremely risky, in relation to my other paintings, structurally. But there's a certain comforting that one requires, in order to be that risky. It's not all about weakness.

COLOR PLATES

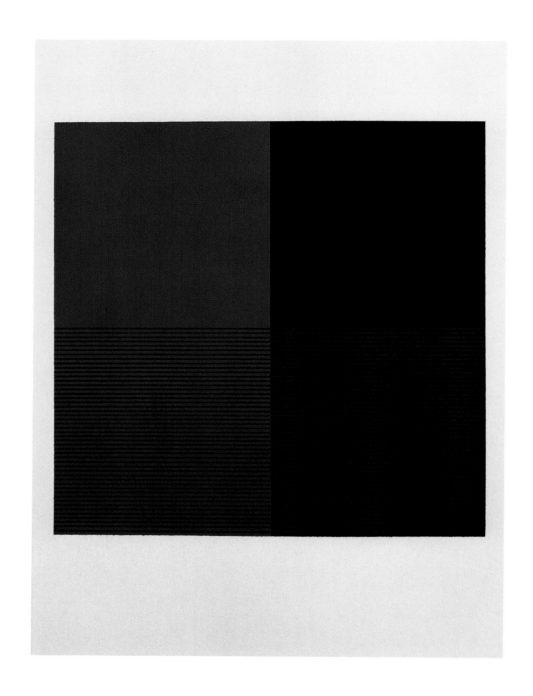

1 UNTITLED
 1976
 gouache on paper
 30 x 22¼ (76 x 56)
 Collection of the artist

2 HORIZONTALS: THIN GREYS
1976
acrylic on canvas
36 x 36 (91 x 91)
Collection of the artist

3 BLUE
1977
oil and alkyd on canvas
48 x 36 (122 x 91)
Collection of the artist

4 REVERSED DIPTYCH

1978
gouache on paper
30 x 22¼ (76 x 56.5)
Collection of the artist

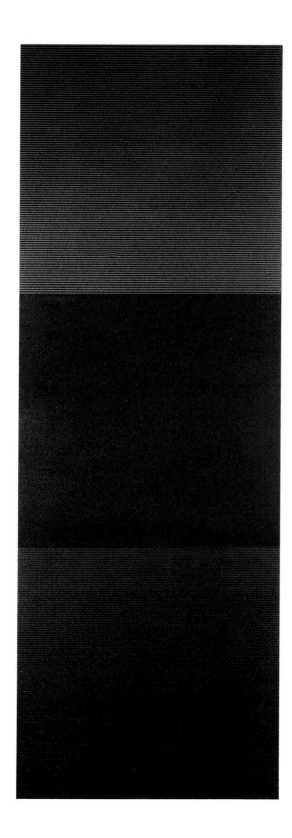

5 ITALIAN PAINTING #2
 1979
 oil on canvas
 84 x 28 (213 x 71)
 Collection of the artist

6 BRENNUS
 1979
 oil on canvas
 84 x 84 (213 x 213)
 Collection of the artist

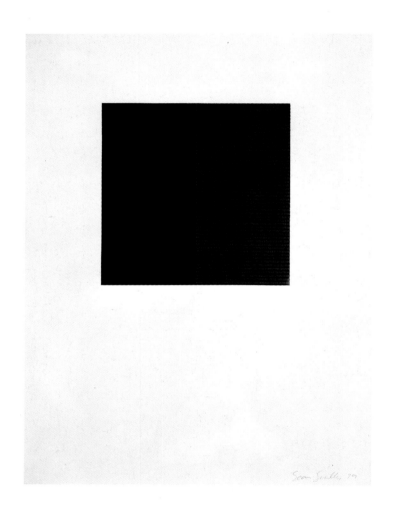

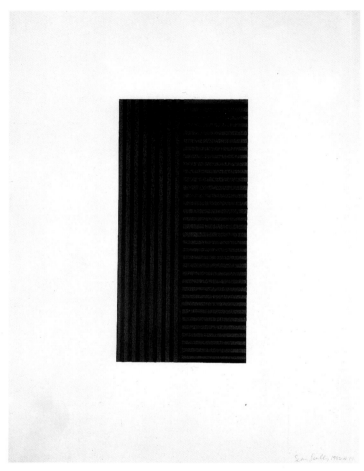

7 UNTITLED
 1979
 acrylic and paper tape on paper
 30½ x 22½ (77.5 x 57)
 Collection of the artist

8 #17
 1980
 graphite on paper
 29½ x 22 (75 x 56)
 Collection of the artist

9 SLATE
1980
oil on canvas
108 x 48 (274 x 122)
Collection of the artist

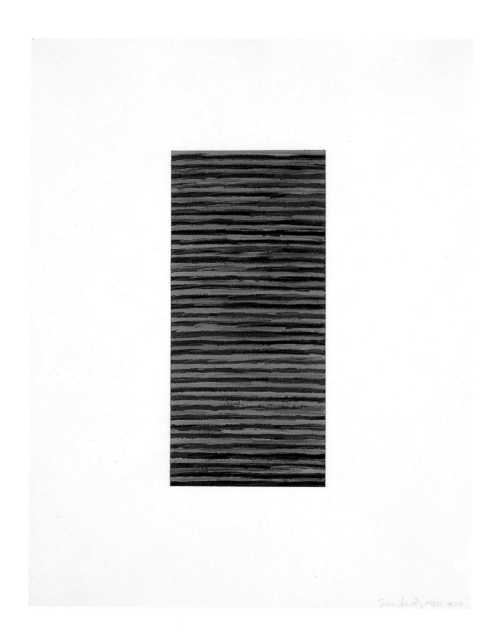

10 #29

1980
oil on paper
30½ x 23¼ (77.5 x 59)
Collection of the artist

11 81#6

1981
charcoal and chalk on paper
30½ x 23½ (77.5 x 59.5)
Collection of the artist

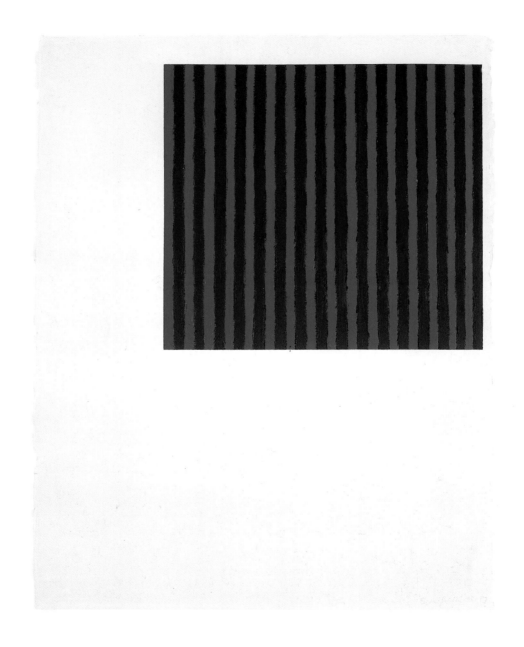

12 P. 7
 1981
 oil on paper
 30½ x 23½ (77.5 x 59.5)
 Collection of the artist

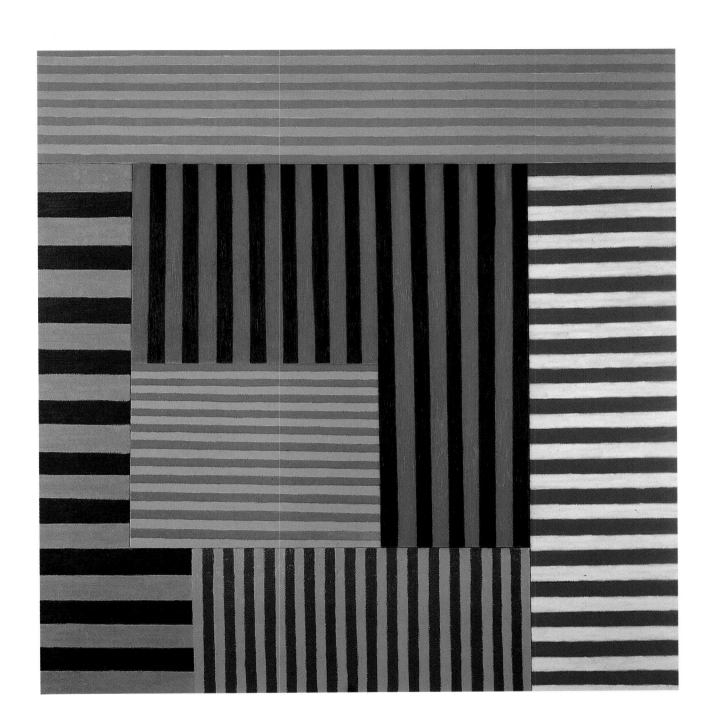

13 ENOUGH

1981
oil on canvas
67 x 65 (170 x 165)
Collection of Mellon Bank Corporation, Pittsburgh, Pennsylvania

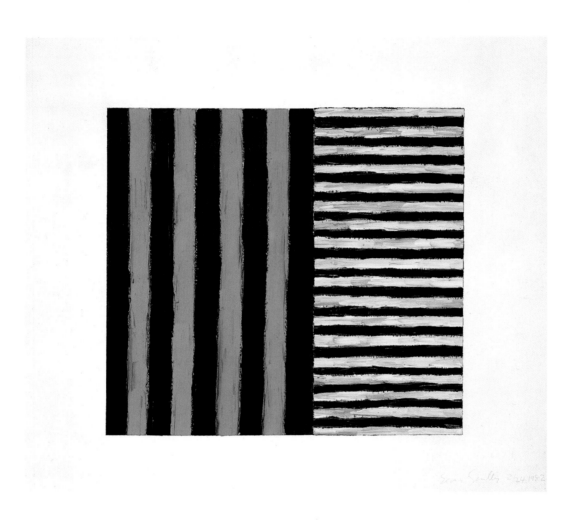

14 2.24.82

1982
oil on paper
26 x 28½ (65.5 x 72.5)
Collection of the artist

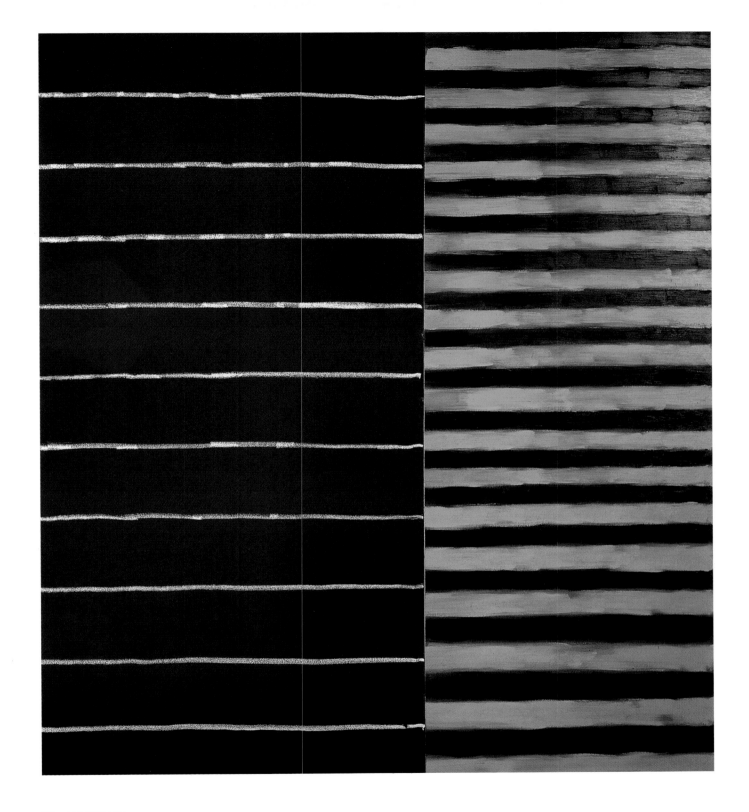

15 ANGELICA

1982
oil on canvas
96 x 84 (244 x 213)
Collection of Judith and Mark Taylor

16 HEART OF DARKNESS
1982
oil on canvas
96 x 144 (244 x 366)
Art Institute of Chicago, Gift of the Society for Contemporary Art
(Washington and Atlanta only)

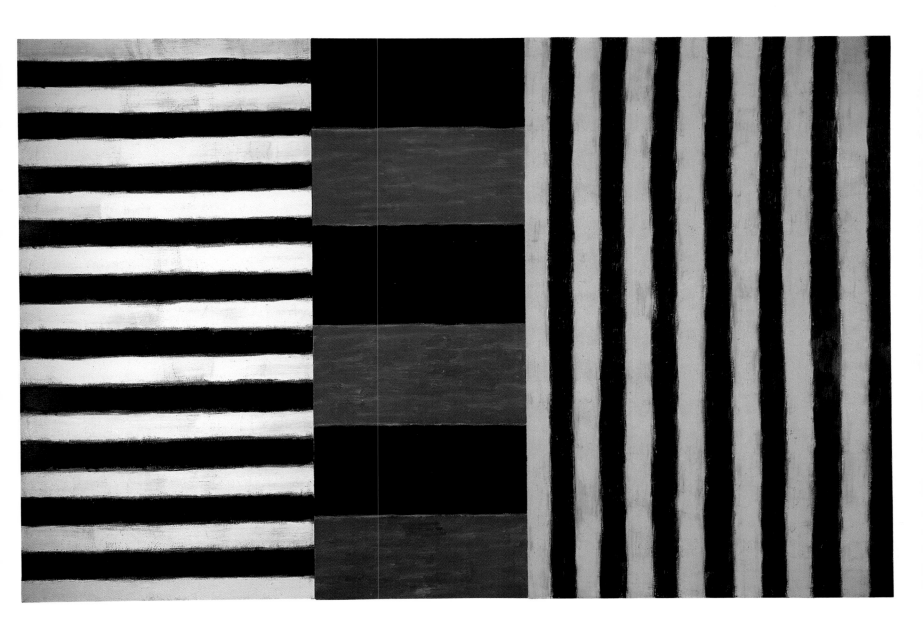

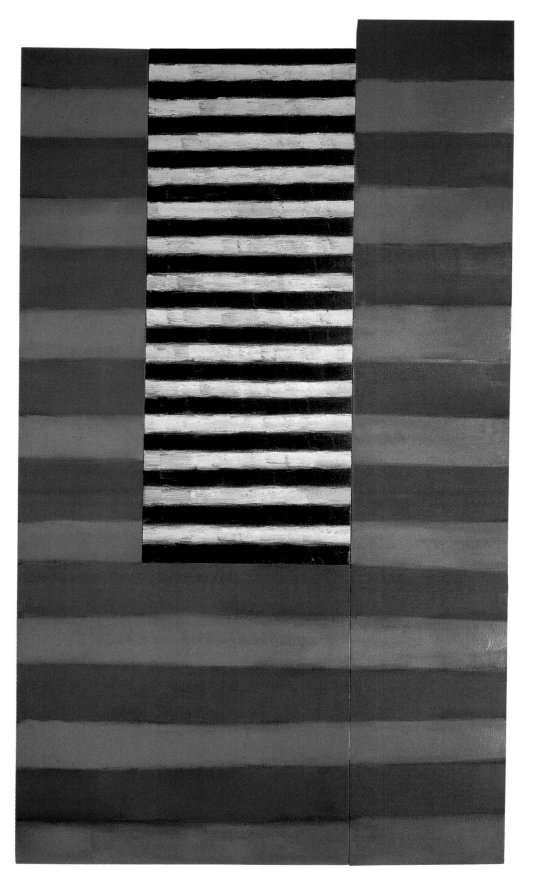

17 THE MOROCCAN

1982
oil on canvas
112 x 63 (284 x 160)
Beadleston Family Collection
(Barcelona and Dublin only)

18 9.3.83

1983
oil crayon on paper
15 x 21¼ (38 x 54)
Collection of the artist

19 ANGEL
 1983
 oil on canvas
 96 x 108 (244 x 274)
 Beadleston Family Collection

Sean Scully 11 20 83 #2

20 11.20.83 #2
1983
oil pastel on paper
30 x 22¼ (76 x 56.5)
Collection of the artist

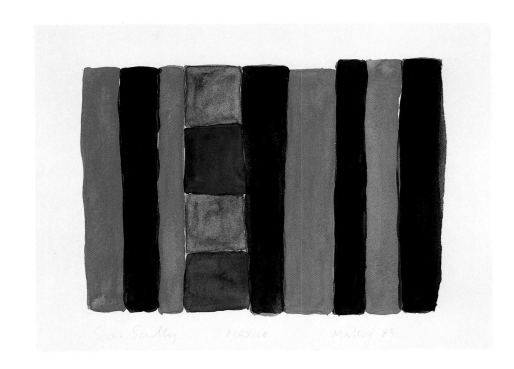

21 MALLOY (MEXICO)

1983
watercolor on paper
9 x 12 (23 x 30.5)
Collection of the artist

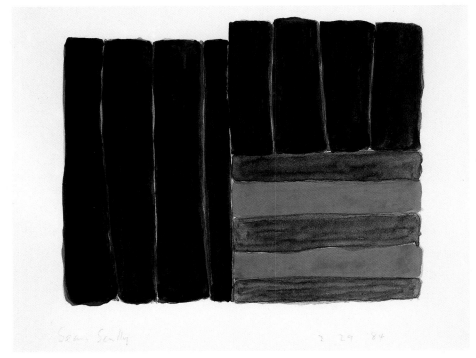

22 2.29.84

1984
watercolor on paper
9 x 12 (23 x 30.5)
Collection of the artist

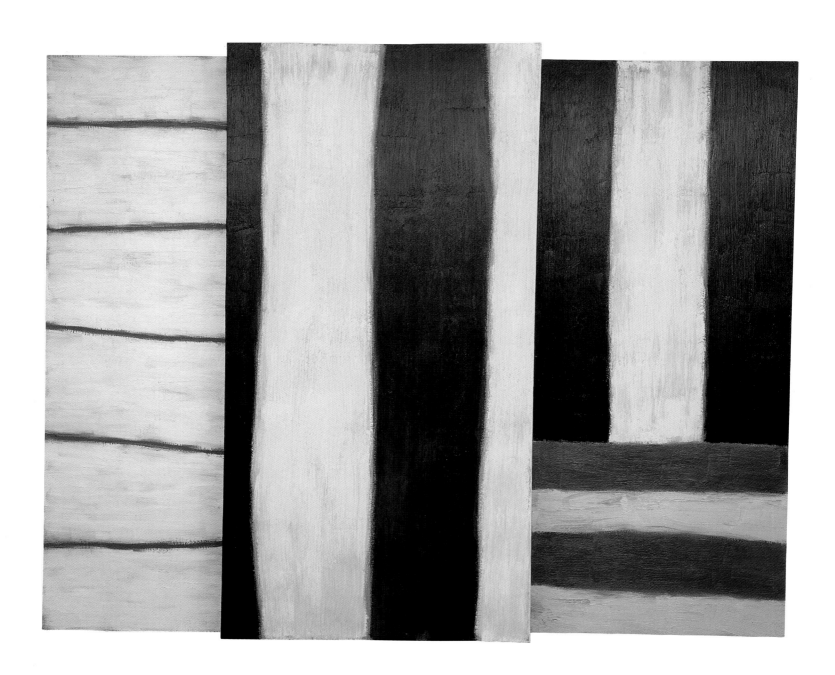

23 NO NEO

1984
oil on canvas
96 x 121 (244 x 307)
Collection of Bo Alveryd, Switzerland

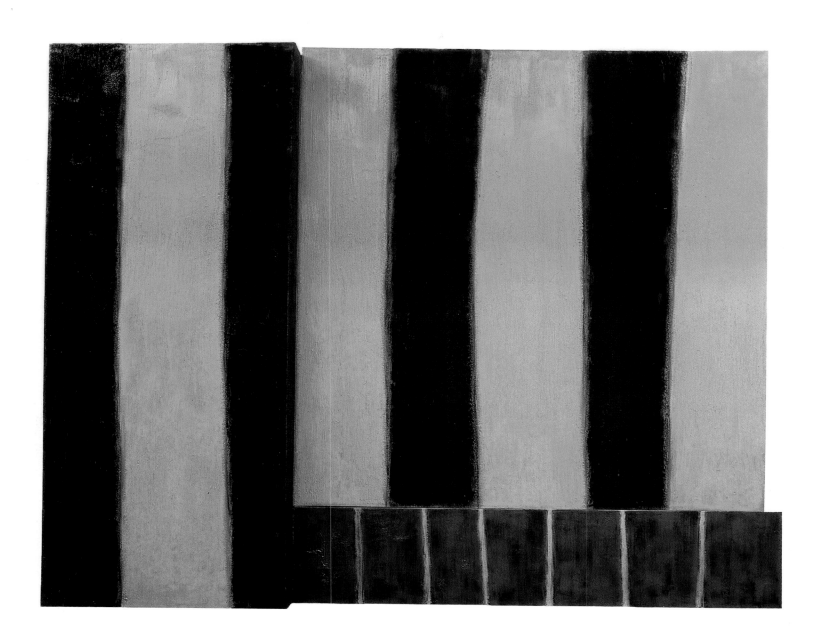

24 MURPHY

1984
oil on canvas
96 x 120 (244 x 305)
Collection of Cindy Workman

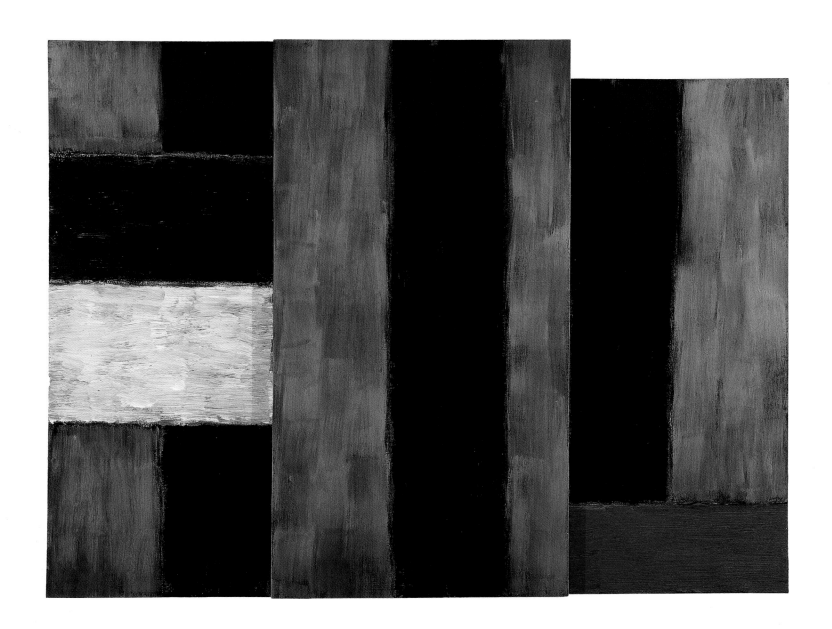

25 FLESH
 1985
 oil on canvas
 96 x 124 (244 x 315)
 Collection of Tom and Charlotte Newby

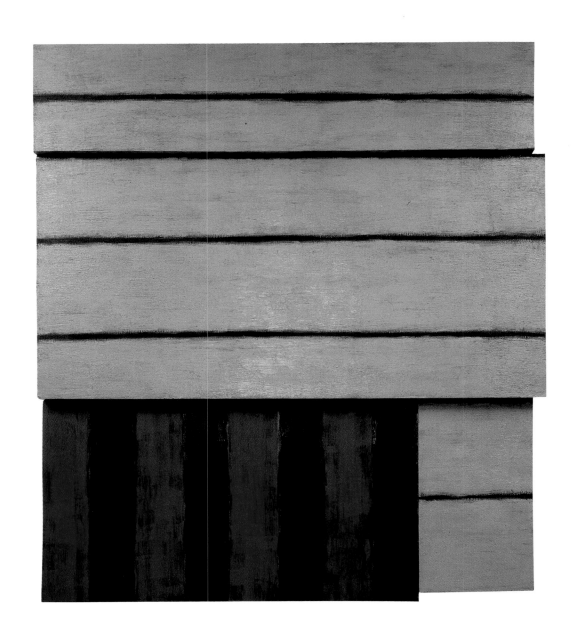

26 THIS, THAT
 1986
 oil on canvas
 114 x 96 (290 x 244)
 Städtische Galerie im Lenbachhaus, Munich

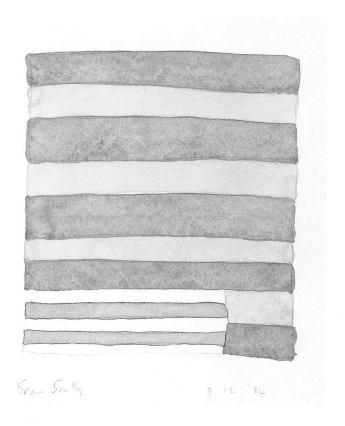

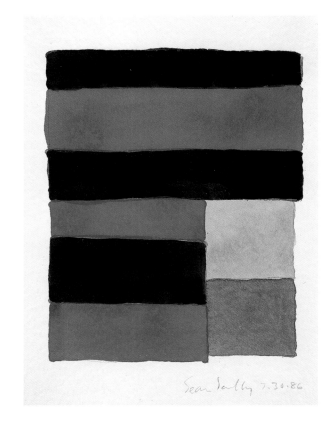

27 3.12.84
1984
watercolor on paper
12 x 9 (30.5 x 23)
Collection of the artist

28 7.30.86
1986
watercolor on paper
14 x 10 (35.5 x 25.5)
Collection of the artist

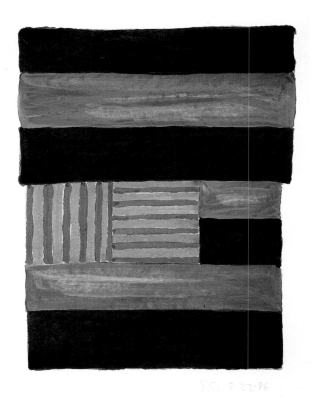

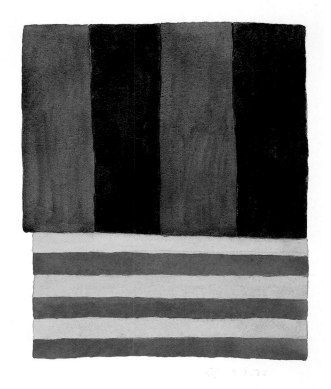

29 8.22.86

1986
watercolor on paper
14 x 10 (35.5 x 25.5)
Collection of the artist

30 9.1.86

1986
watercolor on paper
14 x 10 (35.5 x 25.5)
Collection of the artist

31 EMPTY HEART

1987
oil on canvas
72 x 72 (183 x 183)
Collection of Bo Alveryd, Switzerland

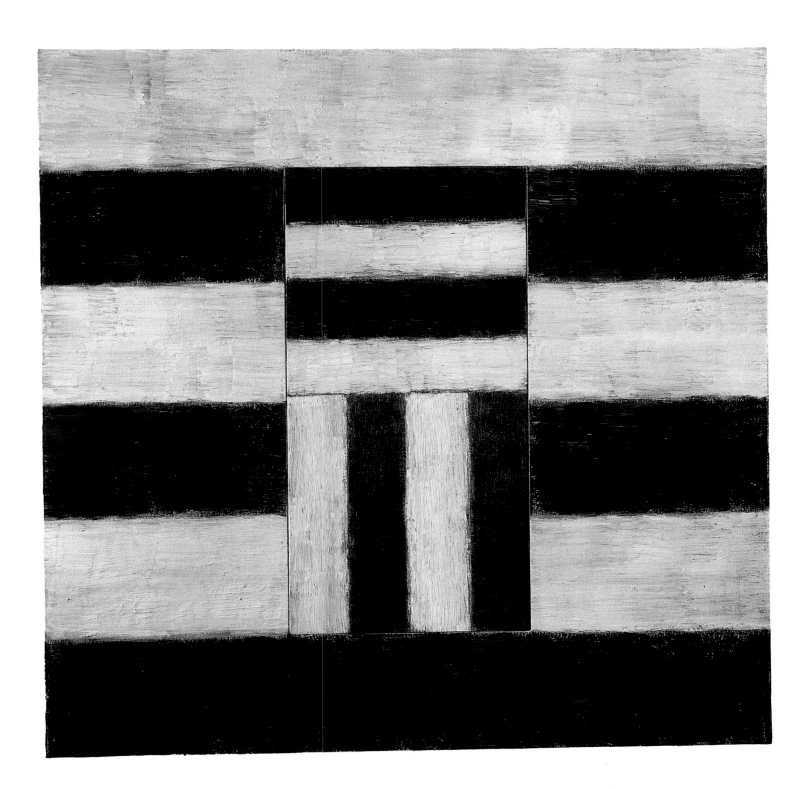

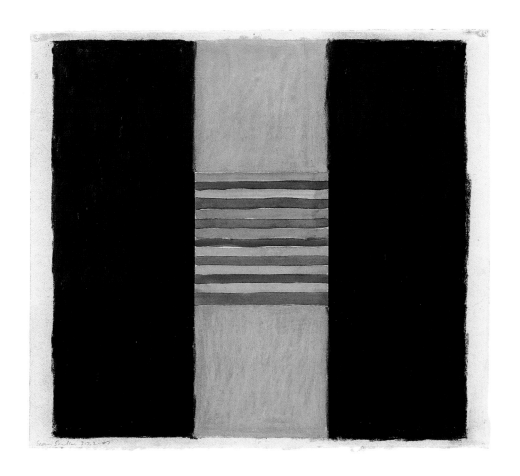

32 3.22.87

1987
pastel and watercolor on paper
22 x 23½ (56 x 59.5)
Collection of the artist

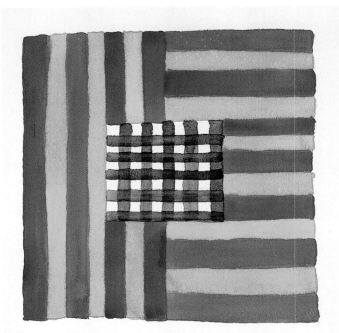

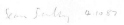

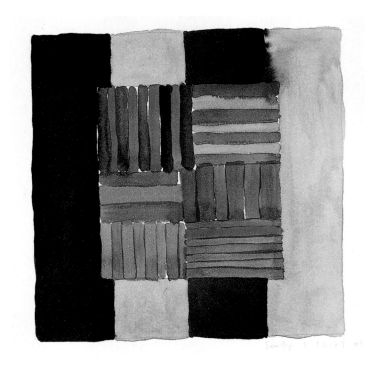

33 4.10.87
1987
watercolor on paper
12 x 16 (30.5 x 40.5)
Collection of the artist

34 5.22.87 #2
1987
watercolor on paper
11 x 15 (28 x 38)
Collection of the artist

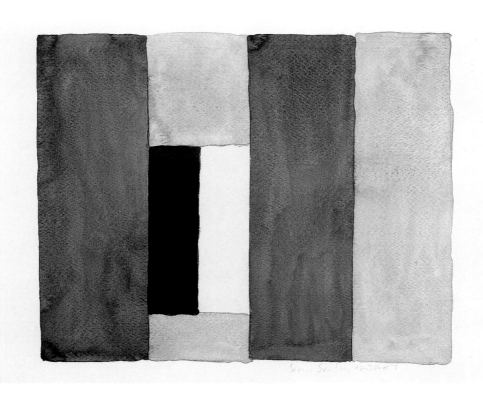

35 10.30.87

1987
watercolor on paper
12 x 18 (30.5 x 45.5)
Collection of the artist

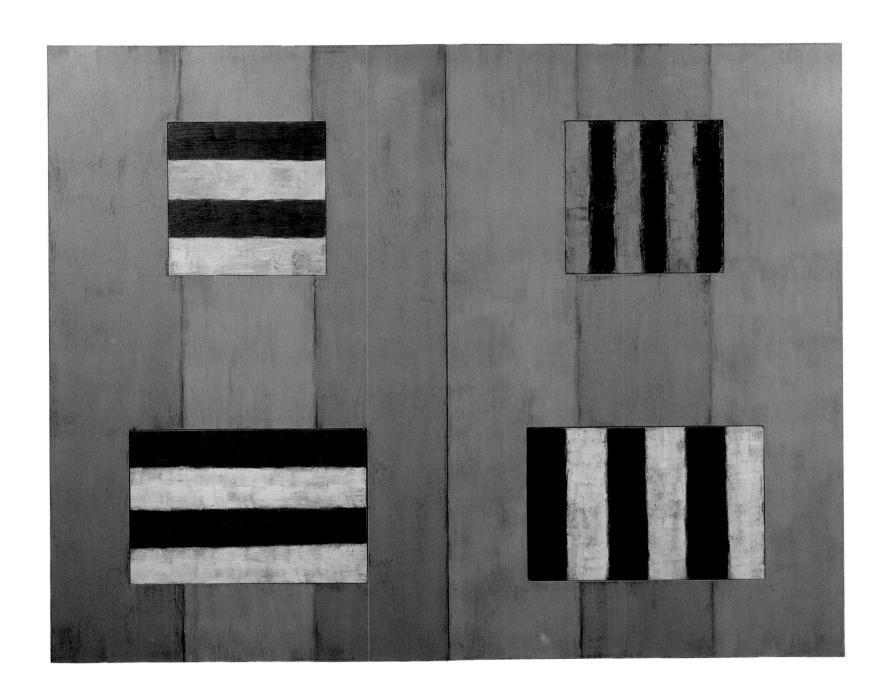

36 US

1988
oil on canvas
96 x 120 (244 x 305)
Collection of PaineWebber Group Inc., New York

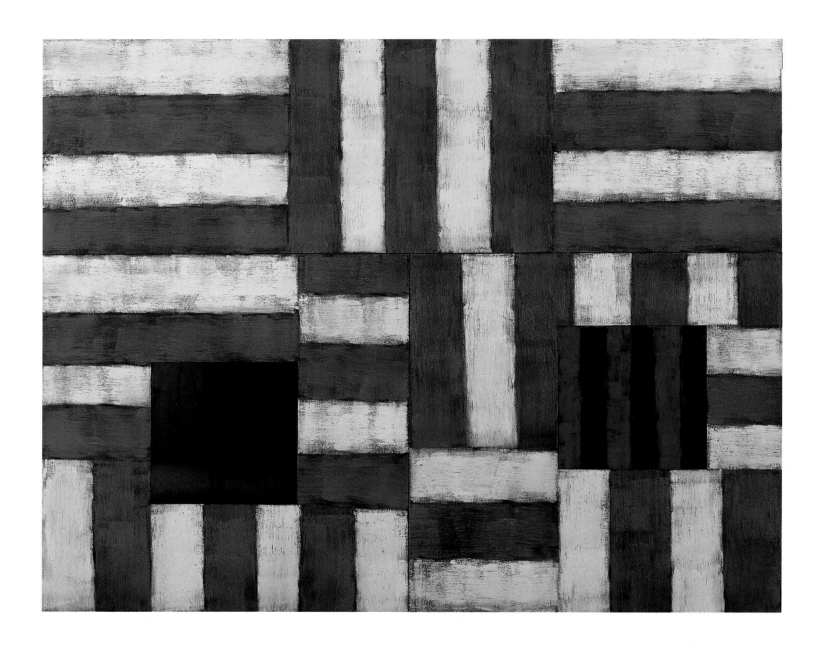

37 WHY AND WHAT (YELLOW)

1988
oil on canvas and steel
96 x 120 (244 x 305)
Hirshhorn Museum and Sculpture Garden, Smithsonian Institution, Washington, D.C. Holenia Purchase Fund

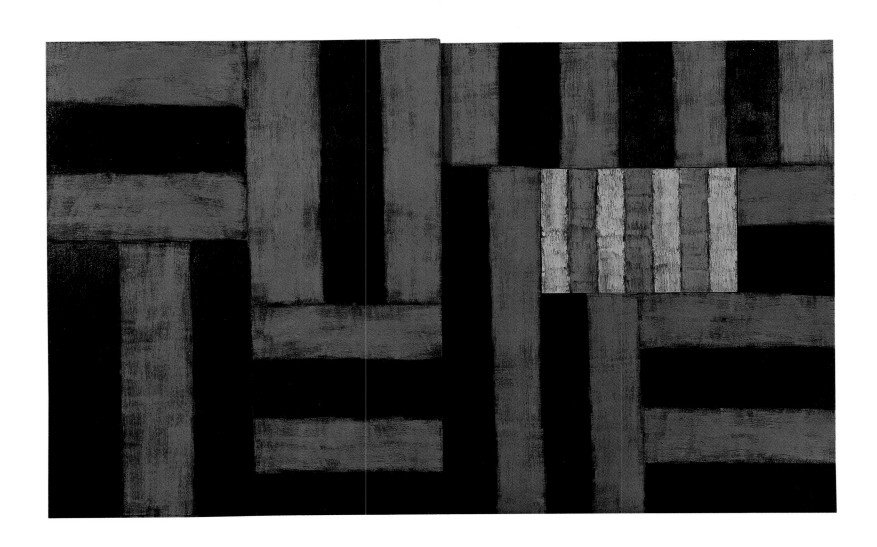

38 AFRICA

1989
oil on canvas
90 x 144 (229 x 366)
Museo Nacional Centro de Arte Reina Sofia, Madrid

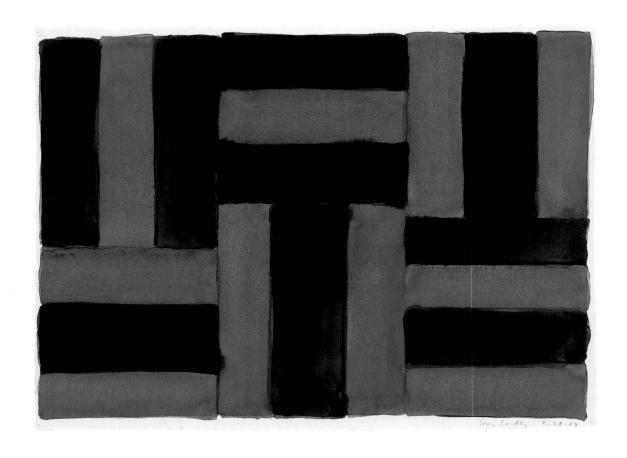

39 8.28.89

1989
watercolor on paper
22 x 30 (56 x 76)
Collection of the artist

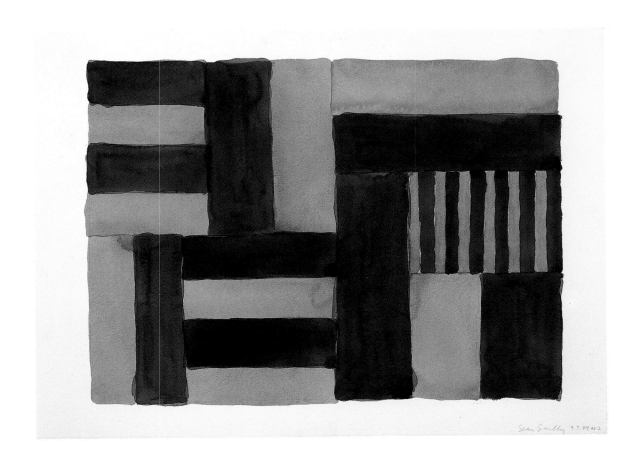

40 9.7.89 #2

1989
watercolor on paper
22 x 30 (56 x 76)
Collection of the artist

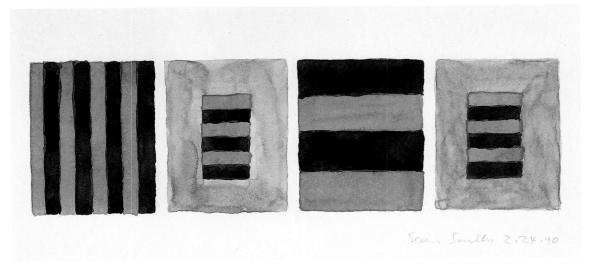

41 2.24.90

1990
watercolor on paper
12 x 16 (30.5 x 40.5)
Collection of the artist

42 FOUR DAYS
 1990
 oil on canvas
 108 x 144 (274 x 366)
 Private Collection, San Francisco

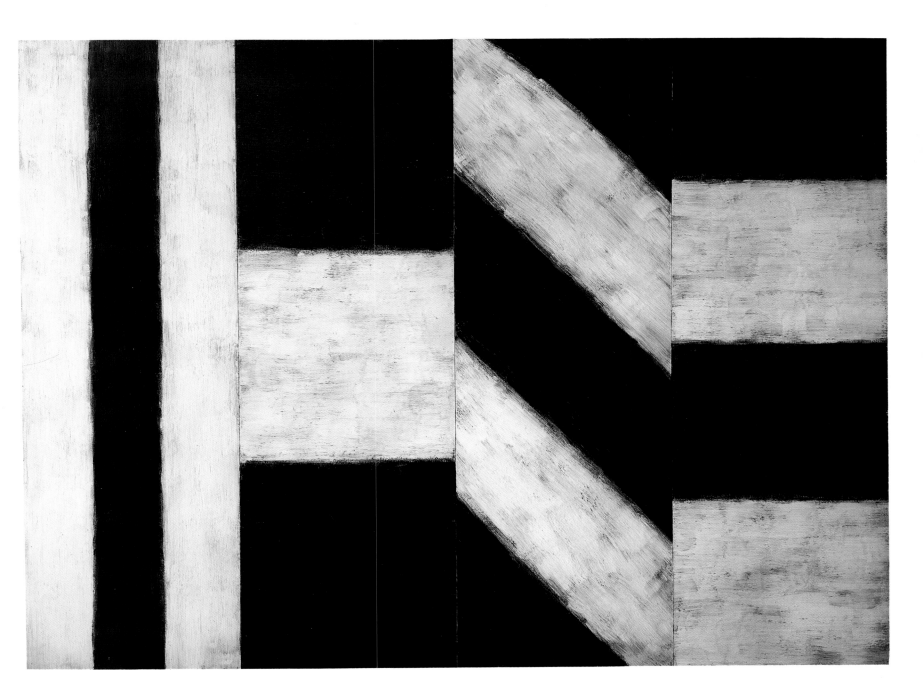

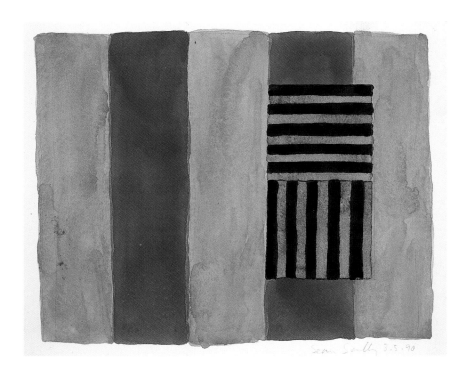

43 3.5.90

1990
watercolor on paper
15 x 18 (38 x 45.5)
Collection of the artist

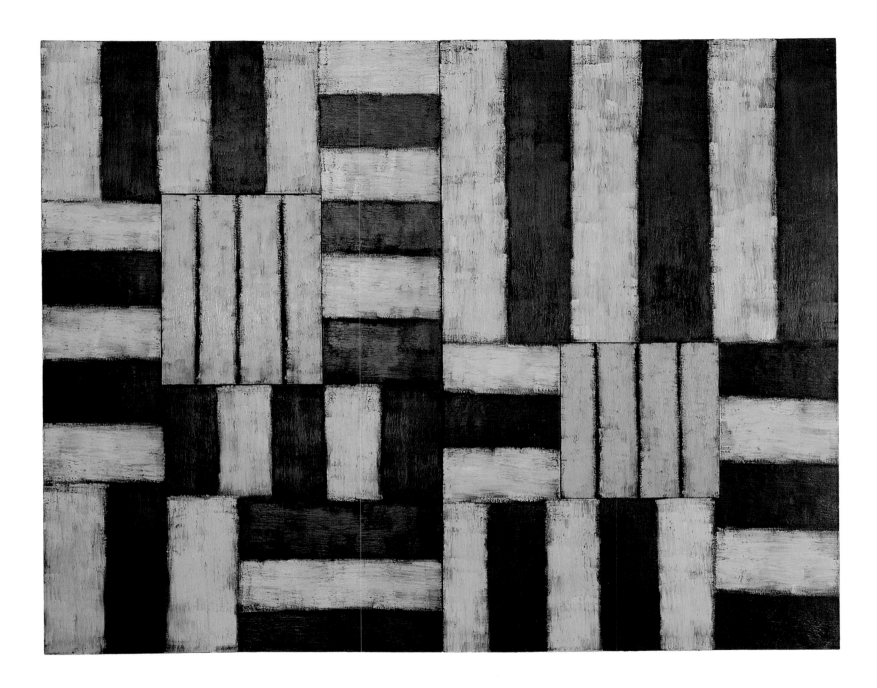

44 WHITE ROBE

1990
oil on canvas
98 x 120 (249 x 305)
High Museum of Art, Atlanta.
Purchase in honor of Richard A. Denny, Jr., President of the Board of Directors, 1991–94, with funds
from Alfred Austell Thornton in memory of Leila Austell Thornton and Albert Edward Thornton, Sr.,
and Sarah Miller Venable and William Hoyt Venable

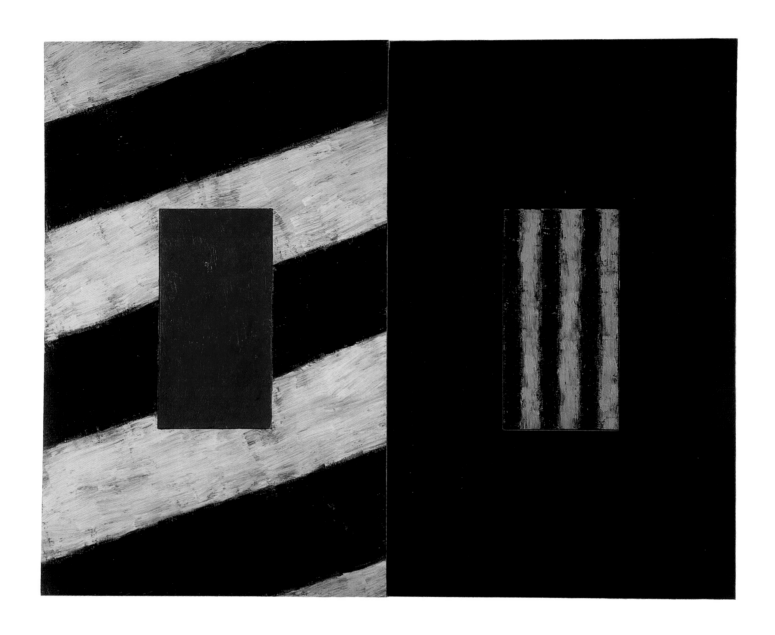

45 FACING EAST

1991
oil on canvas and steel
60 x 72 (152 x 183)
Collection of the artist

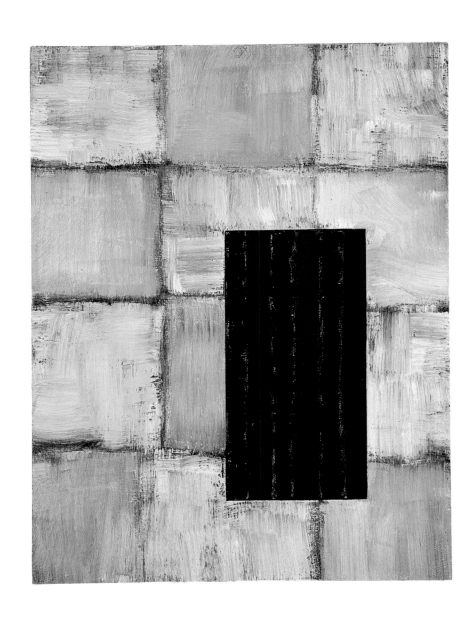

46 UIST

1991
oil on canvas
40 x 30 (102 x 76)
Private Collection, Aschaffenburg

47 4.14.91

1991
watercolor on paper
10 x 14 (25.5 x 35.5)
Collection of the artist

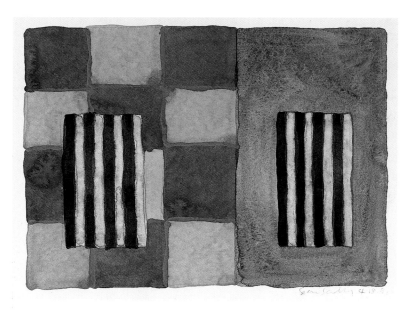

48 4.18.91

1991
watercolor on paper
10 x 14 (25.5 x 35.5)
Collection of the artist

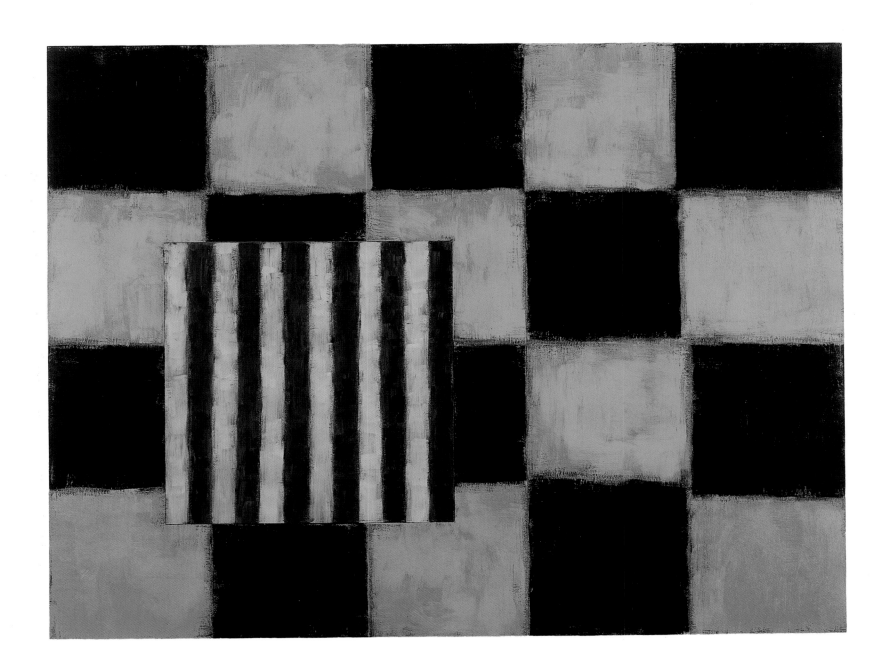

49 TETUAN

1991–93
oil on canvas
84 x 110 (213 x 279)
Collection of Bronya and Andrew Galef

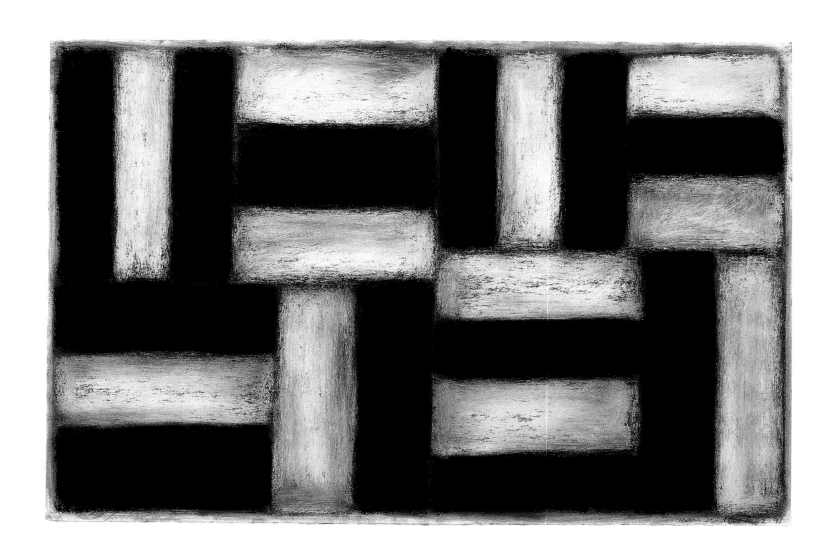

50 10.12.91

1991
pastel on paper
40 x 60 (102 x 152)
High Museum of Art, Atlanta. Gift of David Lurton Massee, Jr. Estate

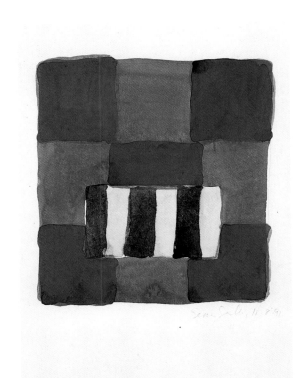

51 11.8.91
1991
watercolor on paper
14 x 10 (35.5 x 25.5)
Collection of the artist

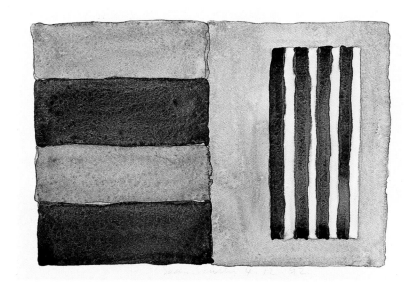

52 4.12.92

1992
watercolor on paper
10 x 14 (25.5 x 35.5)
Collection of the artist

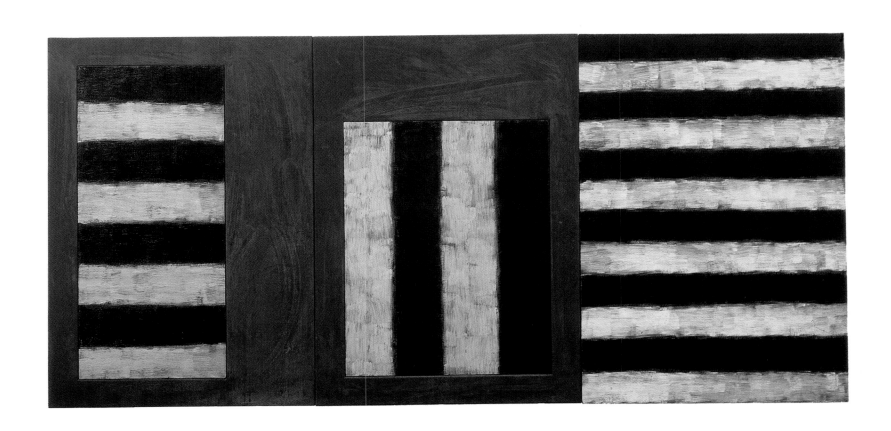

53 SPIRIT
 1992
 oil on canvas and steel
 72 x 162 (183 x 411)
 Collection of the artist

54　STONE LIGHT

1992
oil on canvas
110 x 165 (279 x 419)
Staatsgalerie moderner Kunst, Munich
(Washington and Atlanta only)

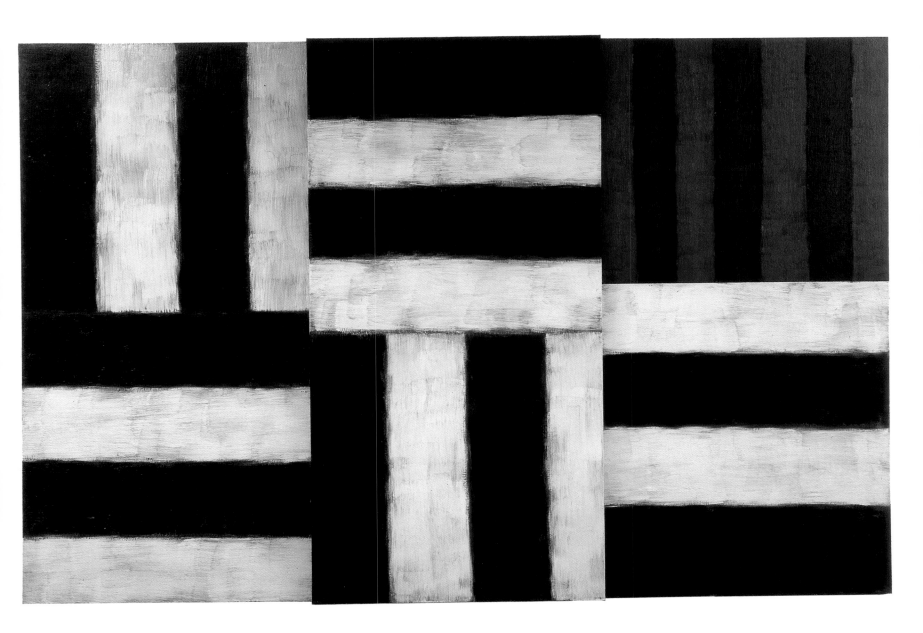

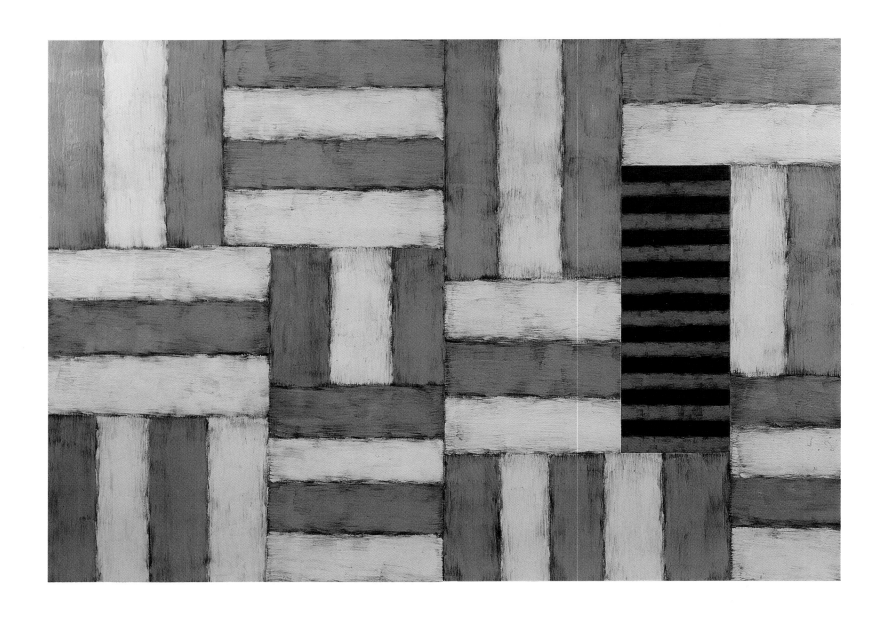

55 GABRIEL

1993
oil on canvas
102 x 144 (259 x 366)
Collection of the artist
(Barcelona and Dublin only)

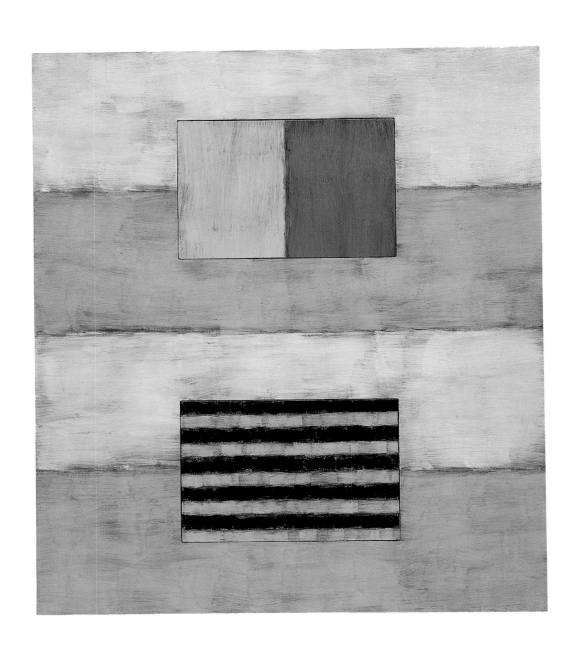

56 MAGDALENA
1993
oil on canvas
80 x 70 (203 x 178)
Collection of Robert and Adele Gardner

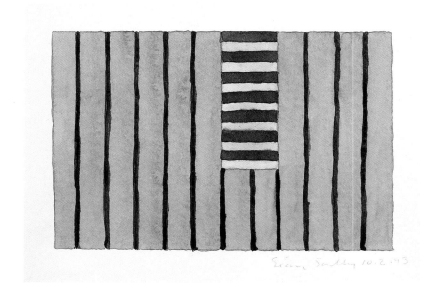

57 10.2.93

1993
watercolor on paper
15 x 18 (38 x 45.5)
Collection of the artist

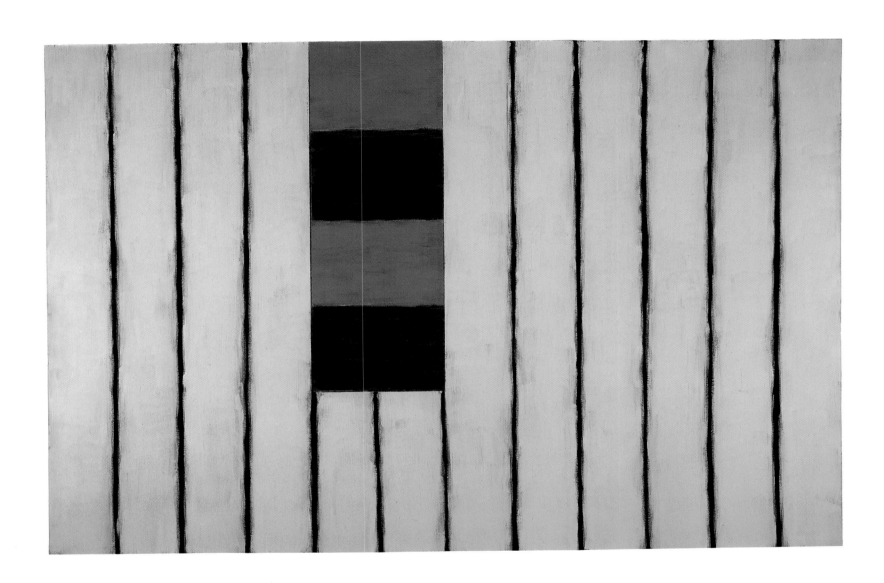

58 UKBAR

1993–94
oil on canvas
96 x 144 (244 x 366)
Collection of the artist

59 ANGELO
 1994
 oil on canvas
 108 x 180 (274 x 457)
 Collection of the artist

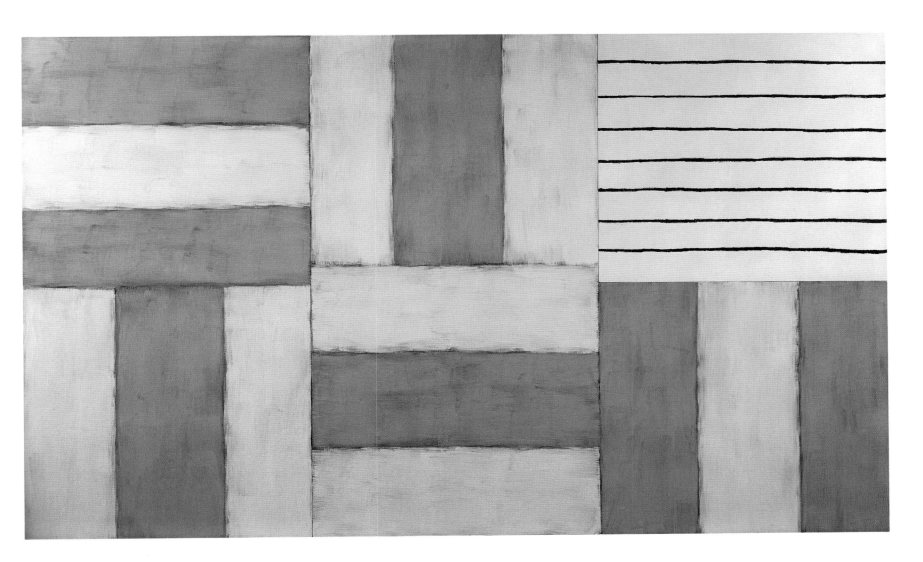

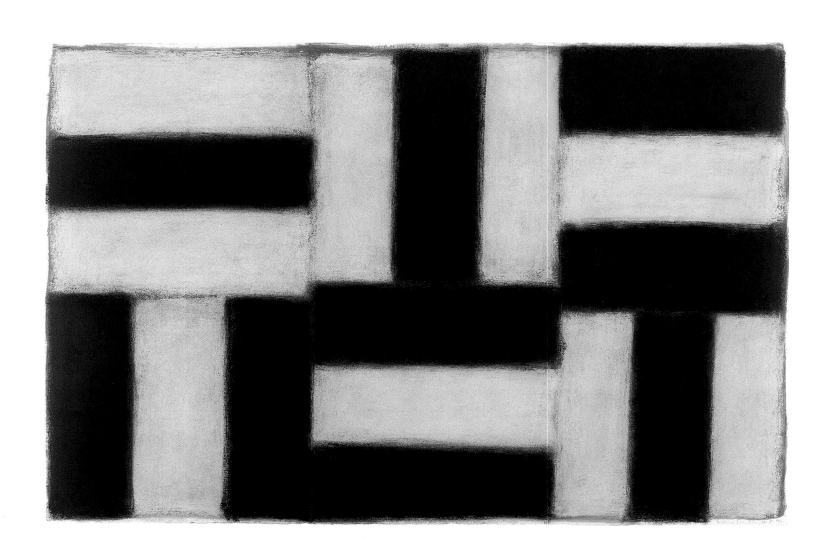

60 HAMMERING #2

 1994
 pastel on paper
 40 x 60 (102 x 152)
 Collection of the artist

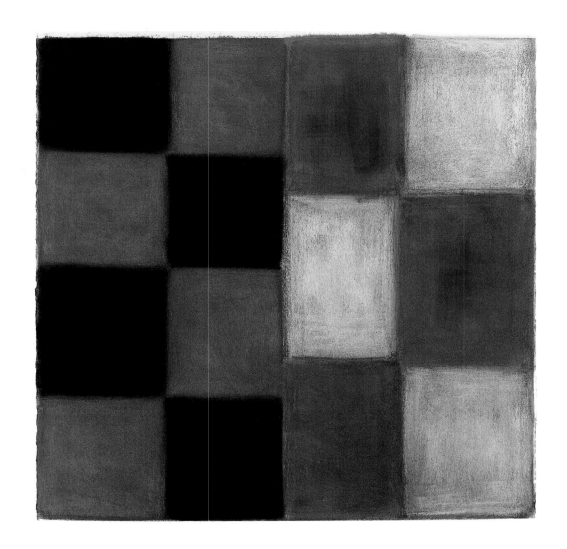

61　UNION

1994
pastel on paper
40 x 40 (102 x 102)
Courtesy of Galerie Lelong, Paris

62 UNION GREY

1994
oil on canvas
96 x 96 (244 x 244)
Collection Klüser, Munich

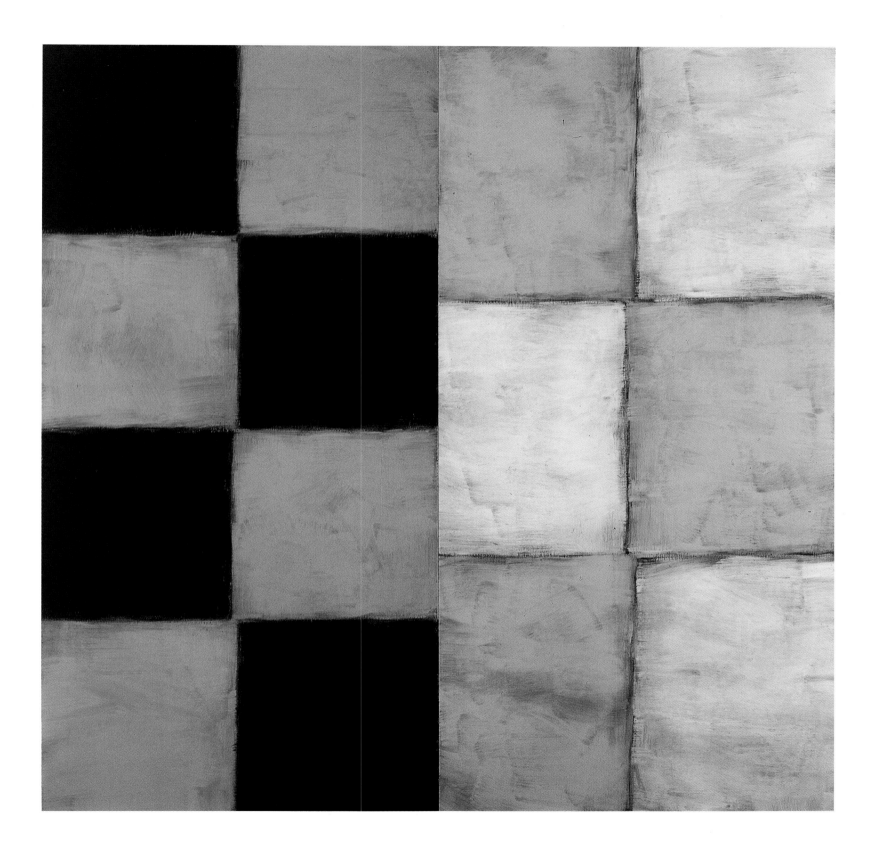

CHECKLIST OF THE EXHIBITION

Dimensions are given in inches (followed by centimeters),
height before width.

1 UNTITLED
 1976
 gouache on paper
 30 x 22¼ (76 x 56)
 Collection of the artist

2 HORIZONTALS: THIN GREYS
 1976
 acrylic on canvas
 36 x 36 (91 x 91)
 Collection of the artist

3 BLUE
 1977
 oil and alkyd on canvas
 48 x 36 (122 x 91)
 Collection of the artist

4 REVERSED DIPTYCH
 1978
 gouache on paper
 30 x 22¼ (76 x 56.5)
 Collection of the artist

5 ITALIAN PAINTING #2
 1979
 oil on canvas
 84 x 28 (213 x 71)
 Collection of the artist

6 BRENNUS
 1979
 oil on canvas
 84 x 84 (213 x 213)
 Collection of the artist

7 UNTITLED
 1979
 acrylic and paper tape on paper
 30½ x 22½ (77.5 x 57)
 Collection of the artist

8 #17
 1980
 graphite on paper
 29½ x 22 (75 x 56)
 Collection of the artist

9 SLATE
 1980
 oil on canvas
 108 x 48 (274 x 122)
 Collection of the artist

10 #29
 1980
 oil on paper
 30½ x 23¼ (77.5 x 59)
 Collection of the artist

11 81#6
 1981
 charcoal and chalk on paper
 30½ x 23½ (77.5 x 59.5)
 Collection of the artist

12 P. 7
 1981
 oil on paper
 30½ x 23½ (77.5 x 59.5)
 Collection of the artist

13 ENOUGH
 1981
 oil on canvas
 67 x 65 (170 x 165)
 Collection of Mellon Bank Corporation, Pittsburgh, Pennsylvania

14 2.24.82
 1982
 oil on paper
 26 x 28½ (65.5 x 72.5)
 Collection of the artist

15 ANGELICA
 1982
 oil on canvas
 96 x 84 (244 x 213)
 Collection of Judith and Mark Taylor

16 HEART OF DARKNESS (Washington and Atlanta only)
 1982
 oil on canvas
 96 x 144 (244 x 366)
 Art Institute of Chicago, Gift of the Society for Contemporary Art

17 THE MOROCCAN (Barcelona and Dublin only)

1982
oil on canvas
112 x 63 (284 x 160)
Beadleston Family Collection

18 9.3.83

1983
oil crayon on paper
15 x 21¼ (38 x 54)
Collection of the artist

19 ANGEL

1983
oil on canvas
96 x 108 (244 x 274)
Beadleston Family Collection

20 11.20.83 #2

1983
oil pastel on paper
30 x 22¼ (76 x 56.5)
Collection of the artist

21 MALLOY (MEXICO)

1983
watercolor on paper
9 x 12 (23 x 30.5)
Collection of the artist

22 2.29.84

1984
watercolor on paper
9 x 12 (23 x 30.5)
Collection of the artist

23 NO NEO

1984
oil on canvas
96 x 121 (244 x 307)
Collection of Bo Alveryd, Switzerland

24 MURPHY

1984
oil on canvas
96 x 120 (244 x 305)
Collection of Cindy Workman

25 FLESH

1985
oil on canvas
96 x 124 (244 x 315)
Collection of Tom and Charlotte Newby

26 THIS, THAT

1986
oil on canvas
114 x 96 (290 x 244)
Städtische Galerie im Lenbachhaus, Munich

27 3.12.84

1984
watercolor on paper
12 x 9 (30.5 x 23)
Collection of the artist

28 7.30.86

1986
watercolor on paper
14 x 10 (35.5 x 25.5)
Collection of the artist

29 8.22.86

1986
watercolor on paper
14 x 10 (35.5 x 25.5)
Collection of the artist

30 9.1.86

1986
watercolor on paper
14 x 10 (35.5 x 25.5)
Collection of the artist

31 EMPTY HEART

1987
oil on canvas
72 x 72 (183 x 183)
Collection of Bo Alveryd, Switzerland

32 3.22.87

1987
pastel and watercolor on paper
22 x 23½ (56 x 59.5)
Collection of the artist

33 4.10.87

1987
watercolor on paper
12 x 16 (30.5 x 40.5)
Collection of the artist

34 5.22.87 #2

1987
watercolor on paper
11 x 15 (28 x 38)
Collection of the artist

35 10.30.87

1987
watercolor on paper
12 x 18 (30.5 x 45.5)
Collection of the artist

36 US

1988
oil on canvas
96 x 120 (244 x 305)
Collection of PaineWebber Group Inc., New York

37 WHY AND WHAT (YELLOW)

1988
oil on canvas and steel
96 x 120 (244 x 305)
Hirshhorn Museum and Sculpture Garden,
Smithsonian Institution, Washington, D.C. Holenia Purchase Fund

38 AFRICA

1989
oil on canvas
90 x 144 (229 x 366)
Museo Nacional Centro de Arte Reina Sofia, Madrid

39 8.28.89

1989
watercolor on paper
22 x 30 (56 x 76)
Collection of the artist

40 9.7.89 #2

1989
watercolor on paper
22 x 30 (56 x 76)
Collection of the artist

41 2.24.90

1990
watercolor on paper
12 x 16 (30.5 x 40.5)
Collection of the artist

42 FOUR DAYS

1990
oil on canvas
108 x 144 (274 x 366)
Private Collection, San Francisco

43 3.5.90

1990
watercolor on paper
15 x 18 (38 x 45.5)
Collection of the artist

44 WHITE ROBE

1990
oil on canvas
98 x 120 (249 x 305)
High Museum of Art, Atlanta.
Purchase in honor of Richard A. Denny, Jr.,
President of the Board of Directors, 1991–94,
with funds from Alfred Austell Thornton
in memory of Leila Austell Thornton
and Albert Edward Thornton, Sr.,
and Sarah Miller Venable and William Hoyt Venable

45 FACING EAST

1991
oil on canvas and steel
60 x 72 (152 x 183)
Collection of the artist

46 UIST

1991
oil on canvas
40 x 30 (102 x 76)
Private Collection, Aschaffenburg

47 4.14.91

1991
watercolor on paper
10 x 14 (25.5 x 35.5)
Collection of the artist

48 4.18.91

1991
watercolor on paper
10 x 14 (25.5 x 35.5)
Collection of the artist

49 TETUAN

1991–93
oil on canvas
84 x 110 (213 x 279)
Collection of Bronya and Andrew Galef

50 10.12.91

1991
pastel on paper
40 x 60 (102 x 152)
High Museum of Art, Atlanta.
Gift of David Lurton Massee, Jr. Estate

51 11.8.91

1991
watercolor on paper
14 x 10 (35.5 x 25.5)
Collection of the artist

52 4.12.92

1992
watercolor on paper
10 x 14 (25.5 x 35.5)
Collection of the artist

53 SPIRIT

1992
oil on canvas and steel
72 x 162 (183 x 411)
Collection of the artist

54 STONE LIGHT (Washington and Atlanta only)

1992
oil on canvas
110 x 165 (279 x 419)
Staatsgalerie moderner Kunst, Munich

55 GABRIEL (Barcelona and Dublin only)

1993
oil on canvas
102 x 144 (259 x 366)
Collection of the artist

56 MAGDALENA

1993
oil on canvas
80 x 70 (203 x 178)
Collection of Robert and Adele Gardner

57 10.2.93

1993
watercolor on paper
15 x 18 (38 x 45.5)
Collection of the artist

58 UKBAR

1993–94
oil on canvas
96 x 144 (244 x 366)
Collection of the artist

59 ANGELO

1994
oil on canvas
108 x 180 (274 x 457)
Collection of the artist

60 HAMMERING #2

1994
pastel on paper
40 x 60 (102 x 152)
Collection of the artist

61 UNION

1994
pastel on paper
40 x 40 (102 x 102)
Courtesy of Galerie Lelong, Paris

62 UNION GREY

1994
oil on canvas
96 x 96 (244 x 244)
Collection Klüser, Munich

CHRONOLOGY

Per Jensen

1945	Born 30 June in Dublin, Ireland
1949	Family moved to London, England, where Scully attended local convent schools
1960–62	Apprenticed at a commercial printing shop in London; joined a graphic design studio
1962–65	Attended evening classes at the Central School of Art, London
1965–68	Attended Croydon College of Art, London
1968–72	Attended Newcastle University, Newcastle-upon-Tyne, England; remained after graduation as teaching assistant
1969	Traveled to Morocco
1970	Awarded the Stuyvesant Foundation Prize
1972	Prizewinner in *John Moore's Liverpool Exhibition 8*
1972–73	Awarded a John Knox Fellowship
Attended Harvard University, Cambridge, Massachusetts	
1973	First solo exhibition in London, at the Rowan Gallery
1973–75	Taught at Chelsea School of Art and Goldsmiths' College, University of London
1975	Awarded a Harkness Fellowship
Moved to the United States	
1977	First solo exhibition in New York, at the Duffy-Gibbs Gallery
Began teaching at Princeton University, Princeton, New Jersey, a position he would retain until 1983	
1981	Ten-year retrospective exhibition at the Ikon Gallery, Birmingham, England (traveled within the United Kingdom under the auspices of the Arts Council of Great Britain)
1982	Spent part of summer working at Edward Albee's artists' colony in Montauk, Long Island

1983	Awarded a Guggenheim Foundation Fellowship
Became an American citizen	
Joined the David McKee Gallery	
1984	Awarded an Artist's Fellowship from the National Endowment for the Arts
Participated in *An International Survey of Recent Painting and Sculpture* at The Museum of Modern Art, New York	
1985	First solo exhibition in an American museum, at the Museum of Art, Carnegie Institute, Pittsburgh, Pennsylvania (traveled to the Museum of Fine Arts, Boston, Massachusetts)
1989	First solo exhibition in a European museum, at the Whitechapel Art Gallery, London (traveled to the Palacio Velázquez, Madrid, and the Städtische Galerie im Lenbachhaus, Munich)
1990	Monograph published by Hudson Hills Press, New York, New York
1992	Revisited Morocco in December to make a film on Matisse for the BBC
Joined the Galerie Bernd Klüser, Munich, and the Waddington Galleries, London	
1993	Joined Knoedler and Company, New York
First exhibition of the *Catherine Paintings* in the Modern Art Museum of Fort Worth, Texas	
1994	Made first paintings in new studio in Barcelona in the summer

149

EXHIBITION HISTORY

Per Jensen

SOLO EXHIBITIONS

1973 Rowan Gallery, London, England

1975 Rowan Gallery, London, England
Tortue Gallery, Santa Monica, California

1976 Tortue Gallery, Santa Monica, California

1977 Duffy-Gibbs Gallery, New York, New York
Rowan Gallery, London, England

1979 *Painting for One Place*, Nadin Gallery, New York, New York
Rowan Gallery, London, England
The Clocktower, New York, New York

1980 Susan Caldwell Gallery, New York, New York

1981 Rowan Gallery, London, England
Museum für (Sub)Kultur, Berlin, Germany
Sean Scully: Paintings 1971–1981, Ikon Gallery, Birmingham, England, exhibition under the auspices of the Arts Council of Great Britain, traveled to: Sunderland Arts Centre; Douglas Hyde Gallery, Dublin; Arts Council of Northern Ireland, Belfast; Warwick Arts Trust, London*
Susan Caldwell Gallery, New York, New York
McIntosh/Drysdale Gallery, Washington, D.C.

1982 William Beadleston Gallery, New York, New York

1983 David McKee Gallery, New York, New York

1984 Juda Rowan Gallery, London, England
Galerie S65, Aalst, Belgium

1985 David McKee Gallery, New York, New York
Museum of Art, Carnegie Institute, Pittsburgh, Pennsylvania; Museum of Fine Arts, Boston, Massachusetts*
Drawings, Barbara Krakow Gallery, Boston, Massachusetts
Sean Scully: Neue Arbeiten, Galerie Schmela, Düsseldorf, Germany

1986 *Sean Scully: Paintings, 1985–1986*, David McKee Gallery, New York, New York*

1987 *Monotypes from the Garner Tullis Workshop*, Pamela Auchincloss Gallery, Santa Barbara, California; David McKee Gallery, New York, New York; Flanders Contemporary Art Center, Minneapolis, Minnesota*
Mayor Rowan Gallery, London, England*
Galerie Schmela, Düsseldorf, Germany*

1987–88 Art Institute of Chicago, Chicago, Illinois*

1988 *Four Paintings at the Art Institute of Chicago*, Matrix/University Art Museum, University of California, Berkeley, California*
Fuji Television Gallery, Tokyo, Japan*
Prints, Crown Point Press, New York, New York; San Francisco, California

1989 David McKee Gallery, New York, New York*
Whitechapel Art Gallery, London, England; Palacio Velázquez, Madrid, Spain; Städtische Galerie im Lenbachhaus, Munich, Germany

1989–90 *Pastel Drawings*, Grob Gallery, London, England

1990 Karsten Greve Gallery, Cologne, Germany
Galerie de France, Paris, France*
McKee Gallery, New York, New York*

1991 *Paintings and Works on Paper*, Jamileh Weber Gallery, Zurich, Switzerland*

1992 *Prints*, Weinberger Gallery, Copenhagen
Sean Scully: Woodcuts, Pamela Auchincloss Gallery, New York, New York
Sean Scully: Prints and Related Works, Brooke Alexander Editions, New York, New York
Woodcuts, Bobbie Greenfield Gallery, Los Angeles, California
Woodcuts, Stephen Solovy Fine Art, Chicago, Illinois
Daniel Weinberg Gallery, Santa Monica, California
Sean Scully: Paintings, 1973–1992, Sert Gallery, Carpenter Center for the Visual Arts, Harvard University, Cambridge, Massachusetts

1993 *Sean Scully*, Waddington Galleries, London, England
 Sean Scully, Mary Boone Gallery, New York, New York
 Sean Scully: The Catherine Paintings, Modern Art Museum of Fort Worth, Fort Worth, Texas*
 Sean Scully: Paintings, Works on Paper, Galerie Bernd Klüser, Munich, Germany*

1994 *Sean Scully: The Light in the Darkness*, Fuji Television Gallery, Tokyo, Japan*
 Knoedler and Company, New York, New York
 Butler Gallery, Kilkenny Castle, Kilkenny, Ireland

SELECTED GROUP EXHIBITIONS

1969 *Northern Young Contemporaries*, Whitworth Art Gallery, Manchester, England

1970 *London Young Contemporaries*, traveling exhibition, Arts Council of Great Britain

1971 *Art Spectrum North*, Laing Art Gallery, Newcastle-upon-Tyne, England; City Art Gallery, Leeds, England; Whitworth Art Gallery, Manchester, England

1972 *John Moore's Liverpool Exhibition 8* (prizewinner), Walker Art Gallery, Liverpool, England
 Northern Young Painters, Stirling University, Scotland

1973 *La Peinture anglaise aujourd'hui*, Musée d'Art Moderne, Paris, France*
 Critic's Choice, Gulbenkian Gallery, Newcastle-upon-Tyne, England

1974 *Tenth International Biennale of Art*, Menton, France
 Rowan Gallery, London, England
 British Painting, Hayward Gallery, London, England

1975 Contemporary Art Society, Art Fair, London, England

1976 *Invitational*, John Weber Gallery, New York, New York

1977 *Four Artists*, Nobe Gallery, New York, New York
 Rowan Gallery, London, England

1978 *Certain Traditions*, traveling exhibition, Canada

1979 *New Wave Painting*, The Clocktower, New York, New York
 Fourteen Painters, Lehman College, New York, New York
 First Exhibition, Toni Birkhead Gallery, Cincinnati, Ohio

1980 *Marking Black*, Bronx Museum of Art, New York, New York
 New Directions, Princeton University Art Museum, Princeton, New Jersey

1981 *Arabia Felix*, Art Galaxy Gallery, New York, New York
 New Directions, Sidney Janis Gallery, New York, New York

1982 *Recent Aspects of All-Over*, Harm Boukaert Gallery, New York, New York
 Abstract Painting, Jersey City Museum, Jersey City, New Jersey

1983 *American Abstract Artists*, traveling exhibition, Nocturne, Siegel Contemporary Art, New York, New York
 Contemporary Abstract Painting, Muhlenberg College, Allentown, Pennsylvania*

1984 *An International Survey of Recent Painting and Sculpture*, The Museum of Modern Art, New York, New York*
 Part 1: Twelve Abstract Painters, Siegel Contemporary Art, New York, New York
 ROSC, The Guinness Hops Store, Dublin, Ireland
 Currents #6, Milwaukee Art Museum, Milwaukee, Wisconsin
 Small Works: New Abstract Painting, Lafayette College and Muhlenberg College, Allentown, Pennsylvania
 Hassam & Speicher Purchase Fund Exhibition, American Academy of Arts and Letters, New York, New York

1985　　*Painting 1985*, Pam Adler Gallery, New York,
　　　　New York
　　　　Abstract Painting as Surface and Object, Hillwood Art
　　　　Gallery, C.W. Post Center, Long Island University,
　　　　Greenvale, New York*
　　　　An Invitational, Condeso/Lawler Gallery, New York,
　　　　New York
　　　　Decade of Visual Arts at Princeton: Faculty 1975–85,
　　　　Princeton University Museum of Art, Princeton,
　　　　New Jersey
　　　　Abstraction/Issues, three-gallery show at Tibor de Nagy,
　　　　Oscarsson Hood, Sherry French, New York, New York
　　　　Art on Paper, Weatherspoon Art Gallery, University
　　　　of North Carolina, Greensboro, North Carolina
　　　　Masterpieces of the Avant-Garde, Annely Juda Fine Art
　　　　/Juda Rowan Gallery, London, England*

1986　　*After Matisse*, traveling exhibition organized by
　　　　Independent Curators, Inc.
　　　　*An American Renaissance in Art: Painting and
　　　　Sculpture since 1940*, Fort Lauderdale Museum of
　　　　Fine Art, Fort Lauderdale, Florida*
　　　　Public and Private: American Prints Today, Brooklyn
　　　　Museum of Art, Brooklyn, New York*
　　　　Sean Scully and Catherine Lee, Cava Gallery,
　　　　Philadelphia, Pennsylvania
　　　　Cal Collects I, University Art Museum, University of
　　　　California, Berkeley, California
　　　　The Heroic Sublime, Charles Cowle Gallery,
　　　　New York, New York
　　　　Structure/Abstraction, Hill Gallery, Birmingham,
　　　　Michigan
　　　　Courtesy David McKee, Pamela Auchincloss Gallery,
　　　　Santa Barbara, California
　　　　Detroiters Collect: New Generation, Meadowbrook
　　　　Art Gallery, Oakland University, Rochester,
　　　　Michigan
　　　　Recent Acquisitions, Contemporary Arts Center,
　　　　Honolulu, Hawaii

1987　　*Corcoran Biennial*, Corcoran Gallery of Art,
　　　　Washington, D.C.*

Harvey Quaytman & Sean Scully, Helsinki Festival,
　　Helsinki, Finland*
Drawing from the 80's—Chatsworth Collaboration,
　　Carnegie Mellon University Art Gallery,
　　Pittsburgh, Pennsylvania
Drawn-Out, Kansas City Art Institute, Kansas City,
　　Missouri*
Magic in the Mind's Eye: Parts I & II, Meadow Brook
　　Art Gallery, Rochester, Michigan*

1987–88　*Logical Foundations*, Pfizer Inc., New York,
　　New York, Curated by the Advisory Service, The
　　Museum of Modern Art, New York, New York
Works on Paper, Nina Freundenheim Gallery,
　　Buffalo, New York

1988　*17 Years at the Barn*, Rosa Esman Gallery, New York,
　　New York
*Works on Paper: Selections from the Garner Tullis
　　Workshop*, Pamela Auchincloss Gallery, New York,
　　New York
New Additions, Crown Point Press, San Francisco,
　　California, and New York, New York
Sightings: Drawing with Color, Pratt Institute, New
　　York, New York*

1989　*The Elusive Surface*, The Albuquerque Museum,
　　Albuquerque, New Mexico
Drawings and Related Prints, Castelli Graphics,
　　New York, New York
Essential Painting, Nelson-Atkins Museum of Art,
　　Kansas City, Missouri
The 1980s: Prints from the Collection of Joshua P. Smith,
　　National Gallery of Art, Washington, D.C.*

1990　*Drawings: Joseph Beuys, Paul Rotterdam, Sean Scully*,
　　Arnold Herstand & Company, New York,
　　New York*
Anthony Ralph Gallery, New York, New York
Sean Scully/Donald Sultan: Abstraction/Representation,
　　Stanford Art Gallery, Stanford University,
　　Stanford, California*
Geometric Abstraction, March Richards Gallery, Santa
　　Monica, California

Artists in the Abstract, Weatherspoon Art Gallery, University of North Carolina, Greensboro, North Carolina*

1991 *Small Format Works on Paper*, John Berggruen Gallery, San Francisco, California
Postmodern Prints, Victoria and Albert Museum, London, England
Louver Gallery, New York, New York
La Metafisica della Luce, John Good Gallery, New York, New York*

1992 *Four Series of Prints*, John Berggruen Gallery, San Francisco, California
Recent Abstract Painting, Collaboration in Monotype from the Garner Tullis Workshop, Cleveland Center for Contemporary Art, Cleveland, Ohio
Geteilte Bilder, Museum Folkwang, Essen, Germany*
Behind Bars, Thread Waxing Space, New York, New York*
Color Block Prints of the 20th Century, Associated American Artists, New York, New York*
Whitechapel Open, Whitechapel Art Gallery, London, England
Painters on Press: Recent Abstract Prints, Madison Art Center, Madison, Wisconsin
Monotypes, Woodcuts, Drawings, Europäische Akademie für Bildende Kunst, Trier, Germany
Monotypes from Garner Tullis Workshop, SOMA Gallery, San Diego, California
44th Annual Academy-Institute Purchase Exhibition, American Academy of Arts and Letters, New York, New York
Galleria Sergio Tossi, Prato, Italy*

1993 *Tutte le strade portano a Roma*, The Exhibition Centre of Rome, Italy*
Beyond Paint, Tibor de Nagy Gallery, New York, New York
Drawing in Black and White, The Museum of Modern Art, New York, New York
The Grolier Club, New York, New York*

American and European Prints, Machida City Museum of Graphic Arts, Tokyo, Japan*
American and European Work on Paper, Gallery Martin Wieland, Trier, Germany
Italia/America: L'Astrazione ridefinita, Dicastro Cultura, Galleria Nazionale d'Arte Moderna, Repubblica di San Marino*
Partners, Annely Juda Fine Art, London, England*
25 Years, Cleveland Center for Contemporary Art, Cleveland, Ohio*
New Moderns, Baumgartner Galleries, Washington, D.C.
5 One-Person Shows, Jamileh Weber Gallery, Zurich, Switzerland

1994 *Recent Print Acquisitions*, The Tate Gallery, London, England
Contemporary Watercolors: Europe and America, University of North Texas Art Gallery, Denton, Texas
For 25 Years: Brooke Alexander Editions, The Museum of Modern Art, New York, New York
Recent Acquisitions: Paintings from the Collection, The Irish Museum of Modern Art, Dublin, Ireland
L'Incanto della Trascendenza, Galleria Civica de Arte Contemporanea, Trento, Italy

* denotes exhibition catalog

PUBLIC COLLECTIONS

NORTH AMERICA

Albright-Knox Gallery, Buffalo, New York
Art Institute of Chicago, Chicago, Illinois
Museum of Art, Carnegie Institute, Pittsburgh, Pennsylvania
Centro Cultural de Arte Contemporaneo, Mexico City, Mexico
Chase Manhattan Bank, New York, New York
Chemical Bank, New York, New York
Cleveland Museum of Art, Cleveland, Ohio
Corcoran Gallery of Art, Washington, D.C.
Dallas Museum of Art, Dallas, Texas
Denver Art Museum, Denver, Colorado
First Bank of Minneapolis, Minneapolis, Minnesota
Fogg Art Museum, Harvard University, Cambridge,
 Massachusetts
Hirshhorn Museum and Sculpture Garden, Washington, D.C.
High Museum of Art, Atlanta, Georgia
Modern Art Museum of Fort Worth, Fort Worth, Texas
McCrory Corporation, New York, New York
Mellon Bank, Pittsburgh, Pennsylvania
Metropolitan Museum of Art, New York, New York
The Museum of Modern Art, New York, New York
National Gallery of Art, Washington, D.C.
Orlando Museum of Art, Orlando, Florida
PaineWebber Group, Inc., New York, New York
Philip Morris, Inc., New York, New York
The Phillips Collection, Washington, D.C.
Santa Barbara Museum of Art, Santa Barbara, California
The St. Louis Art Museum, St. Louis, Missouri
Walker Art Center, Minneapolis, Minnesota

GREAT BRITAIN

Arts Council of Great Britain, London
British Council, London
Ceolfrith Art Centre, Sunderland
Contemporary Arts Society, London
Council of National Academic Awards, London
Eastern Arts Association, Cambridge
Fitzwilliam Museum, Cambridge

Laing Art Gallery, Newcastle-upon-Tyne
Leicestershire Educational Authority, Leicester
Manchester City Art Gallery, Manchester
Northern Arts Association, Newcastle-upon-Tyne
Tate Gallery, London
Victoria and Albert Museum, London
Whitworth Art Gallery, Manchester

IRELAND

Hugh Lane Municipal Gallery of Modern Art, Dublin, Ireland
The Irish Museum of Modern Art, Dublin, Ireland
Ulster Museum, Belfast, Northern Ireland

CONTINENTAL EUROPE

Centro de Arte Reina Sofia, Madrid, Spain
Kunsthalle Bielefeld, Bielefeld, Germany
Kunstsammlung Nordrhein-Westfalen, Düsseldorf, Germany
La Fondation Edelman, Lausanne, Switzerland
Städtische Galerie im Lenbachhaus, Munich, Germany
Louisiana Museum, Humlebaek, Denmark
Museum für (Sub)Kultur, Berlin, Germany
Staatsgalerie moderner Kunst, Munich, Germany
Zentrum für Kunst und Medien Technologie, Karlsruhe,
 Germany

AUSTRALIA

Australian National Gallery, Canberra
National Gallery of Victoria, Felton Bequest, Melbourne
Power Institute of Contemporary Art, Sydney

BIBLIOGRAPHY

Per Jensen

SELECTED BOOKS AND EXHIBITION CATALOGS

Bowman, Russell. *Currents #6: New Abstraction.* Milwaukee: Milwaukee Art Museum, 1984.

Carrier, David. *The Aesthete in the City: The Philosophy and Practice of American Abstract Painting in the 1980s.* University Park, Pennsylvania: Penn State Press, 1994.

The Fortieth Biennial Exhibition of Contemporary American Painting. Washington, D.C.: Corcoran Gallery of Art, 1987.

Harvey Quaytman and Sean Scully. Helsinki: Helsinki Festival, 1987. Interview with Mari Rantanen.

An International Survey of Recent Painting and Sculpture. New York: Museum of Modern Art, 1984.

Masheck, Joseph. *Modernities.* University Park, Pennsylvania: Penn State Press, 1993.

New York Studio Events: Sean Scully. New York: Independent Curators, 3, 1988.

Poirier, Maurice. *Sean Scully.* New York: Hudson Hills Press, 1990.

Sean Scully. Pittsburgh: Museum of Art, Carnegie Institute, 1985. Contributions by John Caldwell, David Carrier, and Amy Lighthill.

Sean Scully. New York: David McKee Gallery, 1986. Conversation with Joseph Masheck.

Sean Scully. Düsseldorf: Galerie Schmela, 1987. Essay by Susanne Lambrecht.

Sean Scully. London: Mayor Rowan Gallery, 1987.

Sean Scully. Berkeley: University Art Museum, 1987. Essay by Constance Lewallen.

Sean Scully. Chicago: Art Institute of Chicago, 1987. Essay by Neal Benezra.

Sean Scully. Tokyo: Fuji Television Gallery, 1988. Essays by Takashi Nibuya and John Loughery; interview by Kazu Kaido.

Sean Scully. New York: David McKee Gallery, 1989.

Sean Scully. Tokyo: Fuji Television Gallery, 1994. Essays by Masaaki Noda and Demetrio Paparoni.

Sean Scully: The Catherine Paintings. Fort Worth: Fort Worth Modern Art Museum, 1993. Essays by Arthur C. Danto, Steven Henry Madoff, and Carter Ratcliff.

Sean Scully: Monotypes from the Garner Tullis Workshop. Santa Barbara: Pamela Auchincloss Gallery, 1987.

Sean Scully: Paintings, 1971–1981. Birmingham, England: Ikon Gallery, 1981. Essays by Sam Hunter and Joseph Masheck.

Sean Scully: Paintings and Works on Paper. London: Whitechapel Art Gallery, 1989. Essay by Carter Ratcliff.

Sean Scully: Paintings and Works on Paper. Munich: Galerie Bernd Klüser, 1993. Essay by Armin Zweite.

Sean Scully: Prints from the Garner Tullis Workshop. New York: Garner Tullis, 1991. Essay by David Carrier.

Wheeler, Daniel. *Art Since Mid-Century: 1945 to the Present.* New York: Vendome Press; London: Thames and Hudson, 1991.

SELECTED ARTICLES AND REVIEWS

Adams, Brooks. "The Stripe Strikes Back." *Art in America*, October 1985.

Andrada, Beatriz. "Sean Scully: 'Intento que mis cuadros sean profundos, agresivos y hasta salvajes.'" *El Diario*, 16, 14 September 1989.

Artner, Alan G. "Stripe Up the Band." *Chicago Tribune*, 17 January 1988.
—— "Monograph." *Chicago Tribune*, 2 December 1990.
—— "Sean Scully." *Chicago Tribune*, 10 April 1992.

Aukeman, Anastasia. "Sean Scully at Bernd Klüser." *ARTnews*, April 1994. (Reprinted in *ARTnews* [Japanese edition], August 1994.)

Auer, James. "Monograph." *Milwaukee Journal*, 2 December 1990.

Baker, Kenneth. "Prime Displays of Anti-Minimalist Art on Peninsula." *San Francisco Chronicle*, 21 March 1990.

Barringer, Felicity. "Matisse: 'He's Kind of Cast a Spell on Me.'" *ARTnews*, April 1993.

Bass, Ruth. "Sean Scully." *ARTnews*, March 1991.

Bennett, Ian. "Minimal Respect." *Financial Times*, 17 December 1977.
—— "Loneliness of the Abstract." *Financial Times*, 25 August 1979.
—— "Sean Scully." *Flash Art*, January–February 1980.
—— "Sean Scully." *Flash Art*, Summer 1989.
—— "Sean Scully." *Tema Celeste*, January–March 1992.

Berryman, Larry. "Abstraction of Opposites." *Arts Review*, December 1992.

Bevan, Roger. "Scully's Decade." *Antique and New Art*, Winter 1990.
—— "Controversy over the Turner Prize." *The Arts Newspaper*, November 1991.

Billen, Andrew. "The Brits in the Bonfire." *Observer Magazine*, 17 March 1991.

Bode, Peter M. "Reine Malerei." *Abendzeitung*, 15 November 1993.

Bonaventura, Paul. "Sean Scully: 'Hay que ligar la abstracción a la vida.'" *RS*, October 1989.

Braff, Phyllis. "Testing the Edge." *Cover Magazine*, May 1994.

Brenson, Michael. "Sean Scully." *New York Times*, 8 February 1985.
—— "True Believers Who Keep the Flame of Painting." *New York Times*, 7 June 1987.

Bromberg, Craig. "The Untitled Orbit." *Art and Auction*, October 1991.
—— "Gefühl ist wieder angesagt." *Artis*, February 1992.

Brooks, Richard. "Prize Oils Hit Troubled Water." *Observer* (London), 3 November 1991.

Burkhart, Dorothy. "Critic's Choice." *San Jose Mercury News*, 18 February 1990.

—— "Form, Light and Color Combine to Bring the Abstract to Life." *San Jose Mercury News*, 2 March 1990.

Cappuccio, Elio. "Interview with Arthur Danto." *Segno*, November 1992.

Carrier, David. "Corcoran Gallery 40th Biennial." *Burlington Magazine*, July 1987.
—— "Art Criticism and Its Beguiling Fictions." *Art International*, Winter 1989.
—— "Piet Mondrian and Sean Scully: Two Political Artists." *Art Journal*, Spring 1991.
—— "Abstract Painting and Its Discontents." *Tema Celeste*, Fall 1991.
—— "After Light." *Arts Magazine*, March 1992.
—— "Sean Scully: New York and Fort Worth." *Burlington Magazine*, July 1993.
—— "Italia/America: L'Astrazione ridefinita." *Segno*, Fall 1993.

Carty, Ciaran. "Sean Scully." *Irish Independent*, 25 November 1984.

"Catherine Paintings." *Commercial Recorder* (Fort Worth), 11 and 13 May 1993.

"Catherine Paintings." *Star Telegram* (Fort Worth), 11 May 1993.

Checkland, Sarah Jane. "London's Arty Street Party." *Times* (London), 21 November 1992.

Conway, Joan. "Whitechapel." *Irish Post*, 27 May 1989.

Cook, Emma. "A Room of My Own: Sean Scully." *Observer Magazine*, 19 September 1993.

Cooke, Lynne. "Sean Scully." *Galeries Magazine*, August–September 1989.

Cotter, Holland. "Sean Scully." *Flash Art*, April–May 1985.

Crichton, Fenella. "Sean Scully at the Rowan." *Art International*, 15 June 1975.

Cyphers, Peggy. "Sean Scully." *Tema Celeste*, March–April 1991.

Dannatt, Adrian. "Sean Scully: An Interview." *Flash Art*, May–June 1992.

Danto, Arthur. "Astrattismo post-storico." *Tema Celeste* (Italian edition), April–May 1992.
—— "Art after the End of Art." *Artforum*, April 1993.

Danvila, José Ramon. "Sean Scully: 'La Emoción de la geometría.'" *El Punto*, 22 September 1989.

De Eguino, Inaki Moreno Ruiz. "El Palacio de Velázquez mafrileno acoge una muestra del minimalista Sean Scully." *Diario Vasco*, 1 October 1989.

Dorment, Richard. "Scully Earns His Stripes." *Daily Telegraph*, 17 May 1989.

Durand, Regis. "Sean Scully: Une Abstraction ancrée dans le monde." *Art Press*, February 1991.

Faure-Walker, James. "Sean Scully." *Studio International*, April–May 1975.

Faust, Gretchen. "Herstand Group Show." *ARTnews*, Summer 1990.

Feaver, William. "Farewell Blaze of Colour." *Manchester Guardian*, 18 July 1972.
—— "Sean Scully." *Art International*, November 1973.
—— "Six Artists—A Critic's Choice." *Manchester Guardian*, December 1973.
—— "Sean Scully." *Observer* (London), 6 November 1977.
—— "Sean Scully." *ARTnews*, January 1978.
—— "Sean Scully." *Art International*, November 1979.
—— "Sean Scully." *Observer* (London), 5 September 1981.
—— "Irish Continental." *Observer* (London), 28 October 1984.
—— "Sean Scully." *Observer* (London), 4 November 1984.
—— "Starring in Stripes." *Observer* (London), 7 May 1989.
—— "Sean Scully." *Observer* (London), 15 November 1992.

Forgey, Benjamin. "Sean Scully." *Washington Post*, 13 October 1981.

Gardner, Paul. "Waking Up and Warming Up." *ARTnews*, October 1992.

Garlake, Margaret. "Double Scully." *Gallery Magazine*, November 1987.

Gayford, Martin. "Gallery Round-up." *Daily Telegraph*, 15 November 1993.
—— "Sean Scully." *Telegraph Magazine*, 20 November 1993.

Gosling, Nigel. "Sean Scully: Too Soon for Resuscitation." *Observer* (London), 6 April 1975.

Graham-Dixon, Andrew. "Anti-Cool Rules." *Vogue* (British edition), October 1987.
—— "Between the Lines." *Independent*, 13 May 1989.
—— "Velasquez: The Greatest Living Artist." *Vogue* (British edition), March 1990.

Gutterman, Scott. "Sean Scully." *Journal of Art*, January 1991.

Hegenisch, Katharina. "Liberty with Stripes." *Frankfurter Allgemeine Zeitung*, 8 August 1989.

Higgins, Judith. "Sean Scully and the Metamorphosis of the Stripe." *ARTnews*, November 1985.

High, Graham. "Sean Scully." *Riverside Artists Group Magazine*, December–January 1993.

"Highlights of the Week." *Guardian*, 7 November 1992.

Hill, Andrea. "Sean Scully." *Artscribe International*, September 1979.

Hilton, Timothy. "Art." *Independent*, 22 November 1992.

Hjort, Oestein. "Sean Scully." *Politiken* (Copenhagen), 22 March 1992.

Hughes, Robert. "Earning His Stripes." *Time*, 14 August 1989.
—— "Sold." *Time*, 27 November 1989.
—— "A Domain of Light and Color." *Time*, 2 July 1990.
—— "The Great Massacre of 1990." *Time*, 3 December 1990.

Humeltenberg, Hanna. "Sean Scully stellt in der Galerie Schmela aus ein Stück weit verfremdt." *Rheinische Post*, 28 October 1987.

Hunter, Sam. "Sean Scully's Absolute Paintings." *Artforum*, November 1979.

Jarques, Fietta. "Sean Scully: 'Busco la emoción, no el sentimentalismo.'" *El Pais*, 14 September 1989.

Jiménez, Pablo. "Sean Scully: 'La Geometría es una ética sin fe, pura utopia, algo asi como Suiza.'" *ABC*, 9 September 1989.
—— "Un Brillante final de siglo." *ABC*, 21 September 1989.

Johnson, Anna. "Stripe Hype." *Vanity Fair*, May 1993.

Juncosa, Enrique. "Las Estrategias de Apolo." *Lápiz*, 6, 1989.
—— "Sean Scully." *Tema Celeste*, Winter 1993.

Krauter, Anne. "Sean Scully at Jamileh Weber." *Artforum*, Summer 1992.

Lambrecht, Susanne. "Schmela Exhibition: Blick auf das Wesentliche." *Rheinische Post*, 2 December 1985.

Larson, Kay. "Sean Scully." *New York Magazine*, 3 October 1983.

Lederman, Erika. "Sean Scully at Fuji Gallery." *Japan International Journal*, April 1994.

Lehrman, Robert. "Art Reviews: Corcoran Biennial." *Washington Review*, June–July 1987.

Levy, Mark. "The Permutations of the Stripe." *Shift*, 1, 1988.

Litt, Steven. "Abstract Paintings, Concrete Feelings." *The Plain Dealer* (Cleveland), 29 February 1992.

Loughery, John. "Sean Scully." *Arts Magazine*, December 1986.
—— "17 Years at the Barn." *Arts Magazine*, April 1988.

Lucie-Smith, Edward. "British Painting for Paris." *Illustrated London News*, February 1973.
—— "Sean Scully—Gaining on the Roundabouts." *Evening Standard*, 17 November 1977.

MacAdam, Barbara A. "A Stripe Day."*ARTnews*, February 1992.
—— "La Metafisica della luce." *ARTnews*, February 1992.

Madoff, Steven Henry. "Sean Scully at William Beadleston." *Art in America*, March 1983.

Matsumura, Toshio. "Sean Scully at Fuji Gallery." *Sankei Shimbun*, 10 April 1994.

McCarron, John. "Sean Scully." *Shift*, 2, 1988.

Mitchell, Charles Dee. "Artist Scully Speaks of Life in the Abstract." *Morning News* (Dallas), 29 May 1993.

Morgan, Robert C. "Physicality and Metaphor: The Paintings of Sean Scully." *Art Journal*, Spring 1991.

Motoe, Kunio. "Sean Scully's Prints."*Hangwa Geijutsu*, September 1993.

Nagoya, Satoru. "Advocating a Return of the Humanistic Painting." *Japan Times*, 3 April 1994.

Napack, Jonathan. *New York Observer*, 27 September 1993.

Noda, Masaaki. "Art Evolved from Struggling Situation." *Chugoku Shimbun*, 7 December 1993.

Norman, Geraldine. "Contemporary Art Market." *Independent*, 23 November 1992.

Ostrow, Saul. "Sean Scully at Mary Boone." *Flash Art*, December 1993.

Packer, William. "Sean Scully." *Financial Times*, 22 April 1975.
—— "A Scott Comes to Artistic Judgement." *Financial Times*, 4 December 1984.
—— "Simple Statements Speak Volumes." *Financial Times*, 6 June 1989.

Paparoni, Demetrio. "Interview with Sean Scully." *Tema Celeste*, April–May 1992.
—— "L'Astrazione ridefinita." *Tema Celeste*, 1994.

Pérez-Guerra, José. "Sean Scully: Geometría y emoción." *Cinco Dias*, 17 September 1989.

Princenthal, Nancy. "Irrepressible Vigor: Printmaking Expands." *ARTnews*, September 1990.

Puvogel, Renate. "Sean Scully: Neue Arbeiten." *Kunstwerk*, February 1986.

Quaderni di Gestalt, 13, 1991 (drawings throughout).

Ratcliff, Carter. "Artist's Dialogue: Sean Scully. A Language of Materials."*Architectural Digest*, February 1988.

Raynor, Vivien. "Sean Scully." *New York Times*, 19 June 1987.

Reboiras, Ramon F. "Hay que humanizar el abstracto, romper su habitual distanciamiento." *El Independiente*, 14 September 1989.

Rippon, Peter and Ben Jones. "An Interview with Sean Scully." *Artscribe*, 12, June 1978.

Rosenthal, Adrienne. "Painting by Sean Scully." *Artweek*, 29 March 1975.

Rubenstein, Meyer Raphael. "Books: Sean Scully." *Arts*, March 1991.

Russell, John. "Building on the Flat." *Sunday Times* (London), 11 November 1973.

—— "Sean Scully." *New York Times*, 10 December 1976.

—— "Sean Scully." *New York Times*, 4 March 1977.

—— "Sean Scully." *New York Times*, 14 December 1979.

—— "Sean Scully." *New York Times*, 23 January 1981.

—— "Sean Scully." *New York Times*, 24 December 1982.

—— "Sean Scully." *New York Times*, 30 September 1983.

Sachs, Brita. "Stachel im Fleisch der Ordnung." *Frankfurter Allgemeine Zeitung*, 5 February 1994.

Saltz, Jerry. "Mayday, Mayday, Mayday." *Art in America*, September 1993.

"Satellite." *Artscribe International*, January–February 1990.

Saure, Wolfgang. "Sean Scully." *Weltkunst*, January 1994.

Schappell, Elissa. "Sean Scully: Star of Stripes." *GQ* (British edition), April–May 1989.

Schwabsky, Barry. "Sean Scully at Mary Boone." *Artforum*, December 1993.

Schwarz, Arturo. "Italia/America: L'Astrazione ridefinita." *Segno*, Fall 1993.

"Sean Scully." *Boston Phoenix*, 13 November 1992.

"Sean Scully." *Antique and New Art*, Winter 1992.

"Sean Scully." *Münchner Stadtmagasin*, January 1994.

"Sean Scully and Mimmo Paladino: 'In at the Deep End'" (interview). *Modern Painters*, Summer 1993.

"Sean Scully: 'Quiero quedarme en España durante algún tiempo.'" *El Punto*, 21 September 1989.

Searle, Adrian. "Sean Scully at Waddington." *Time Out*, 16–30 December 1992.

Shone, Richard. "Sean Scully." *Burlington Magazine*, January 1993.

Smith, Alistair. "Sean Scully." *Irish Arts Review Yearbook*, 1994.

Smith, Roberta. "Sean Scully." *New York Times*, 7 December 1990.

Solomon, Deborah. "Art Market Bust." *New York Times Magazine*, 28 February 1993.

Sonna, Birgit. "Einer der über Malerei sinniert." *Süddeutsche Zeitung*, 29–30 January 1994.

Spalding, Frances. "Unequal Halves." *Arts Review*, September 1993.

Sugaware, Norio. "Sean Scully at Fuji Gallery." *Yomiuri Shimbun*, 25 March 1994.

Tanner, Marcia. "Vistas into Shared Terrain." *Artweek*, 8 March 1990.

Taylor, John Russell. "Whitechapel." *Times* (London), 16 May 1989.

Trenas, Miguel Ángel. "Scully: La Humanización del abstracto." *La Vanguarda*, 15 September 1989.

Trepp, Judith. "5 One-Man Shows: Jamileh Weber." *ARTnews*, January 1994.

Trimario, Angelo. "San Marino, 34 voci per dire astrazione." *Il Mothno*, 30 July 1993.

—— "Italia/America: L'Astrazione ridefinita." *Tema Celeste*, Fall 1993.

Tyson, Janet. "The Modern Has Multitudes of Scully's Work." *Star Telegram* (Fort Worth), 7 May 1993.

—— "Love in the Abstract." *Star Telegram* (Fort Worth), 11 May 1993.

—— "Contemporary Watercolors: Europe and America." *Star Telegram* (Fort Worth), 26 January 1994.

Vaizey, Marina. "Sean Scully." *Times* (London), 5 April 1981.

—— "Painting Takes to the Stage." *Times* (London), 2 December 1984.

—— "Shedding Light on Simplicity." *Times* (London), 14 May 1989.

Varley, William. "Art Spectrum: North in Newcastle." *Manchester Guardian*, Summer 1971.

"Vasari Diary." *ARTnews*, September 1992.

Vescovo, Marisa. "San Marino, Italia e America." *La Stampa*, 23 August 1993.

Vogel, Carol. "Art Market." *New York Times*, 5 June 1992.

—— "Inside Art." *New York Times*, 17 September 1993.

Walker, Dorothy. "Sean Scully at the Douglas Hyde Gallery"
 (letter to the editor). *Irish Times*, 13 December 1981.
—— "Arts and Studies." *Irish Times*, 4 January 1985.

Walker, Iain and J. Midwinter. "Scully/Saatchi." *The Mail*,
 26 November 1989.

Welish, Marjorie. "Abstraction, Advocacy of." *Tema Celeste*,
 January–March 1992.

Wiedemann, Christoph. "Lenbachhaus." *Süddeutsche Zeitung*,
 14 July 1989.

Winter, Peter. "Blüten, Streifen, Neonlicht." *Frankfurter
 Allegmeine Zeitung*, 26 November 1987.
—— "Perfekte Tektonik der Streifen: Der Ire Sean Scully in der
 Kölner Galerie Karsten Greve." *Frankfurter Allgemeine
 Zeitung*, 3 February 1990.
—— "Shape is Not Abstract." *Art International*, Summer 1990.
—— "Streit zwischen ungleichen Brüdern." *Frankfurter
 Allgemeine Zeitung*, 9 April 1992.

Yau, John. "Sean Scully." *Artforum*, April 1991.

Zimmer, William. "Heart of Darkness: New Stripe Paintings by
 and an Interview with Sean Scully." *Arts Magazine*,
 December 1982.